MAGRITTE:
THE TRUE ART
OF PAINTING

magritte magritte magritte ｒ

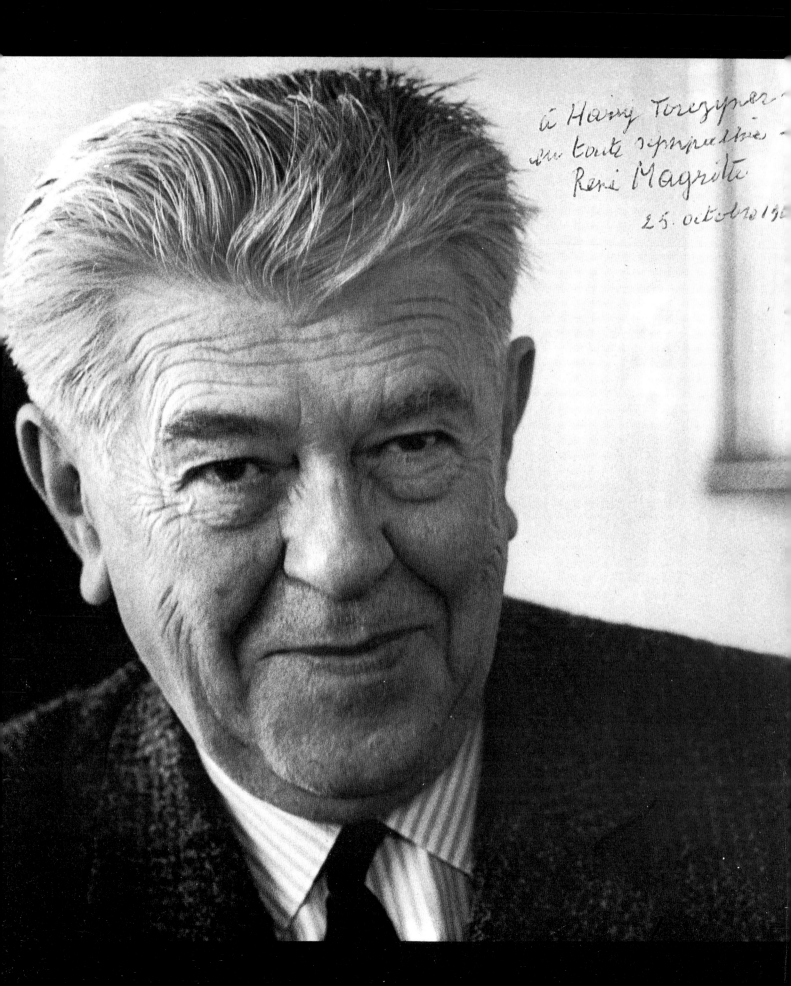

à Harry Torczyner
en toute sympathie-
René Magritte
25. octobre 19

magritte *magritte* *magritte* *magr*

MAGRITTE: THE TRUE ART OF PAINTING

HARRY TORCZYNER

With the collaboration of Bella Bessard

Translated by Richard Miller

ABRADALE PRESS / HARRY N. ABRAMS, INC.

NEW YORK

For my friend Fritz Landshoff

Frontispiece: 1. Photograph of René Magritte

Editor: John P. O'Neill
Assistant Editor: Ellen Schwartz

Library of Congress Cataloging in Publication Data
Magritte, René, 1898–1967.
 Magritte, the true art of painting.
 Translation of: Véritable art de peindre.
 Bibliography: p.
 1. Magritte, René, 1898–1967. I. Torczyner, Harry. .
II. Bessard, Bella. III. Title.
ND673.M35A4 1985 759.9493 84-24260
ISBN 0-8109-8064-9

This 1985 editon is published by Harry N. Abrams, Incorporated, New York.
It is a concise, completely reorganized edition of Abrams' *Magritte: Ideas and Images,*
originally published in 1977, which was itself a translation of *René Magritte: Signes et Images.*
A paperback concise editon was also published by Abrams, distributed by New American Library,
in 1979. All rights reserved. No part of the contents of this book may be reproduced without
the written permission of the publishers.

Printed and bound in France

CONTENTS

PREFACE

René Magritte and I were destined to meet. Indeed, if a film projectionist were simultaneously to flash two series of images—one dealing with the first forty years of Magritte's life and the other with the first forty years of mine—onto adjoining parts of a screen, there would unroll before the viewer many of the same figures of both men and women playing various roles at different moments in both films. Some members of this cast of characters, deliberately or capriciously brought together by fate during the last decade of Magritte's life, would appear synchronously in both films.

Magritte and I were both born in Belgium, although in different centuries. Only a fortnight separated our birthdays, and we were both born under the sign of Scorpio. Magritte once pointed out to me that his birthday, November 21, meant he was born under the same sign as Edgar Allan Poe, whom he admired enormously. However, he did not enjoy it when I remarked that Charles de Gaulle, whom he disliked, was also a Scorpio. In order to tease Magritte a little about his birth date, I told him that it was on a November 21, in 1811, that the German dramatist and poet Heinrich von Kleist had taken his own kind of revenge on fate and on the victor of Wagram, Napoleon, by first killing his beloved, Henriette Vogel, and then by firing a bullet into his own head.

These remarks were exchanged during my first meeting with René Magritte and his wife Georgette, which occurred on a Saturday afternoon, October 26, 1957, at their apartment on the Boulevard Lambermont, Brussels. Their black Pomeranian Loulou was present at this meeting as a certified witness. Politely but systematically, Magritte subjected me to a close cross-examination. "Did I know his work?" "Truly?" "What was an international lawyer?" To the last question I explained that an international lawyer was one who traveled a great deal. Magritte later handed me a book. With some emotion I realized I held in my hands Magritte's copy of Lautréamont's *Les Chants de Maldoror,* a volume that in my youth had completely changed my views on life. Upon turning the pages, I discovered the images that Magritte had drawn to accompany Lautréamont's text.

"Where did my travels take me?" Magritte continued. Was I, like Maldoror, in Madrid today, in St. Petersburg tomorrow, Peking yesterday? "No, no, you'll find me in Brussels today," I explained, "Abidjan tomorrow, then Moscow, Jerusalem, even Paris!" Magritte replied, "You must travel the skies for me. It would be a pleasure to discover through you distant lands and half-barbarous tribes. Since you live in the United States, you could also give me news about my dealer, my pictures, my friends, even my critics. You could send me reports, minutes, dispatches." "So you need an ambassador to the United States?" I queried. "Exactly," he said, and then Magritte burst out laughing.

After my return to Manhattan, I received my Magrittian credentials, but they had been issued from 97 rue des Mimosas instead of the apartment on the Boulevard Lambermont, because René and Georgette had moved. They were now oc-

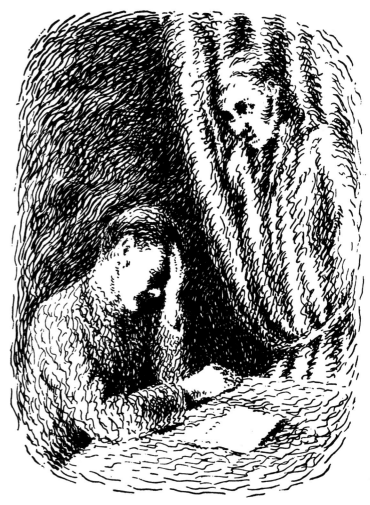

2. Illustration for *Les Chants de Maldoror* by Lautréamont, 1948

cupying the whole of a white house. It was in this dwelling that I visited them five or six times a year.

My conversations with René Magritte dealt principally with what he called his "labors." As I became a familiar visitor, I grew to know exactly the hiding places of his latest gouaches, or "grist," as his close friend Louis Scutenaire called them. These canvases might be casually set on the floor with their faces to the wall, like mislaid or forgotten objects. Sometimes Magritte would spontaneously show me a completed work or a sketch, observing my reaction closely out of the corner of one eye.

Oddly, despite his outward assurance and his certainty of being on the path of truth, Magritte needed reassurance. This is the reason why those friends who had formed part of his intimate circle at the outset of his career continued to be his necessary companions, despite the occasional falling-outs and misunderstandings that led frequently to touching reconciliations, and despite the dissensions that lent a perverse spice to his everyday life. I met one after the other in Magritte's home, when he still saw them, or at their own homes after they had become estranged from him, all of the members of the old-guard Surrealist group in Brussels, the true friends of Magritte. This group included Paul Nougé, biochemist, poet, and thinker; Pierre Bourgeois, the first poet to write a work inspired by one of Magritte's paintings; Camille Goemans, writer and gallery director; Marcel Lecomte, poet and essayist; André Souris, composer; E. L. T. Mesens, musician, poet, and collagist; Louis Scutenaire, Magritte's spiritual brother and the

author of epigrams, poems, and stories, whose "Inscriptions" were engraved on the painter's mind; Irène Hamoir, poet; Marcel Mariën, an iconoclast by birthright, a *poète-agitateur,* a native of Antwerp, who became the devoted computer in whose memory are stored the accomplishments, deeds, and writings of this group of friends. Paul Colinet, the poet and intimate friend of the Magrittes, was also a member of this circle, but I never met him because he was dying throughout the autumn of 1957, at the time of my first visit to the Magrittes. With this group of friends, Magritte signed manifestos and took part in demonstrations, playing his intermittent role of *homo ludens;* in their company he could be solitary without being lonely. From one of their number, Paul Nougé, he had learned that "We are responsible for the universe" and that "Everything is still possible."

Much later new voices joined the chorus to which René Magritte often turned for comment. Among the new arrivals was the youthful André Bosmans, with whom Magritte shared his thoughts. When Bosmans wrote to Magritte that "Nothingness is the sole wonder of the world," it became even clearer to the artist that despair must be faced with the courage of hope.

In 1926, the members of Magritte's circle, like the artist, began to welcome the French Surrealists. From 1927 to 1930, René and Georgette, while living at Le Perreux-sur-Marne, France, often visited André Breton and his friends at Breton's house in the Rue Fontaine, Paris.

Here they met Aragon, Ernst, Éluard, Duchamp, Man Ray, and Dali. Magritte witnessed the minor and major excommunications from the Surrealist movement and participated in all its discussions. He and his work were taken seriously, but in 1928, André Breton did not mention Magritte in his volume *Le Surréalisme et la Peinture.* Magritte's relations with Breton and his circle remained courteous, but the timid artist had no intention of allowing himself to be intimidated, and he and Georgette returned to Brussels. Despite all the ensuing disagreements, Magritte and Breton retained a sincere admiration for one another. One day, when I mentioned Breton to him, Magritte said: "It was hard for me to be in tune with a man who didn't like music."

During World War II, André Breton, along with his entourage, went into exile in New York. He visited the Haitians and the Hopi Indians exactly in the manner that he had once visited the Belgians. During his New York years, I met him frequently. Early in 1945, Brentano's published a new text of Breton's essay *Le Surréalisme et la Peinture.* The cover of this edition bore a reproduction of Magritte's *Le modèle rouge (The Red Model),* a painting that Magritte had executed in 1937. In the sole paragraph of his text that Breton devoted to Magritte, the French Surrealist both judged correctly and wrote with a masterful hand:

> Magritte's nonautomatic but on the contrary fully deliberate progress is the buttress of Surrealism. Alone among us, he has approached painting in the spirit of an "object lesson," and from that angle he has presided over the systematic trial of the visual image, emphasizing its shortcomings and indicating the dependent nature of the figures of language and of thought. A unique and totally rigorous undertaking, within the confines of the physical and the mental, bringing into play all the resources of a mind demanding enough to conceive each picture as the site of the solution of a new problem.

To mark the publication of Breton's volume, my colleague Robert Tenger installed in Brentano's show window on Fifth Avenue a model of *Le modèle rouge* surrounded by copies of the book. Two large black boots ending in cleverly sculpted, flesh-colored toes were placed on the graveled floor of the window. This sight brought thousands of passersby to an abrupt halt.

The United States discovered Magritte early. In 1936, Julien Levy, a disciple of Surrealism and an art dealer, acquired Magritte's painting *La clé des songes (The Key of Dreams),* and he showed the artist's work. Shortly after its opening, the Museum of Modern Art, New York, hung on its walls in 1939 Magritte's painting *Le faux miroir (The False Mirror),* that eye with its hypnotic pupil, that black sun floating among the clouds. When the time would come for the endless hours devoted to the collective delights of shared mental sloth, millions of Americans of all ages, with eyes and ears only for their television sets, would be shaken awake and brought back to reality by this image borrowed to become the emblem of one of the largest American television networks.

In 1946, Magritte's credo, *La Ligne de Vie,* was published *in extenso* in English in an issue of the magazine *View* devoted to him. In 1947, Alexandre Iolas, a young Greek immigrant to New York, born in Egypt, exhibited paintings by Ernst and Magritte in the Galerie Hugo, which he had opened off Madison Avenue. For more than thirty years, until his retirement, Iolas was the splendid herald of these artists in the New World. That same year William Copley, who later became an imaginative painter and a unique Maecenas, began to make Magritte known in California. Copley subsequently lived for many years in Longport-sur-Orge (Seine-et-Loire), where René and Georgette often visited him.

From London, Mesens contacted the Sidney Janis Gallery, New York, to arrange the Magritte exhibition entitled *"Les Mots et les Choses,"* which opened in 1954. The young Robert Rauschenberg and Jasper Johns studied Magritte at that show. However, only one buyer materialized—Saul Steinberg, the witty virtuoso draftsman. Magritte was not yet appreciated by the art press nor by museums, except for those in New York. Modern Belgian art has not as a general rule attracted either international attention or interest. Only James Ensor was known, but who else?

The large New York exhibition of Belgian art held during the summer of 1960, a show in which I collaborated, was organized by Baron Jan Albert Goris, then minister plenipotentiary of Belgium to the United States and the most brilliant contemporary author writing in Dutch. The three paintings most often reproduced in the magazine and newspaper reports of this exhibition were by Magritte: *Le plagiat (Plagiarism), Le château des Pyrénées (The Castle of the Pyrenees),* and *Au seuil de la liberté (On the Threshold of Liberty).*

My assigned tasks as ambassador to the United States had to be carried out at Magritte's convenience. "I'm giving you a lot of difficulties," he wrote in October 1960, "but they are those given to a magnificent and outstanding ambassador." The excessive flattery of these adjectives was a diplomatic indication of the urgency of this particular dispatch.

René Magritte's letters constitute a précis of authentic Magrittism, and they reflect his spirit of precision. One word in a preface, a single turn of phrase in a text—everything in his writings was examined, reviewed, minutely gone over. His

handwriting is clear, each sign giving each letter even greater impact because of his fine calligraphy.

Magritte applied his typical rigor to everything he undertook or advised someone else to undertake. When I was having difficulties in choosing the exactly right frame for *Le château des Pyrénées,* Magritte offered to make me a "Doctor of Framing." He sent me a detailed plan for the frame, while at the same time evidencing a certain amicable tolerance: "I ask you not to take my indications as ultimate dogma. If you are calling in an experienced framer (and not a mere carpenter), he may be able to suggest another shape of frame than the one I have designed."

Magritte cared little for chronology. The order in which his paintings were hung in an exhibition was unimportant to him; only the works counted, not their dates. Often, to confuse those animated by a passion for art-historical exactitude, or to confound the compilers of so-called *catalogues raisonnés,* he would inscribe a fanciful date in large numerals on the back of a picture. *Le tombeau des lutteurs (The Tomb of the Wrestlers),* painted in the peaceful summer of 1960, bears the fateful date "1944." Even the dates of his letters often mock time: for example, "Almost the end of September 1958" and "Already February 2nd, 1959." A banner bears the date "July 14," but there is no indication of the year of this particular "July 14."

The first museum exhibitions devoted solely to René Magritte's painting finally took place. They marked an end to those invitations extended to two artists at the same time because of the parsimony and narrowmindedness of curators. The Museum of Modern Art exhibition in New York in 1961, in the honorable company of Yves Tanguy, was the last show in tandem in which Magritte participated. In accord with Magritte, Douglas McAgy put together an important group of paintings, gouaches, drawings, and documents for the exhibition "René Magritte in America," which took place in 1961 at the Dallas Museum of Fine Arts, Dallas, Texas, and then moved to the Houston Museum of Fine Arts, Houston, Texas. That same year, however, the Tate Gallery in London barred its doors to the Belgian painter of mystery, despite the intervention of Mesens, Sir Roland Penrose, and other enlightened and educated spirits. Magritte's images did not illuminate this museum until after his death, when David Sylvester organized a retrospective.

As a result of continuous efforts and initiatives, a series of *vernissages* took place in the United States. Plans and projects for these exhibitions were submitted to Magritte for his approval. The artist often sent me directives, he expressed his wishes, and we collaborated on the texts and drew up meticulous memoranda for me to discuss with the authors of catalogue introductions—who often dared both to engage in explanations of his work and to indulge in comparisons that Magritte felt to be insufferable.

The triumphant and moving reception given Magritte during the opening of the Museum of Modern Art exhibition in December 1965 in New York remains unforgettable. *Le jour de gloire* had come at last. That was the day Magritte chose to pay a visit to a lifelong friend. On that rainy Sunday afternoon, I accompanied Georgette and René to Edgar Allan Poe's residence in the Bronx. What had his invisible friend said to him in that tiny bedroom? Magritte was in tears.

At the beginning of our relationship, Magritte had insisted that I create new verbal expressions, and sensitive to his taste for precise terminology, I began calling his pictures "Magrittian children," began to use the adjective "Magrittian" to describe images and ideas characteristic of him, and began to speak of "Magrittism," all with his approval.

Often, plays on words—by which I mean the spiritual exchange of serious thoughts—brought forward a problem whose solution called for Magritte's presence of mind. Thus Max Jacob's line "Seen against the light or otherwise, I do not exist, and yet I am a tree," and my lines, "Let the day sleep/Let the night wake/The living green Tree/Watches over the life/The survival of man," posed this kind of question to him. Magritte's inspired solution was that tree enhaloed with sparse leaves, that glorious image with its greens and blues that was given the only title worthy of it: *L'arc de triomphe (The Arch of Triumph).*

When Magritte painted my portrait, he executed it from a photograph, just as if he did not know me. In so doing he was following the example set by Albrecht Dürer, who made a drawing of a rhinoceros on May 20, 1515, from a friend's sketch, which had been made in Lisbon where a rhinoceros had been sent to King Manuel by an Indian grandee. Would the portrait be better if I had posed for it? One day at Le Perreux-sur-Marne, Magritte painted in one sitting the portrait of a friend of Éluard, a Madame Pomme or Apfel. When it was finished, the pretty little face resembled the sitter's face, but

3. Illustration for *Les Chants de Maldoror* by Lautréamont, 1948

the head was completely bald. Do Ionesco's *Rhinoceros* and *The Bald Soprano* speak Magritte's language?

Magritte disliked turning toward his past, but his loyalty was constant. He gratefully preserved the memory of those who had believed in him when he was the object of derision and contempt from a hostile world and those who had remained devoted to him throughout his overlong, difficult years.

Magritte introduced me to three stalwart friends who had been among the first to recognize his works—P. G. Van Hecke, M. Schwarzenberg, and Geert Van Bruaene. In 1959, when the most prestigious art dealers in the world were making proposals to him that would have quadrupled his earnings, Magritte firmly refused them and remained faithful to Alexandre Iolas, with whom, he always said, he had a contract. In fact Magritte had no contract with Iolas, but Magritte did have respect for his given word, and he never forgot that Iolas had encouraged him and continued to represent him despite the failure of the 1947 show at which not one single canvas had been sold. Magritte explained his point of view in his "pomp and circumstance" style in a letter to me, dated November 19, 1959: "Since the end of the war, Iolas has been faithfully buying from me all or almost all of my 'output.' This faithfulness (which at the outset was sometimes translated with difficulty into monetary form) is a kind of dogma.... A perfect dogma, with the minor imperfections inherent to anthropology, nevertheless, and which would be just as imperfect were that dogma adhered to by some other Iolas."

Magritte talked to me about his paintings, but he did not indulge me with talk about his family. I never met his two brothers. One day when Magritte was giving me several musical compositions of his younger brother Paul to show to New York publishers, he mentioned in passing a brother named Raymond who was comfortably off and whom he never saw.

Nonetheless, Magritte took an interest in genealogy. Were the Magrittes of the same family as General Jean-Antoine Margueritte, the unhappy hero of the charge at Reichshoffen, of which the king of Prussia, the future Emperor William I, had remarked that it had been "as beautiful as it had been useless"? Magritte could have been related to this general's sons, Paul and Victor Margueritte, preferably Victor (the author of the scandalous novel *La Garçonne* [the literary forerunner of today's liberated woman], who was stricken from the lists of the Legion of Honor for having "insulted French womanhood"), as his genealogy was elective. According to Georgette, three Margueritte brothers came from France to Pont-à-Celles, in the Belgian province of Hainaut, during the French Revolution. Léopold Magritte, René's father, was supposed to have been the direct descendant of one of these brothers, Jean-Louis Magritte, known as de Roquette, the local pronunciation having altered the orthography of his name.

Magritte, however, told me many times that he had neither a predecessor nor a successor in painting. The question of influences seemed to him a superfluous one. His moving discovery of Chirico's *Le chant d'amour*, which has so often been alluded to, was a revelation to him, but not the beginning of an influence, no more so than was the discovery of certain elements or aspects of Max Ernst's work.

On the question of the quantity and the numerous variations on his images, I once asked him if he was trying to make the Magrittian children as numerous as the stars in the sky. "Yes, that is my wish," he replied. He encouraged the reproduction of his paintings in every medium, mechanical or otherwise,

4. Illustration for *Les Chants de Maldoror* by Lautréamont, 1948

as posters or as postcards. Magritte disliked the orthodox, conformist notion of the unique *exemplum*. However, while preaching the multiplication and dispersion of his images, he hated plagiarism and its ramifications. His curtain, his stone balustrade, were sincerely considered by him as trademarks that were intended to discourage or unmask counterfeiters. Unlike most artists, Magritte had no desire to retain a finished painting for study or for his personal collection. As soon as they were born, the Magrittian children were sent out into the world to make their way; however, he did not lose interest in them and he remained curious as to who took them in and how they were appreciated. For example, in regard to *L'art de la conversation (The Art of Conversation),* he was eager to know how I thought it was getting on in the New Orleans museum that had given it a home. Some of Magritte's other canvases met with a cruel fate. *Le messager (The Messenger),* now known as *Le voyageur (The Voyager),* was damaged by fragments from a V-bomb explosion in 1945 and later returned to the artist. A long time afterward, some friends saw it in his home in its sad state, and upon their urging Magritte gave it to them with permission to have it restored. In this way this astounding image was saved.

Magritte's relations with those who liked or were purported to like his painting were ambivalent. An amateur who had been interested in Magritte's work at the time when he was still comparatively unknown continued to enjoy the artist's affection because of his obvious sincerity. But after Magritte be-

came famous, he spoke to me—not without some bitterness—about the latecomers, the *"visiteurs du soir,"* who brought him nothing and who wanted to take away everything, at any price. Just as an Englishman thinks a man should not be hanged if he is a duke, so did Magritte feel that one should not despise a man for being rich. But he also felt that there was nothing admirable about this quality. One day in New York, when a millionaire collector of Magritte's work took the artist by his arm in a familiar manner, Magritte whispered to me, "He leads me around like a racehorse wearing his colors."

Magritte fortunately had friends in the world of Belgian officialdom who formed at the same time part of his spiritual family. Émile Langui of the Ministry of Fine Arts and Robert Giron of the Brussels Palais des Beaux-Arts both served his cause. They saw to it that frescoes were commissioned from Magritte and that a large sum of money was granted to him as a "prize to crown his career"—but only after the entire world had come to know Magritte's name. Nevertheless, when the Belgian government seriously began to consider making Magritte a baron, the artist found it both ridiculous and not enough. "Tell them," he said to me, "that Maeterlinck was at least a count!"

In refusing to singularize himself, Magritte showed the world that he was not like everyone else and that he intended to protect himself from everyone else. Out of politeness, he did not interfere with the literati when they described him as they imagined him to be: as the hero of a detective story or a spy novel. To please these writers he allowed them to believe that he was a character in search of an author. Herein was born the legend that threatens to be handed down from book to book. No one was more intelligently direct than Magritte; he had no artifice. He was not a secret agent. He made known his likes and dislikes, his opinions and his prejudices. He openly confronted everyone who attempted to impose the conventional lies upon mankind, under the pretext of whatever religion or ideology.

Magritte was curious, voyeuristic, and analytical. He was often negative, like the Geist der Verneint in Goethe's *Faust,* like that Spirit of Denial who stalks the dunes, the moors, the mists in Caspar David Friedrich's landscapes, with which the artist was familiar.

Georgette was Magritte's lifelong companion. In the house that she had decorated on the rue des Mimosas, Magritte was surrounded by the *Magies noires* for which she had posed and by her portraits. For him, Georgette represented "The Likeness." For her, he had a tenderness and a concern that were evident to any visitor. He was displeased with the film Luc de Heusch had made about him because Georgette was not in it. In Nice one day in June 1964, as I was strolling with Magritte, he stopped before a shop window in which he had espied a porcelain rooster. "I must buy that for Georgette," he said to me. "She'll love it." "Are you still courting her, René?" "It's true," he replied, smiling.

I saw Magritte for the last time on the afternoon of August 8, 1967, in his room in the Clinique Edith Cavell in Brussels. Georgette, René, and I chatted as though nothing were wrong. Georgette related how Stéphane Cordier of the review L'Arc had just called to request authorization to publish Magritte's drawings for *Maldoror* in an issue of the review to be devoted to Lautréamont, and she added that René had agreed. His room gave onto the garden. That pleased him. Magritte was walking around in his dressing gown and eating some dried beef he had had smuggled in. He was completely yellow. He wasn't in great pain and he told me he was suffering from jaundice. Georgette and I looked at each other. I kissed Georgette and I kissed René and I left for New York. What could I think? What could I believe? On August 12, I telephoned the clinic and was informed that Magritte had left the hospital and gone home. I was overjoyed. I called the house on the rue des Mimosas. Georgette came to the telephone, sobbing: "It's bad, very bad," she told me.

On August 15, at 3:55 PM, I received the following telegram:

```
FIA 112 (27) CDV296
04918 B229221 7 PD INTL FR CD
BRUXELLES VIA WUI 15 1815
TORCZYNER
(DELR) 521 FIFTHAVE NYK
RENE DECEDE
GEORGETTE.
```

Magritte's Ideas and Images give evidence of a life worth living. More than fifty years ago, Magritte gave the starting signal to his Lost Jockey, that rider whose mysterious race will persist as long as men exist who know that everything is always possible. What he thought, what he believed, what he created, needs neither interpreters nor exegetes. "Women, children, men who never think about art history," Magritte said, "have personal preferences just as much as aesthetes do."

I have chosen from my book *Magritte: Ideas and Images* the necessary elements to make known and appreciated by a larger public what René Magritte considered to be the True Art of Painting.

HARRY TORCZYNER

New York, New York
October 11, 1978

THE LIVING MIRROR

THE MENTAL UNIVERSE

His gray eyes interrogated you with a curiosity mingled with a real and strange tenderness, for he knew you were the prisoner of his look, that you deserved his compassion, and yet he kept you in this uneasy state. He spoke French slowly, in an even voice, with a strong Walloon accent he made no attempt to conceal. He expressed himself in short, clear, concise sentences.

Magritte attached no importance whatsoever to his art, but the greatest importance to the problems that art posed for him. These problems obsessed him until he had solved them. He was meticulous in all things: each day had its schedule. Whatever the weather, he was on time for appointments. He liked neatness and cleanliness. He liked to receive letters, but didn't want to be burdened with them. He was a shy man, a solitary man who avoided unexpected meetings. One did not enter either his mind or his home without knocking. No physical contact. Although he liked those with whom he was on familiar terms, he detested familiarities. He expected everything from everyday life, but nothing from life itself.

Under the rain-drenched Belgian sky, the apartments and houses in which Magritte lived were all the same to him and all alike. When in 1963 he decided to build, he tried to oversee the most unimportant details and suffered the presence of an architect as had Ludwig Wittgenstein. In a short time, however, these concerns began to appear ridiculous to him and he lost interest in the project, as well as in the architect, and went back to indifference.

For Magritte, Woman was a far different thing from the synthetic, artificial, mythological creature that was the fashion with the Surrealists. She was neither destructive goddess nor guardian muse. In his work, no Pygmalion appears to bring the marble statue to life. He knew love and loved love, about which he spoke openly and without equivocation. He wished his friends a good night of love as naturally as he wished them *"bon appetit."*

Magritte abhorred violence. He hated soldiers and detested those organized massacres, wars. Yet, under the Nazis he worked for the Resistance.

He was a hypochondriac. After he had reached sixty, however, his imaginary illnesses were succeeded by real ones: violent headaches, neuralgias, liver attacks. He injured his right wrist, which depressed him deeply, for he was afraid he had lost that absolute manual mastery that had enabled him to paint without a single smudge. He fought against and tried to master fate up until the day he succumbed to his final illness.

5. *Le miroir vivant (The Living Mirror).* 1926. Oil on canvas, 21¼ x 28¾" (54 x 73 cm). Collection Mme. Sabine Sonabend, Brussels, Belgium

Man

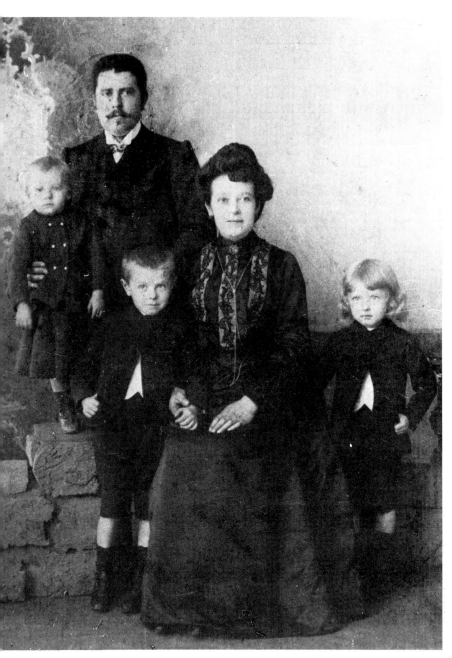

6. Photograph of René Magritte (holding his mother's hand) with his parents and two younger brothers, Raymond and Paul

I despise my own past and that of others. I despise resignation, patience, professional heroism, and all the obligatory sentiments. I also despise the decorative arts, folklore, advertising, radio announcers' voices, aerodynamics, the Boy Scouts, the smell of naphtha, the news, and drunks.

I like subversive humor, freckles, women's knees and long hair, the laughter of playing children, and a girl running down the street.

I hope for vibrant love, the impossible, the chimerical.

I dread knowing precisely my own limitations.
——*René Magritte, Le Savoir Vivre, Brussels, 1946*

Painting *bores* me like everything else. Unfortunately, painting is one of the activities—it is bound up in the series of activities—that seems to change almost nothing in life, the same habits are always recurring. . . .
——*René Magritte, statement reported by A. Gomez, May-June 1948*

I hope I will never stoop to pulling strings to achieve success, which I can get along without.
——*Letter from René Magritte to André Souris, March 1953*

I dislike money, both for itself and for what it can buy, since I want nothing we know about.
——*René Magritte, statement reported by Maurice Rapin, "René Magritte,"* Aporismes, *1970, p. 23*

"According to my doctrine," it is forbidden (under pain of imbecility) to foresee anything. What I will do *in all* situations is as unpredictable as the emergence of a real poetic image. . . .
——*Letter from René Magritte to Mirabelle Dors and Maurice Rapin, December 30, 1955*

I will tell you . . . that I have some patience with the rich from whom I derive my livelihood; on occasion I may give the impression that I am their "valet": for example, I obey their idiotic caprice that I paint their portraits. I've never claimed to be a "luxury item" in the arts though, and in fact I often make gaffes *au-to-mat-i-cal-ly.* (At my Brussels retrospective in '54: the Minister of Education came to visit the exhibition and I accompanied him through the rooms "like a servant," as Breton would say. However, when looking at *Le civilisateur,* whose title surprised him, I served him with: "Indeed, we have a lot to learn from dogs," etc.)
——*Letter from René Magritte to Mirabelle Dors and Maurice Rapin, March 7, 1956*

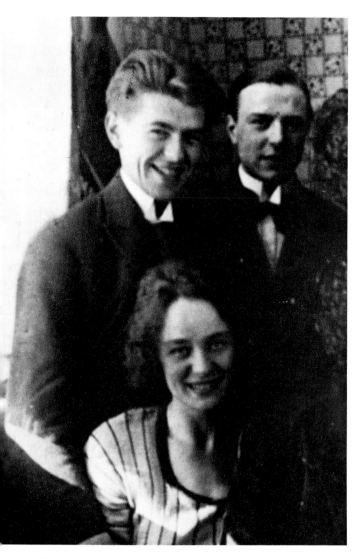

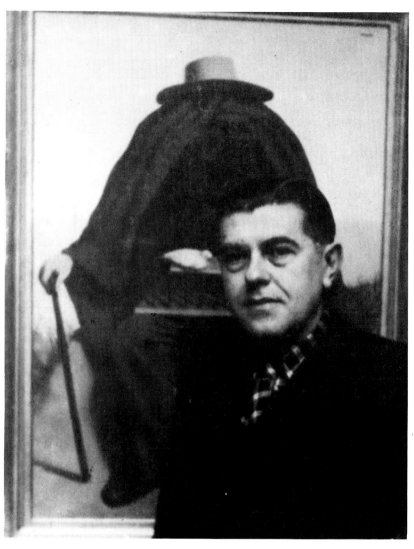

7. Photograph of (left to right) René Magritte, E.L.T. Mesens, Georgette Magritte, 1922

8. Photograph (taken by Man Ray) of René Magritte in front of his painting *Le thérapeute (The Healer)*, Brussels, Belgium, 1937

I can write texts that are interesting to people who don't play a conventional game. If one wants to reach other people, one must appear to play on their terms, while at the same time avoiding in any way being for an instant conventional. In short, I take pains never to be conventional when I am painting, and insofar as possible when I am not painting, I appear to play a conventional game: to paint, for example, or to live in a house, to eat at regular mealtimes, etc. . . . Maybe because some conventions are not stupid, but then those are not the annoying ones. Still, it's a fact that despite the conventional appearance of my paintings, they look like paintings without, I believe, fulfilling the requirements defined by the treatises on aesthetics.
——*Letter from René Magritte to Mirabelle Dors and Maurice Rapin, March 15, 1956*

I am *very* sensitive in some instances, I take it as a personal insult when stupidity is calmly displayed right under my eyes. On the other hand, I am delighted and my vanity is not injured when someone corrects a mistake I have made. It's not easy to correct mistakes and to say something good about something bad. It requires only a moment's discomfort.
——*Letter from René Magritte to Mirabelle Dors and Maurice Rapin, March 30, 1956*

I too have some horrible memories, but I'll never understand "repentance," I only feel remorse.
——*Letter from René Magritte to Mirabelle Dors and Maurice Rapin, November 1956*

1) My father was in the real estate business, buying and selling factories, etc. I was married when I was about 20 years of age, and I had to "earn my living," my father's support having been withdrawn (as the result of bad business deals). I don't think I know the circumstances that may have determined my character or my art. I don't believe in "determinism."

2) Married circa 1920.

3) No children.

4) Married or not, it's easy either to frequent or avoid cafés.

5) Experimentation ended in 1926, and gave way to a concept of the art of painting to which I

have remained faithful. The term "composition" supposes a possible "decomposition," for example, in the form of analysis. To the extent that my pictures have any value, they do not lend themselves to analysis.

6) The critic or the historian can do better than to put a facile label on a school or so-called school. Language and writing can bring out the unpredictable possibilities suggested by a picture. I hope so. I don't want to give a name to the images I paint.

7) My wife and I have preferred to observe Paris from a distance. This has not affected my relations with the Surrealists.

8) There is no explicable mystery in my painting. The word *Vague* (Wave) inscribed on the picture manifests inexplicable mystery.

9) The objects accompanying my wife's face are no more symbols than the face is. "Why?" is not a "serious" question; it is too easy, for example, to reply: "Familiar objects have been assembled together in the portrait to obtain a sensational result."

10) "Total portraits" are to me not worth looking at. All the information they give is meaningless.

11) Political ideas or current ideas about art cannot help me paint a picture, nor imagine one.

Thus I am not *engagé,* as one generally hears. The only thing that engages me is the mystery of the world, definitively, I believe.

12) I am not trying to "provoke" anything or anyone when I paint: I have barely enough attention for the painting itself.

13) I do not feel I am "adding" something to the world: where would I get what I am adding if not from the world?

14) I have never thought such a thing. Progress is a preposterous notion.

15) André Gide's "morality" may have contributed to an increase in the criminal court clientele. But I doubt it: that clientele is not at all literary.

16) The absurd is the belief that a particular logic (called reason) can dominate the logic of mystery. A picture seems valid to me if it is not absurd and if it is capable, like the world, of dominating our ideas and our feelings, good or bad.

17) There is no choice: no art without life.

18) The basic thing, whether in art or in life, is "presence of mind." "Presence of mind" is unpredictable. Our so-called will does not control it. We are controlled by "presence of mind," which reveals reality as an absolute mystery.

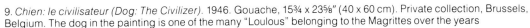

9. *Chien: le civilisateur (Dog: The Civilizer).* 1946. Gouache, 15¾ x 23⅝" (40 x 60 cm). Private collection, Brussels, Belgium. The dog in the painting is one of the many "Loulous" belonging to the Magrittes over the years

19) Without art, of course, there would be no pictures to look at. But although painters are sometimes stimulated by the strangest of motives, I recognize only one motive for the act of painting: the desire to paint an image one would like to look at.

20) Whether art is made for this or that reason makes very little difference: what counts is what it will be.

21) The language of symbols makes me miss the precision one loses in employing it. For example, a key, diamonds, insofar as they are symbols, signify confusion.

22) Great artists are against the "common meanings," but is it urgent to draw a conclusion from that (urgent for our happiness)?

23) This question seems to me to involve the isolation of the human being, whether or not he is an artist, whether or not he is "aware" of it. It is basic enough to cease being a "question" and to stand revealed as an affirmation of the mystery in which we live.

24) Like some madmen, artists have achieved similar *tours de force*. We exist within mystery, whether we know it or not.

25) The "subject," which in my opinion is the essential thing, cannot without losing this importance yield to or share its "place" with completely secondary pictorial material.

26) An object does not become more remarkable because it is represented in a picture. The error of certain painters resides in thinking the opposite.

27) In the case of great painters, "pictorial material" plays a large role on the *secondary* level. Indeed, it must be perfect and *stay in its place*.

28) In fact, looking at my pictures sometimes gives me a strange feeling. This fact is not an end I pursue, since any "end" I might imagine seems ridiculous to me.

——Rough draft of a response to a questionnaire sent to René Magritte by M. Pierredon, pen name of Louis Thomas, journalist of La Lanterne. Included in a letter to Maurice Rapin, June 20, 1957

If you look at this painting with the point of view necessary to admit that the work is a work of art whatever it is, you will change your opinion.* This point of view is not possible if outside preoccupations, utilitarian or rational, occupy the mind. Indeed, from the point of view of immediate usefulness, what would correspond to the idea that, for example, the sky covers the walls of a room, that a gigantic match lies on the rug, that an enormous comb is on a bed?

Such an idea would be *impotent* to resolve a utilitarian problem posed by life in society. The social individual needs a repertory of ideas in

10. *Les valeurs personnelles (Personal Values)*. 1952. Oil on canvas, 31⅞ x 39⅜" (81 x 100 cm). Private collection, New York, New York

which, for example, the comb becomes the *symbol* that permits him to combine certain events, permitting him, the social individual, to act in society in accordance with movements intelligible to society: the comb will part his hair, the comb will be manufactured, will be sold, etc. In my painting, the comb (and the other objects also) have lost precisely their "social character." It is only a superfluous luxury object that can, even as you put it, disarm the onlooker and even make him sick. Well, this is exactly the proof of the efficacy of this painting. A really vibrant painting has to make the onlooker sick and if the onlookers are not sick,

it is because: (1) they are too gross; (2) they are used to this malaise, which they mistake for pleasure (my painting of 1931–32 (?) *Le modèle rouge* [*The Red Model*] is now accepted, but when it was new, it made quite a number of people sick). The contact with reality (and not the symbolic reality that serves social exchanges and violences) always makes people sick.

——*Letter from René Magritte to Alexandre Iolas, October 24, 1952*

*Iolas had written to Magritte on October 15, 1952, that *Les valeurs personnelles (Personal Values)* depressed him, deranged him, and made him sick.

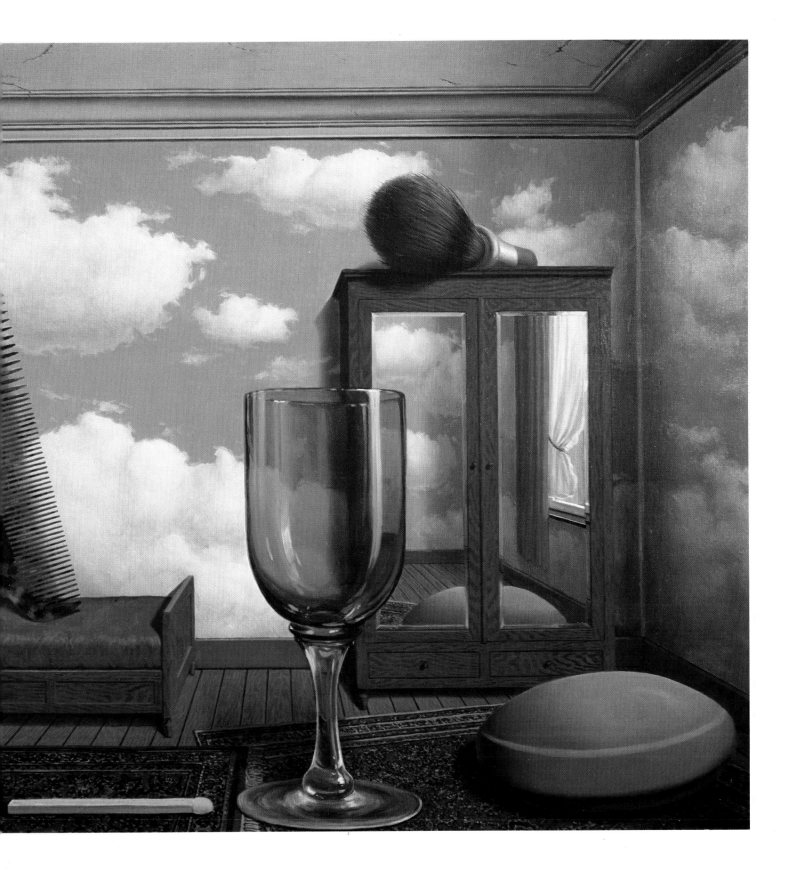

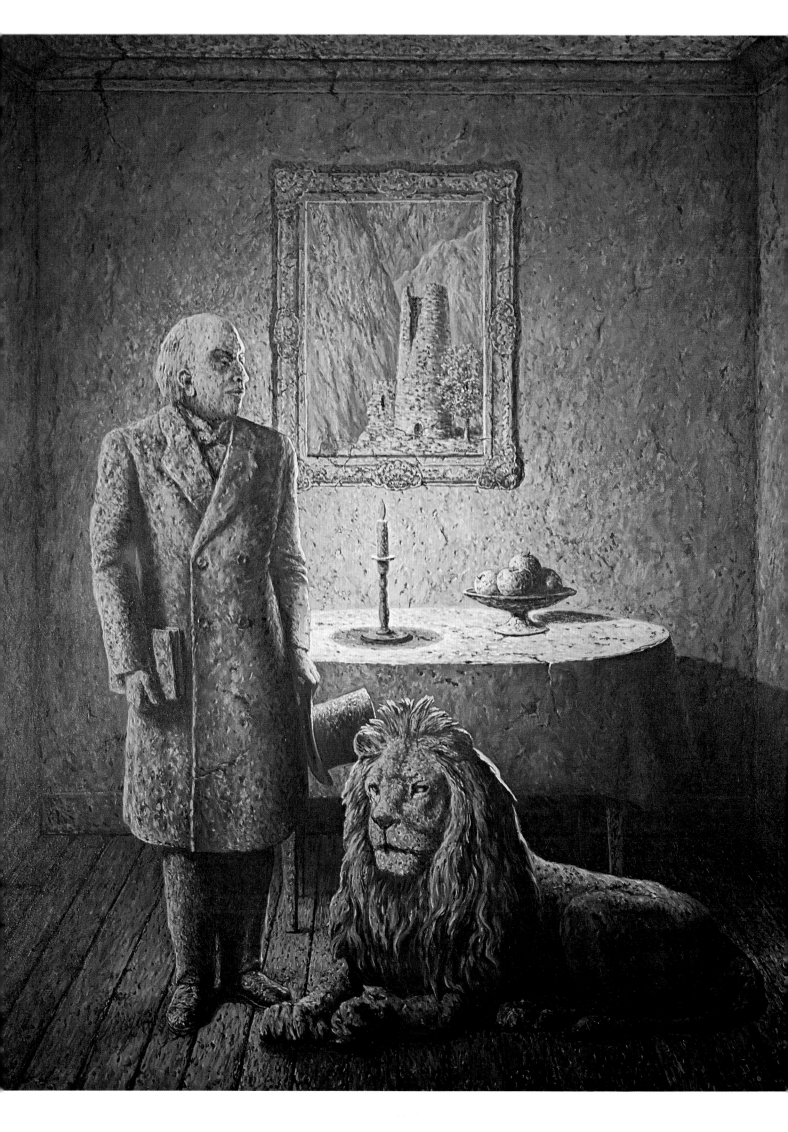

Self-Portrait

It can happen that a portrait tries to resemble its model. However, one can hope that this model will try to resemble its portrait.
——*René Magritte, quoted by Louis Scutenaire,* Magritte, *1943*

Your idea for a "portrait of the artist" brings up a "question of conscience": I have on occasion (three times) painted myself in a picture, but at the outset there was an idea for a picture, not for a portrait. I can paint (or rather, could have) some portraits starting with the idea of a portrait, but if it concerns me, my visual appearance, that presents a problem I'm not sure I can resolve. *Of necessity* I will think about it, since the problem has come up. I cannot promise to see the end of it this year! However that may be, inspiration — which comes spontaneously — may break through in the meantime.
——*Letter from René Magritte to Harry Torczyner, July 2, 1963*

Le sorcier (The Magician) is simultaneously the *auto (mobile) portrait* (self-portrait) of its author.
——*Letter from René Magritte to G. Puel, November 4, 1953*

Maniacs of movement and maniacs of immobility will not find this image to their taste.
——*René Magritte,* Rhétorique, *no. 7, October 1962*

11. *Souvenir de voyage (Memory of a Voyage).* 1955. Oil on canvas, 63⅞ x 51¼" (162.2 x 130 cm). The Museum of Modern Art, New York, New York

12. *Le sorcier (The Magician).* Self-portrait with four arms. 1952. Oil on canvas, 13¾ x 18⅛" (35 x 46 cm). Collection Mme. J. Van Parys, Brussels, Belgium

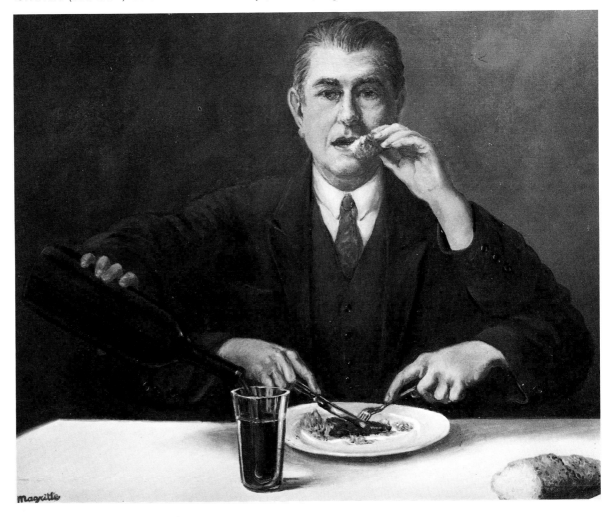

[Dear Bourgoignie,

You're a charming man, Bourgoignies (I once lived at Soignies), for having brought the lovely plants for Georgette, who liked them very much. I guess you're writing to me: I think the following Thought: like Thought, it resembles what I think. And thanks to your answer, we will make a nice little collection for the edification of people who like that sort of thing.

I'll be at my future new address from the 18th of this month, leaving 207 Boulevard Lambermont, and I will at once call a meeting to settle the plans with regard to the research into objects, or to catch them with your pole, all of which will reinforce our respective positions, which are somewhat drained of vital force.

Mag.]

14. Photograph of René and Georgette Magritte at 97 rue des Mimosas, Brussels, Belgium, 1965

13. Letter from René Magritte to Paul Colinet, 1957. *See* Appendix *for translation*

Dwellings

Cher Bourgogne,
Vous êtes un charmant Bourgoignies,
(Et j'ai vécu jadis à Soignies)
Pour avoir apporté des plantes charmantes
à Georgette qui en était toute contente.
Je pense que vous m'écrirez: je pense
que la Pensée est ceci: elle ressemble
à la Pensée, à ce que je pense.
Et grâce à votre réponse, nous ferons ensemble
Un joli petit recueil pour l'édification
Des esprits respectueux des constitutions.
A ma future nouvelle adresse, dès le 18
de ce mois, faisant une sorte de 207
Boulevard Lambermont, je ferai de s'8
une réunion pour la mise au net
des projets relatifs à la recherche
des choses, pour les capturer avec votre perche
qui renforcera nos perches respectives
un peu démunies de forces vives.

Mag.
——*Letter from René Magritte to Paul Bourgoignie, May 8, 1954*

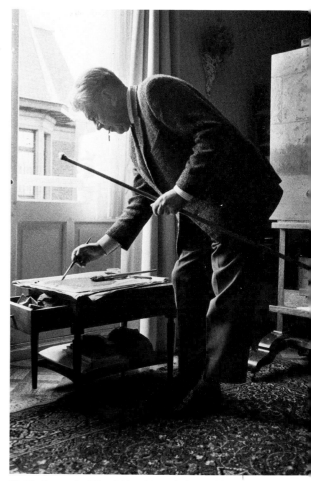

15. Photograph of René Magritte painting at 97 rue des Mimosas, Brussels, Belgium, 1965

If all goes well, my address from the first of the year will be: 97 rue des Mimosas. In many respects, it will be better there for "living" and "working."

——*Letter from René Magritte to Maurice Rapin, December 17, 1957*

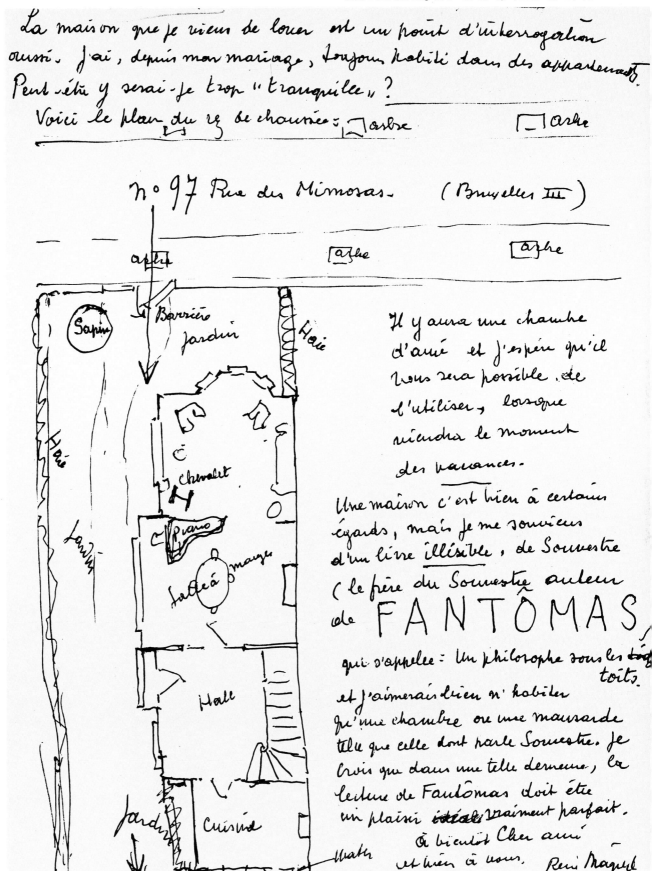

16. Floor plan of the Magritte house at 97 rue des Mimosas, Brussels, Belgium, included in a letter from René Magritte to Maurice Rapin, December 20, 1957. *See* Appendix *for translation*

Woman

17. Photograph of René and Georgette Magritte, 1932

In dreams
Bordellos make
A very strong impression.
One feels one is entering
A conservatory.
——*René Magritte, 391, no. 19, October 1924, p. 130*

REPLIES TO THE QUESTIONNAIRE ON LOVE
I. All I know about the hope I place in love is that it only needs a woman to give it a reality.
II. The progression from the idea of love to the fact of loving is the event whereby a being appearing in reality makes his existence felt in such a way that he makes himself loved and followed into the light or shadows. I would sacrifice the freedom that is opposed to love. I rely on my instincts to make this gesture easy, as in the past.

18. *Il ne parle pas (He Doesn't Speak).* 1926. Oil on canvas, 29½ x 23⅝" (75 x 60 cm). Private collection, Belgium

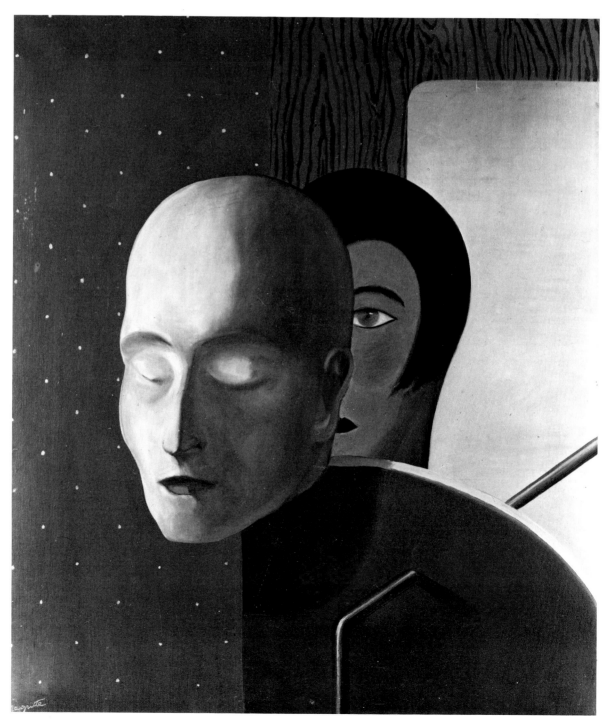

I am prepared to abandon the cause I defend if it corrupts me with regard to love.

I am unable to envy anyone who will never have the certainty of loving.

A man is privileged when his passion obliges him to betray his convictions to please the woman he loves.

The woman has the right to demand such a pledge and to obtain it, if it serves the exaltation of love.

III. No, imposing limits on the powers of love must be done by experiment.

IV. Love cannot be destroyed. I believe in its victory.

——René Magritte, La Revolution Surréaliste, *no. 12, December 15, 1929, p. 2*

I love a woman finding herself in a man, but to my taste it becomes boring if the Holy Scriptures play the least role in this feminine inclination for X, Y, or Z. In fact, the sexual relationship should be "directed," as a doctrine of my own would prescribe, toward innocence.

——*Letter from René Magritte to Marcel Mariën, late 1937*

This afternoon, in bright sunlight, I saw a young woman waiting for the streetcar, accompanied by her body.

——René Magritte, Le Surractuel, *no. 1, July 1946*

19. *L'univers mental (The Mental Universe).* 1947. Oil on canvas, 19⅝ x 28¾" (50 x 73 cm). Private collection, Brussels, Belgium

20. *L'attentat (Act of Violence).* 1934. Oil on canvas, 27⅝ x 39⅜" (70 x 100 cm). Private collection, Belgium

19

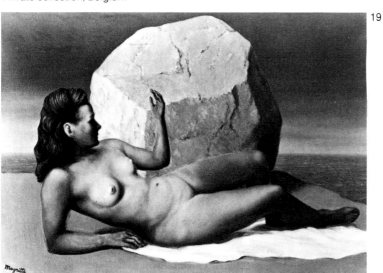

20

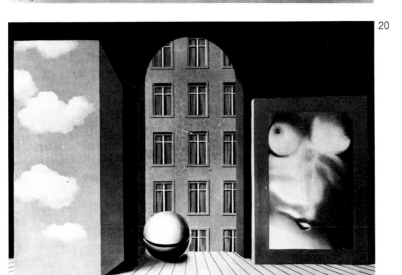

21. *L'évidence éternelle (The Eternal Evidence).* 1930. Oil on canvas, 5 panels, top to bottom: 8⅝ x 4¾" (22 x 12 cm), 7⅛ x 9" (18 x 23 cm), 10⅜ x 7¼" (26.5 x 18.5 cm), 8½ x 6⅛" (21.5 x 15.5 cm), 8½ x 4½" (21.5 x 11.5 cm). Collection William N. Copley, New York, New York

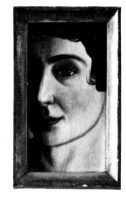

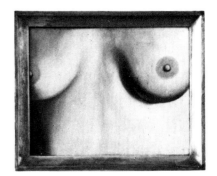

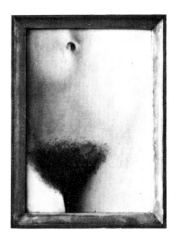

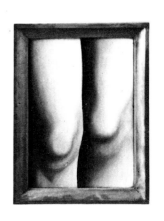

23

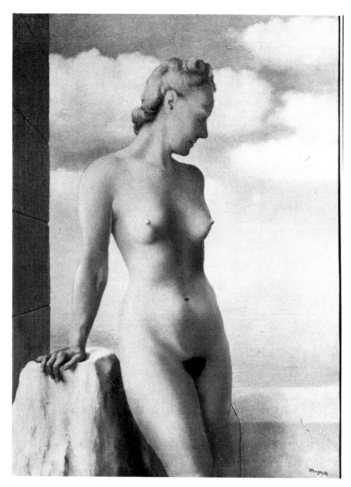

22. *La magie noire (Black Magic)*. 1935. Oil on canvas,
31½ x 23⅝" (80 x 60 cm). Collection Mme. René Magritte,
Brussels, Belgium

Sexual acts amount to very little as soon as they are used to shock or to educate. There is a kind of comfortable misunderstanding that regards the understanding of sexuality as self-knowledge. Sexuality is compatible only with disinterested thought.
——*Letter from René Magritte to G. Puel, February 22, 1954*

I'm searching for a title for the picture of the nude woman (naked torso) in the room with the rock. One idea is that the stone is linked by some "affinity" to the earth, it can't raise itself, we can rely on its generic fidelity to terrestrial attraction. The woman too, if you like. From another point of view, the hard existence of the stone, well-defined, "a hard feeling," and the mental and physical system of a human being are not unconnected.
——*Letter from René Magritte to Paul Nougé, January 1948*

[Magritte] relates: The story of a short, bearded priest met at the post office, invited to the house, where he sees *La magie noire (Black Magic):* "I never knew women were made differently from men, but recently while administering Extreme Unction and annointing the feet of a dying woman, the sheet slipped off."
——*Harry Torczyner, diary entry, Nice, June 2, 1964*

25. *Les liaisons dangereuses (Dangerous Relationships)*. 1936. Oil on canvas, 28⅜ x 25¼" (72 x 64 cm). Private collection, Calvados, France

23. *La ligne de vie/La femme au fusil (The Lifeline/Woman with Shotgun)*. 1930. Oil on canvas, 28⅜ x 20⅝" (72 x 52.5 cm). Private collection, Osaka, Japan

24. *La liberté de l'esprit (Freedom of Thought)*. 1948. Oil on canvas, 38⅛ x 31⅛" (97 x 79 cm). Musée Communal des Beaux-Arts, Charleroi, Belgium

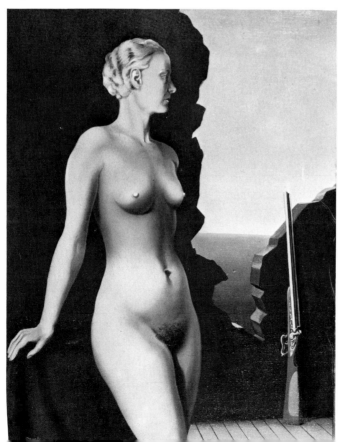

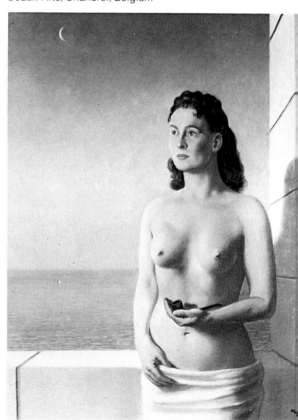

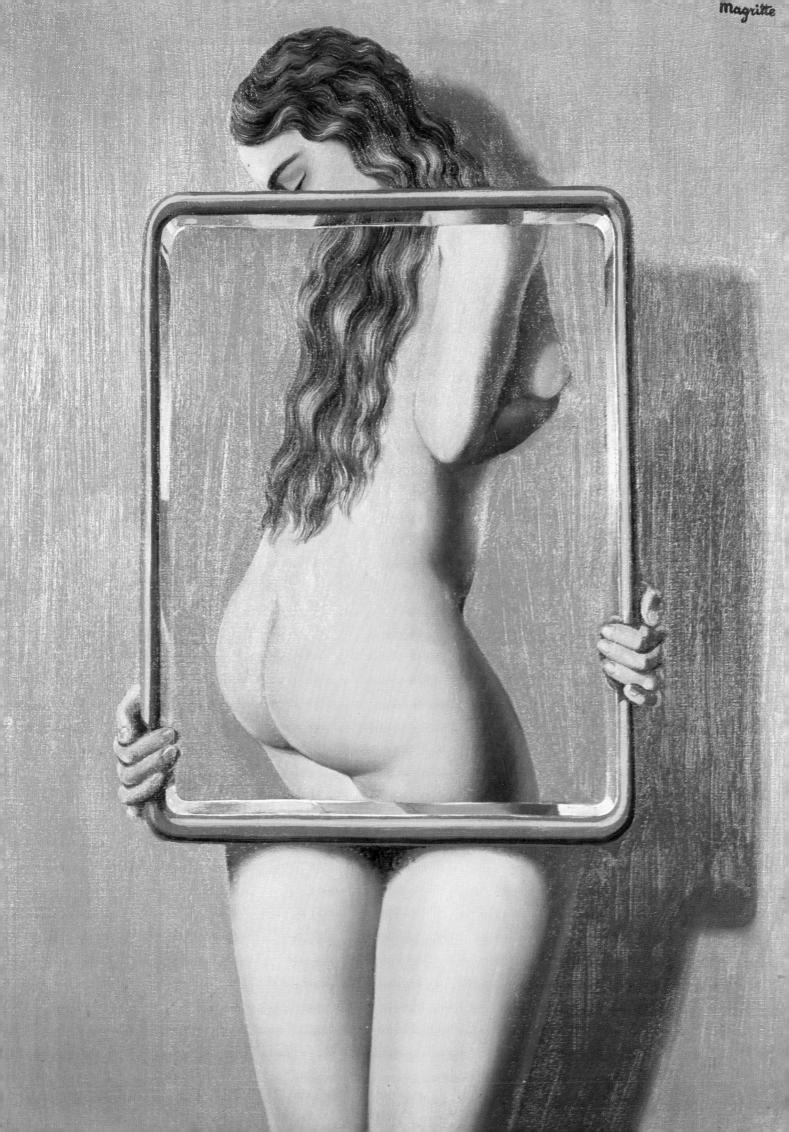

The "Surrealist" woman was as stupid an invention as the "pinup girl" who is now replacing her.
——*Letter from René Magritte to Mirabelle Dors and Maurice Rapin, August 22, 1956*

. . . for the first time I saw women in men's trousers without feeling nauseated.* What a difference there is between the apparel of this working girl, full of nobility, and that of a young girl in trousers.
——*Letter from René Magritte to Louis Scutenaire, undated*

*Magritte is referring to the film *Point du Jour*.

It seems sometimes that, as in fashion designing, it was suddenly decided that today the sack dress or sack-idea is what the world needs. And right away, if you are unable to appreciate these "fads," you are considered a backward peasant. I must have seemed one to Rachel Baes* who came to see me and, doubtless in my honor, had put on a kind of night dress of a vomitous pastel color. She also supported this sack-idea: the time had come for the authorities to recognize my "artistic worth" by making me a baron! If I should lose my powers of self-defense, I'd end up on the canvas.
——*Letter from René Magritte to Maurice Rapin, February 11, 1958*

*A Belgian painter with Surrealist leanings.

I have a great deal of admiration for admirable things, but I detest this tendency to change the forms of admirable things. If those who create fashion could change the shape of the human body (perhaps they will one day!), we would see a pretty woman with a hunchback, for example. It would be the fashion! On this question of forms, *I have nothing to say* that isn't negative: there are enough admirable forms already for the random search for new forms to be desirable. . . . I would go so far as to say that a new style is not worth knowing—no more so than an old style.
——*Letter from René Magritte to André Bosmans, August 22, 1959*

27

26. *Souvenir de voyage (Memory of a Voyage).* 1926. Oil on canvas, 29½ x 25⅝" (75 x 65 cm). Collection M. and Mme. Berger-Hoyez, Brussels, Belgium

27. *Untitled.* 1934–1935. Oil on canvas. Location unknown

28. *Les cornes du désir (The Horns of Desire).* 1960. Oil on canvas, 45¼ x 35" (115 x 89 cm). Collection Tazzoli, Turin, Italy

29. *La philosophie dans le boudoir (Philosophy in the Boudoir).* 1947. Oil on canvas, 31⅞ x 24" (81 x 61 cm). Private collection, Washington, D.C.

26

28

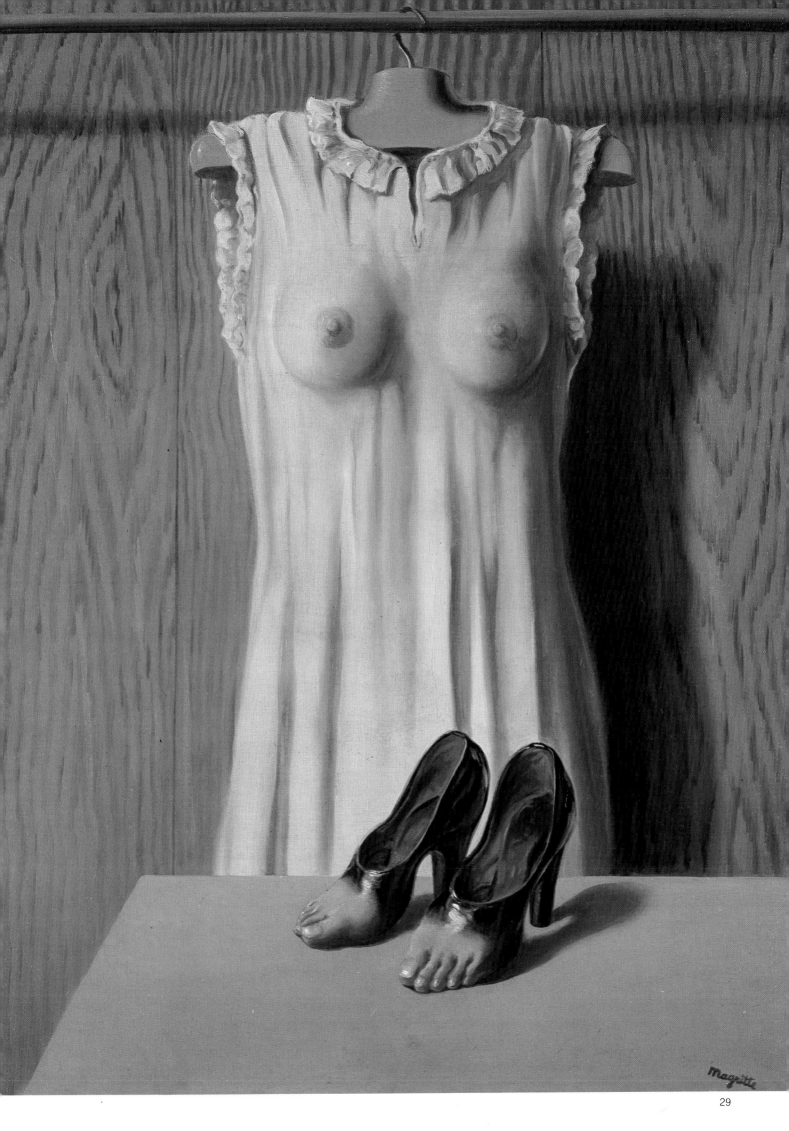

DE GUSTIBUS ET COLORIBUS

Books were essential for Magritte's sustenance. Tempted by the role of author as a very young man, he wrote detective novels under the pseudonym Renghis, a combination of two of his given names, René and Ghislain. Later on, he was to sketch out "literary images," such as his *Théâtre en plein coeur de la vie (Theater in the Heart of Life)*.

His curiosity drew him to the most diverse areas of literature. He admired Simenon as much as Conrad or Stevenson. He passed effortlessly from the world of Souvestre and Allain and their *Fantômas,* which had delighted his youth, to the philosophical garden in which he encountered Spinoza, Hegel, Nietzsche, Marx, Bergson, Heidegger, and Foucault. Foremost among his favorite poets were Edgar Allan Poe, Lautréamont, Apollinaire, and Éluard.

The brother of a composer and husband of a fine pianist, Magritte was an eclectic music lover. His tastes ranged from Bach to Schoenberg, whom he defended as early as 1929, and he was particularly fond of the music of Erik Satie.

His favorite diversions were chess and movies. He was a fervent fan of the films of Laurel and Hardy, westerns, suspense movies—the real "cinema," without pretensions or messages. An amateur filmmaker himself, he made comic or naïvely erotic films with his friends. From time to time, he made documentaries, which he showed at home, such as his last film, made in June 1967, concerning the foundry in Verona where his bronze sculptures were cast.

Chess served him as a sort of mental gymnastics. He liked to move the men around, intrigued by their shapes.

Of course, he liked to walk, or to swim during vacations, but he was not attracted to sports, and although he admired acrobats, he did not think much of athletes.

In his youth he had gone to the races, and he retained in his memory those images of jockeys and horses that we find in his pictures.

After turning sixty, he tried to become an expert driver. He bought a bright red Lancia, but after two accidents in less than one week he gave up this ambition.

Homebody though he was, he sometimes allowed himself to be enticed into traveling, without ever being at heart a tourist. What he disliked most were the preparations, vaccinations, and boring consultations of complicated timetables. In August 1929, during one of his first foreign trips with Georgette, he went to Spain with his friends Camille Goemans, and Paul and Gala Éluard. At Cadaquès, where they met Salvador Dali, they witnessed the adventure that became the soap opera of the art world: the love affair between Dali and Gala, and her leaving Éluard. In 1937, at 35 Wimpole Street, an address as literary as it is elegant, Magritte painted at the home of his host Edward James and discovered the charms of the English language. Toward the end of his life, he traveled to Texas and Israel where his fame had preceded him, and he was impressed by these new lands and customs. Still, the familiar landscapes from the Ardennes to the North Sea remained his favorites. For Magritte, the voyage he most enjoyed was the voyage around his own room.

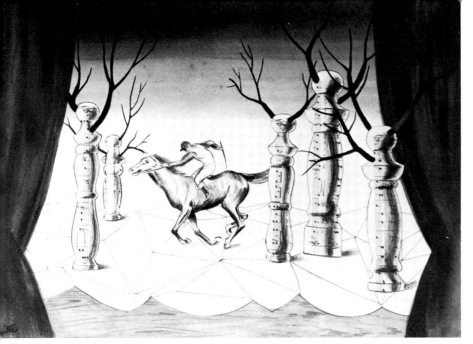

Horses

Le jockey perdu (The Lost Jockey) is the first canvas I really painted with the feeling I had found my way, if one can use that term.
———Remarks by René Magritte reported by E. C. Goossen, January 28, 1966

30. *Le jockey perdu (The Lost Jockey)*. 1926. Collage and gouache, 15½ x 23⅝" (39.5 x 60 cm). Collection Harry Torczyner, New York, New York

31. *Le jockey perdu (The Lost Jockey)*. 1940. Oil on canvas, 23⅝ x 28½" (60 x 72.5 cm). Collection William N. Copley, New York, New York

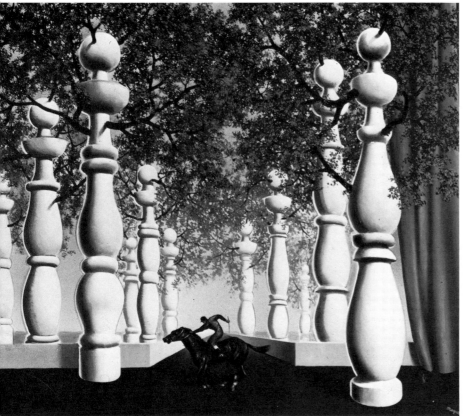

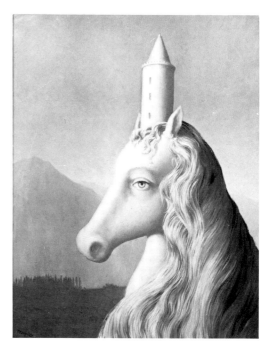

33. *Le coeur du monde (The Heart of the World)*. 1956. Oil on canvas, 26 x 20⅛" (66 x 51 cm). Museum of Art, Carnegie Institute, Pittsburgh, Pennsylvania. Gift of Mr. and Mrs. George L. Craig, Jr.

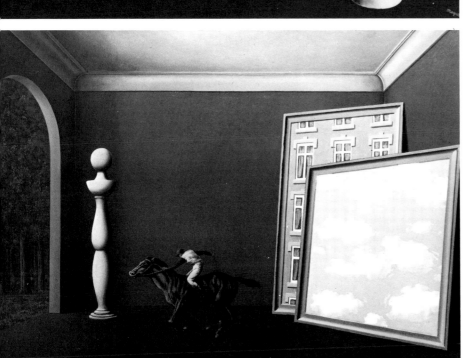

32. *L'enfance d'Icare (The Childhood of Icarus)*. 1960. Oil on canvas, 38⅝ x 51⅜" (98 x 130.5 cm). Location unknown

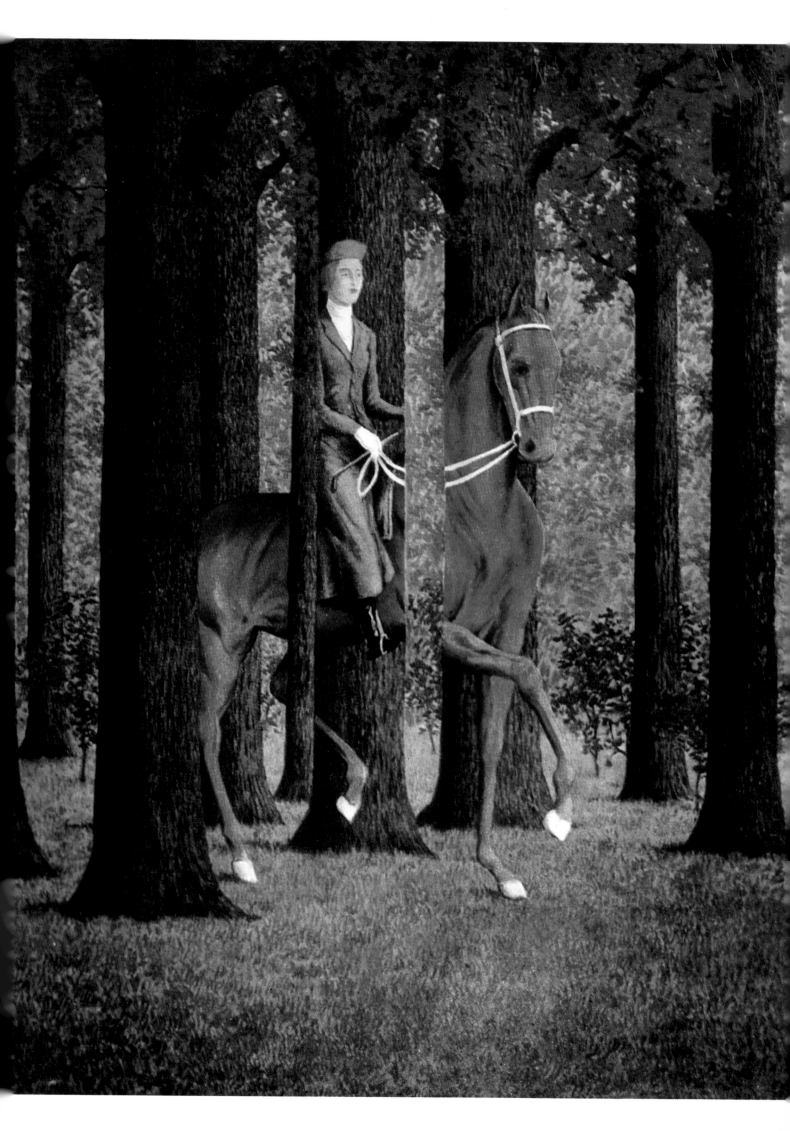

34. *Le blanc-seing (Carte Blanche)*. 1965. Oil on canvas, 31⅞ x 25⅝"
(81 x 65 cm). Collection Paul Mellon, Washington, D.C.

35. *L'arc de triomphe (The Arch of Triumph)*. 1962. Oil on canvas,
51⅛ x 65" (130 x 165 cm). Private collection, New York, New York

36. *Les grâces naturelles (The Natural Graces).* 1962.
Oil on canvas, 15¾ x 11⅝″ (40 x 32 cm). Collection Mme.
Suzanne Ochinsky, Brussels, Belgium

37. *L'île au trésor (Treasure Island).* 1942. Oil on canvas,
27⅝ x 36⅝″ (70 x 93 cm). Collection Mme. René Magritte,
Brussels, Belgium

38. *La mémoire (Memory).* 1938. Oil on canvas, 28½ x 21¼″
(72.5 x 54 cm). Collection Menil Foundation, Houston, Texas

37

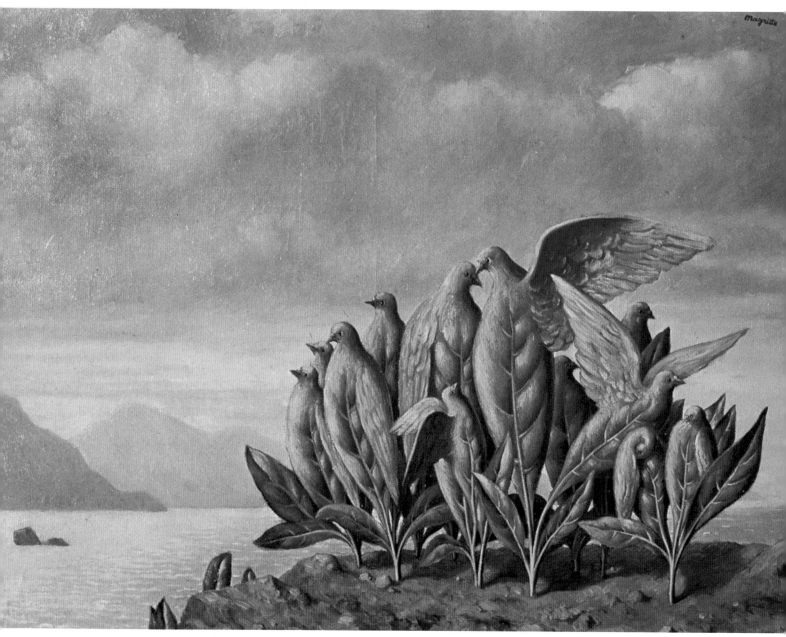

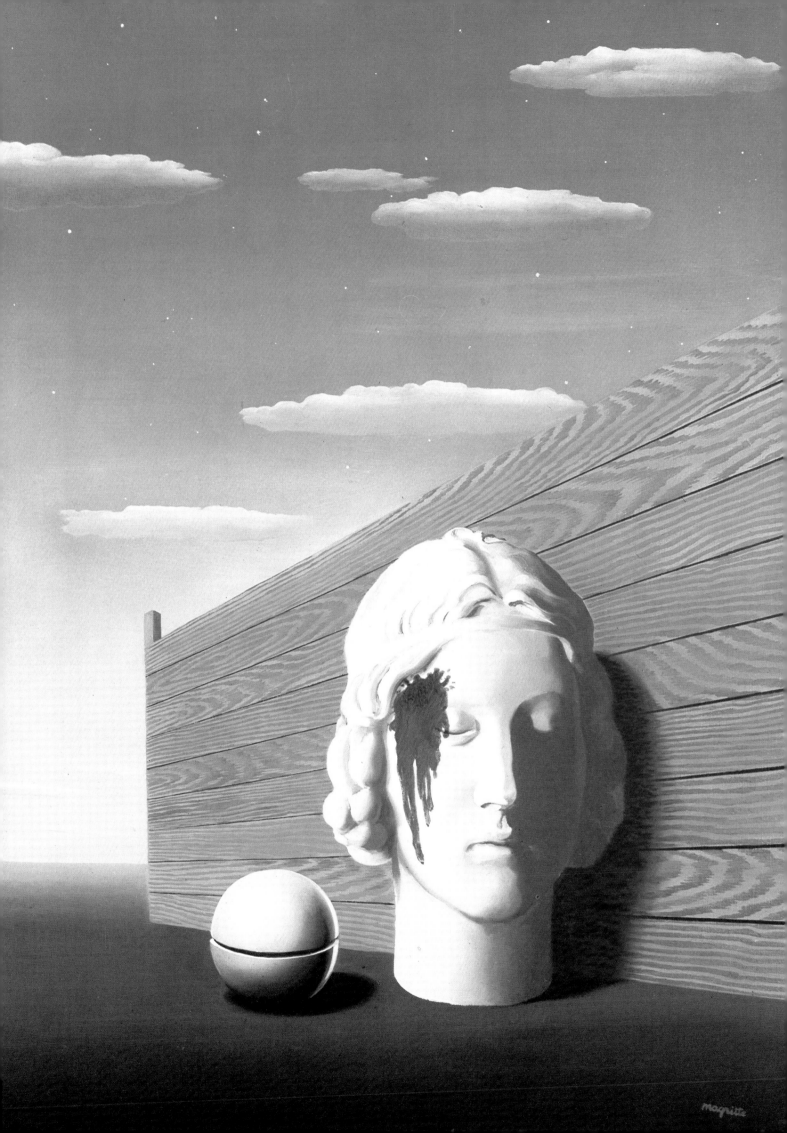

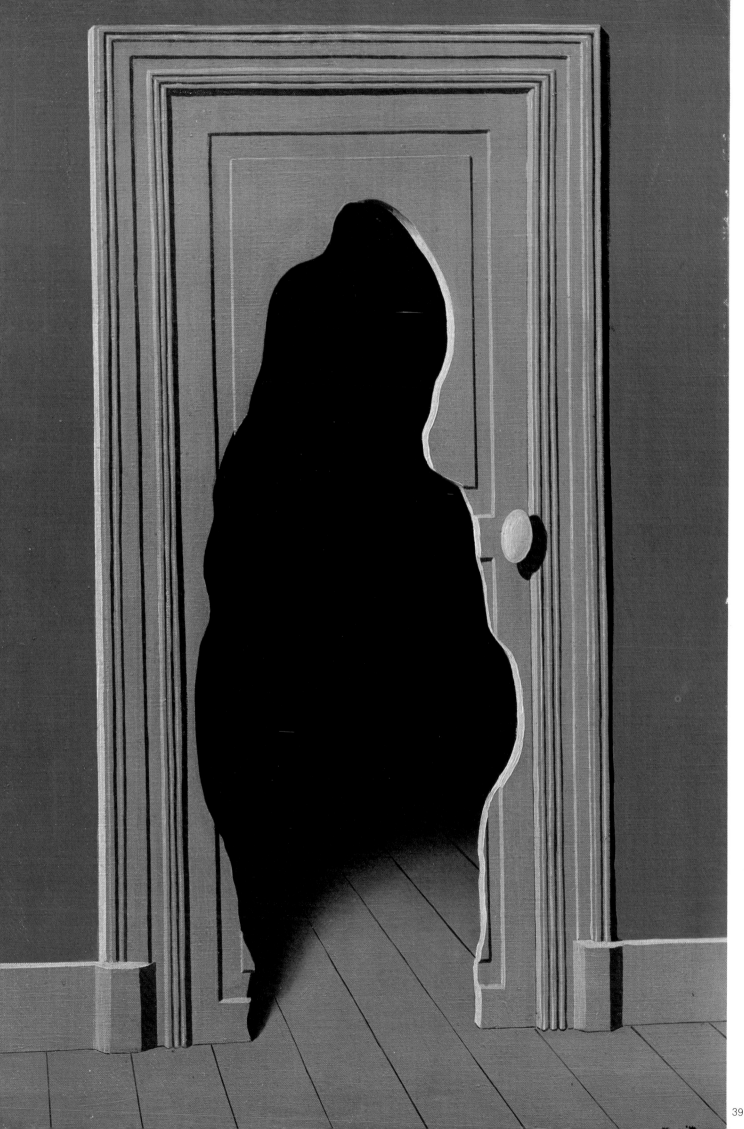

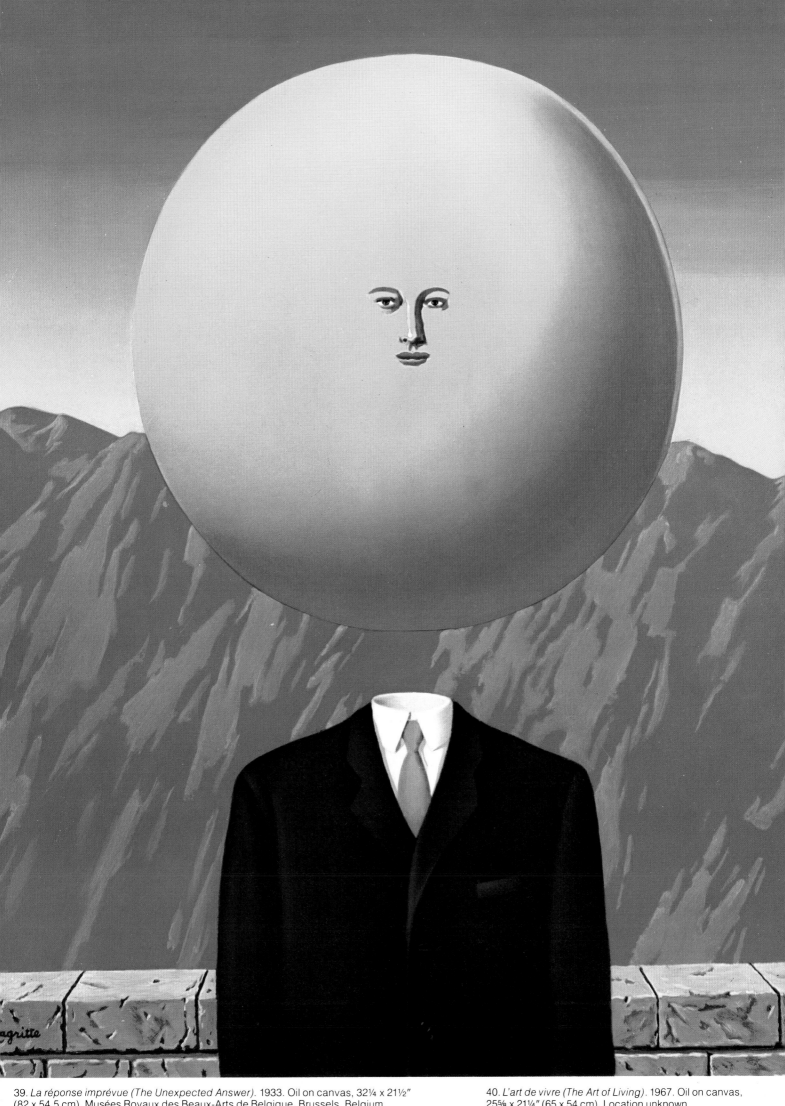

39. *La réponse imprévue (The Unexpected Answer)*. 1933. Oil on canvas, 32¼ x 21½″ (82 x 54.5 cm). Musées Royaux des Beaux-Arts de Belgique, Brussels, Belgium

40. *L'art de vivre (The Art of Living)*. 1967. Oil on canvas, 25⅝ x 21¼″ (65 x 54 cm). Location unknown

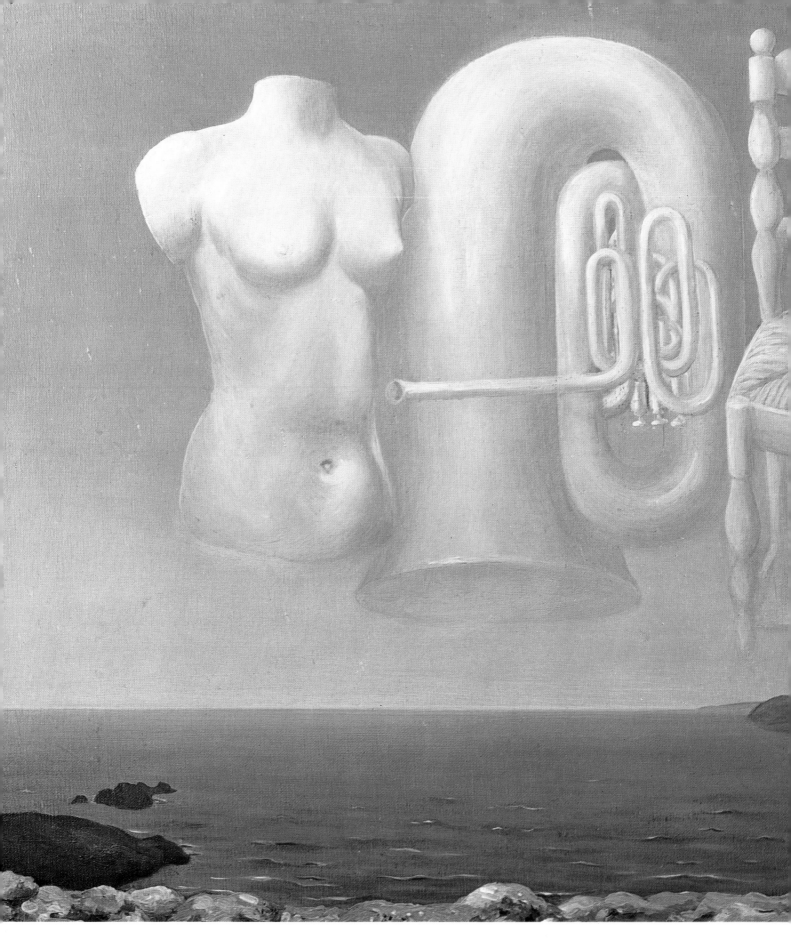

Memories of Travels

Paris is a beautiful city without any raison d'être;
aside from great vistas, it's a vacuum.
——*Letter from René Magritte (Paris) to Paul Nougé, May 13, 1948*

The few days I spent in Paris gave me the impression of a ghost town, where medieval mysticism has merely been transformed into a commercial, political, industrial, scientific mysticism . . . or artistic! (Paris is not an isolated case—it's the same everywhere.)
——*Letter from René Magritte to Mirabelle Dors and Maurice Rapin, January 23, 1956*

I saw some mountains on the way back through Switzerland (that boring country). As one nears Switzerland, France becomes Swiss and makes escape that much easier. You can't wait to get rid of the chalets and cheeses. Mountains quickly bring on indigestion (contrary to what I just read in *Le Rapport d'Uriel* by Benda,* for whom mountains command respect due to their impressive immobility). I recommend Benda to you; he's very amusing reading: he's nearly always angry and never stops attacking so-called reasonable doctors.
——*Letter from René Magritte to Mirabelle Dors and Maurice Rapin, July 23, 1956*

*Julien Benda (1867–1956) was a French philosopher and littérateur known for his antipathy toward Bergson and others who had turned from intellectual discipline toward a more mystical interpretation of the world

I am spending my vacation at home. During the first half of June I'll probably go to Zoute (Belgian coast resort). That will depend on the temperature, which isn't very high here: mornings and evenings one gladly wears a coat.
——*Letter from René Magritte to Harry Torczyner, May 25, 1957*

42

43

Le temps menaçant (Threatening Weather). 1928. on canvas, 21¼ x 28¾" (54 x 73 cm). Collection Sir and Penrose, London, England

Le paysage isolé (The Lonely Landscape). c. 1928. on canvas. Private collection, Belgium

La seconde nature (Second Nature). 1965. Oil on canvas, x 21⅝" (45 x 55 cm). Location unknown

41

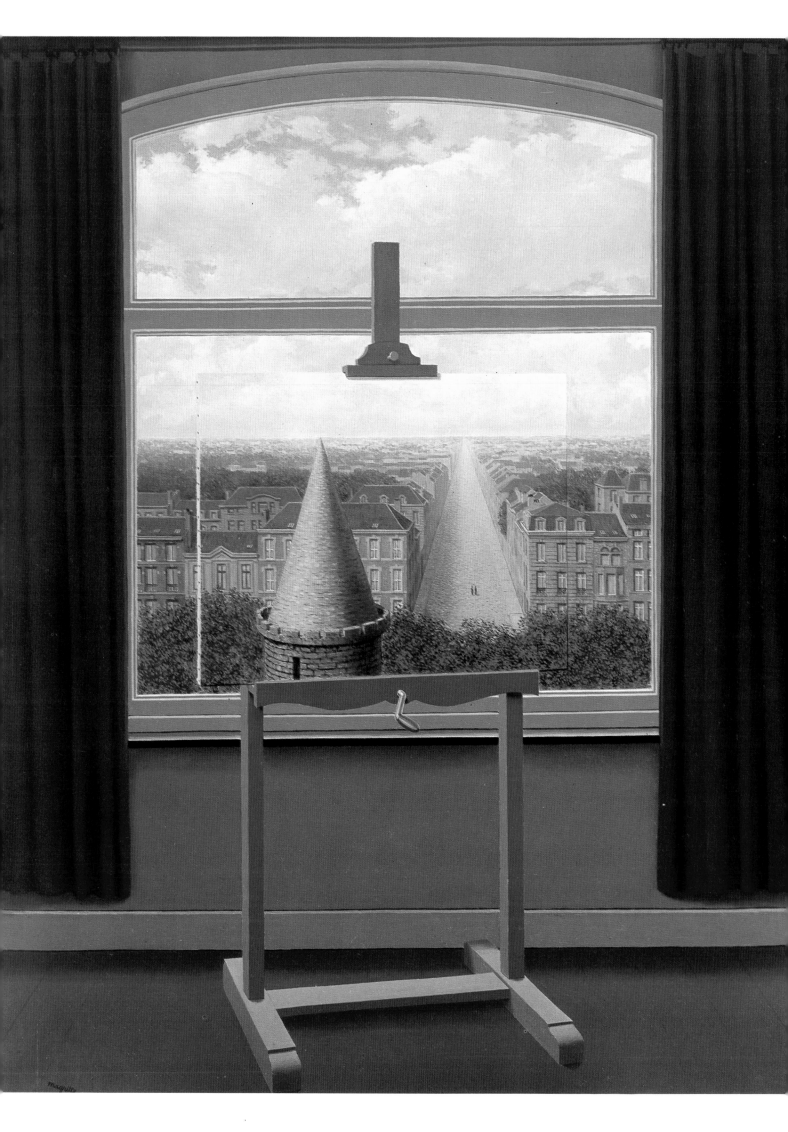

My vacation is being spent at home—I only see the disagreeable side of travel plans. I am completely devoid of the kind of imagination one needs to "set off" on a trip.
——*Letter from René Magritte to André Bosmans, May 26, 1958*

I got back from London tired out from the opening. There are too many people to talk to. I've come away with an unpleasant feeling about airplane trips: the reduction in distance is paid for by a loss of tranquillity; I do not have total confidence in machinery. Still, London seems to have a "power" that Paris, for example, seems to lack. . . .

Finally, I had a fine idea for a painting the night I spent in London: in the middle of a large city, a candle towers very high and lights up the night. You will probably see this image when you come at the beginning of next month. I hope to be able to start painting it very soon.
——*Letter from René Magritte to André Bosmans, October 1, 1961*

We may go to America, but the decision has not been made completely. We would rather go by boat than by airplane—we don't have enough confidence where the heavier-than-air is concerned; heavier-than-water seems less dangerous.
——*Letter from René Magritte to Suzi Gablik, September 29, 1964*

Sheraton-Gladstone Hotel
114 East 52nd Street
New York, N. Y. 10022
Room 703 Phone: Plaza 3–4300
(Please write the number seven
like this: 7, because written
like this: 7̶, the Yankes [sic]
don't understand what number it is.

December 10, 1965.

Dear Irène and Scut, New York isn't bad. For example, a moving (to us) reminder of *Uncle Tom's Cabin*—our chambermaid is black. (Actually, this black is more brown, but you wouldn't notice that.) Upon arrival (after eight long hours on the plane and around thirty kilometers by car) we saw New York by night (at 5 p.m., or midnight Brussels time), and it was magical. By the way I am just now telling Georgette, who has just got dressed, "You're looking very pretty"—so everything is going well, and will get even better. (This "better" does not include the many invitations we are getting: various cocktail parties, etc.)

During the day we stroll around the streets, which oddly enough seem quieter than the Rue Neuve in Brussels. This seven million population seems to live slowly. The tempo of New York life is not much different from that of Braine d'Alleu or Olignie.

Harry Torczyner has a very comfortable office, two secretaries (a white woman and a black woman—another reminder of Uncle Tom), and finally a normal assistant.

Georgette fed nuts to the tame squirrels in the park. Suzi [Gablik] took us there. She is going to have a show soon and curses you because of your deliberate absence from her city. She has shown me her paintings (which are actually "photomontages" she has colored and retouched). They are nice, but, strangely enough, although she has found beautiful titles for me *(La Joconde* [*La Gioconda*], *L'arc de triomphe* [*The Arch of Triumph*]), hers is, for example, *Hermaphrodite Landscape,* and she is sticking to it, despite my suggestion to change it to *The New York Poet* (or *New York 1000 Years Ago,* for example).

I will end by sending you our affectionate greetings.

 Mag. Georgette
——*Letter from René Magritte (New York) to Louis Scutenaire and Irène Hamoir, December 10, 1965*

46. *L'étoile du matin (The Morning Star).* 1938. Oil on canvas, 19⅝ x 24″ (50 x 61 cm). Marlborough Fine Art (London) Ltd., England

We are spending two whole days in Houston, "Western" country. At St. Thomas University, I was pleasantly surprised to find a large collection of my paintings (notably *La lunette d'approche* [*The Field Glass*]). I am delighted by the Texans' interest in my painting: it appears to be considerable. We are being royally entertained by Mr. and Mrs. de Menil.
——*Letter from René Magritte (Houston) to André Bosmans, December 19, 1965*

47. *Le chef d'orchestre (The Orchestra Conductor).* 1954. Oil on canvas, 23⅝ x 19⅝″ (60 x 50 cm). Private collection, Belgium

48. René Magritte at a rodeo in Symington, Texas, December 1965. Photograph by Adelaide de Menil

While Georgette is praying in a *Catholic* church in Houston (Texas), I am manipulating my ballpoint to tell you that fact and to prepare you for seeing me wearing a real cowboy hat and a shirt with metal buttons when we meet again among the mimosas.

——*Letter from René Magritte (Houston) to Louis Scutenaire, December 20, 1965*

The trip to the "holy places" has not given me any religious feeling. But the country is very beautiful and one feels very much at home, even in the desert. Of course, we have been living here only under the best conditions.

——*Letter from René Magritte (Jerusalem) to André Bosmans, April 24, 1966*

Here we are, back from Israel since Friday evening. It was a fine trip: we visited the country north and south—it is very beautiful, and reminds me of a more primitive and more historic Côte d'Azur. We were given the best reception possible, like New York for that matter; despite being tired, we were enchanted, and hope to go back to Jerusalem under calmer conditions. That city's museum has some real treasures—the Dead Sea Scrolls and a beautiful Picasso exhibit. I have two pictures in the museum's (permanent) collection.

I'm starting to recover from the trip, which means that very soon I will be thinking about taking up paints and brushes again.

——*Letter from René Magritte to Harry Torczyner, April 25, 1966*

I don't travel in kilometers—I'm not a traveling salesman. Wherever I go, I say to myself: "It's just like I imagined it would be. I thought so."

——*Remarks by René Magritte reported by Guy Mertens,* Pourquoi Pas, *April 26, 1966*

It has stopped being as hot as a furnace. I wear dark glasses since the light is too brilliant and is therefore tiring. At the risk of shocking you, I will be glad to get back to the Northern mists, the Josephat Park, and the "Deux Magots" at the Porte Louise and the # 65 bus.

——*Letter from René Magritte (Cannes) to Louis Scutenaire, June 27, 1966*

49. Photograph of (left to right) Alexandre Iolas, Marcelle Torczyner, and René Magritte at the opening of the exhibition *René Magritte* at the Museum of Modern Art, New York, New York, 1965. On the wall hangs *Le faux miroir (The False Mirror)*

PERSONAL VALUES

René Magritte considered it almost a duty to ignore the contemporary art scene, with the exception of those painters with whom he felt natural affinities—which he hastened to elevate to the rank of elective affinities—such as De Chirico, Max Ernst, and, much later, Klapheck. Of course, he also paid homage to Picasso and Braque, but only as Cubists. He had a certain regard for such women painters as Rachel Baes, Jane Graverol, and Leonor Fini, a regard due above all to his inherent gallantry.

Criticism's evil eye watched constantly over Magritte. He was called an illustrator, postcard manufacturer, a painter of no pictorial value whatsoever; his work was said to be an insult to intelligence! The benevolent gaze of friendly criticism, even more cruel, took pains to explain Magritte. Alchemy, the cabala, tarot, the art of mime, dreams, and fantasy were all called upon. Between the enmity of one group and the incomprehension of the other, Magritte sat back and accepted the inevitable.

As one once believed in the good savage, he would believe for a long time in the "good" revolutionary, be he Surrealist, communist, or both. Life for him was a threepenny opera with a new cast of characters: Violette Nozières, who poisoned her incestuous father, earned his homage; Dominici, the peasant patriarch who murdered an English lord, his wife, and daughter, inspired him to write a ballad. Although he discoursed, wrote, published manifestos, and took part in all the ritual demonstrations, Magritte knew deep down that his sole and real calling toward changing the world was to paint his images.

Magritte did not want to listen to talk about psychoanalysis. Mad ideas are proper, madness is not. Fantasies are suitable, the fantastic reprehensible. He affirmed the presence of the spirit and denied the influence of dreams. Obstinately he shut doors and windows to the evil spirits.

This extremely inquisitive man was not curious about scientific discoveries. Paradoxically, he considered the sciences a discipline devoid of interest because they applied themselves to the world of the possible. If scientists restricted themselves to mental speculations, they earned his respect, but the concrete goals they set for themselves diminished them in his eyes. Pure research and its uncertainties escaped Magritte.

The awareness, as he told me, that he would never be able to fathom the reason for existence on this earth preoccupied him unceasingly. None of the other questions that life poses seemed to have the same importance. Death, nothingness, of which he spoke dispassionately, did not worry him. He was obsessed with the "why" of the world.

50. Photograph of (left to right) René Magritte, Marcel Duchamp, Max Ernst, and Man Ray, Amsterdam, The Netherlands, October 1966

Art

If we were to bother about an artistic hierarchy . . . André Lhote* would have little place in it, and could be left out with no great loss. On the other hand, Ingres and Picasso would have "prominent" positions. If an aesthete or art historian has any commonsense, he must agree with this. (Picasso, of course, as a Cubist, is a great figure in art history. The Picasso who followed in Lautrec's footsteps was superfluous.)
——*Letter from René Magritte to Maurice Rapin, March 15, 1958*

*André Lhote (1885–) is a French painter who has written and taught extensively about art. He was originally affiliated with the Cubists.

Unfortunately, we have to admit that many "artists" restrict their "messages" to information about the "importance" of the "material" they employ.
——*Letter from René Magritte to André Bosmans, July 10, 1963*

Abstract Art

. . . the current attempt to promote "abstract" painting on a popular level with a lot of help from artistic drill sargeants may be worthy of your assessment. In any case, one must either be for or against the stupidity that is trying to pass itself off as intelligence. Unfortunately . . . although Sacha Guitry* passes as being intelligent with those admirers who were moved by his [portrayal of] Napoleon, the Sacha Guitrys without theaters easily come to guide the consciences of "intellectuals" who think they are smarter than their grocers. In addition, the "battle" of ideas, lively though it may be, cannot at its present level excite anyone but narrow-minded people. The battle would probably be more amusing and less boring if it were not just hot air. I think that, to begin with, we must refuse to play a kind of game (the "Parisian" game, despite the "prestige" it enjoys, makes judgments on the players without the right of ap-

peal) whose complexity is taken for profundity. The word "reaction" could signify the decision to do away with all the idiocies with which we are so busy.
——*Letter from René Magritte to N. Arnaud, May 7, 1955*

*Sacha Guitry (1885–1957) was a French writer, actor, and director active in the theater and cinema. One of his best known plays is *Castles in Spain*.

The many varieties of painting are occasionally amusing and fascinating. About 1915 I was passionately interested in Mondrian and the emergence of abstract painting. All the abstract paintings reveal only *abstract painting,* and absolutely nothing else. Painters have been making and remaking the same abstract picture since 1915 (whether red, black, or white, large or small, etc.).

The world and its mystery can never be remade; they are not a model that can just be copied. What is more, I cannot share an interest in what abstract painting is able to say, which was summed up once and for all by the first abstract painting.
——*Letter from René Magritte to André Bosmans, August 1959*

Age-old stupidity was manifested recently by a claimant that appeared when the art of painting was replaced by a so-called abstract, nonfigurative, or formless art—which consists in depositing the "material" on a surface with varying degrees of fantasy and conviction. However, the act of painting is undertaken so that poetry can emerge, not so the world is reduced to the variety of its material aspects.

Poetry is not oblivious to the world's mystery: it is neither a means of evasion nor a taste for the imaginary, but rather the presence of mind.
——*René Magritte, Rhétorique, no. 9, 1963*

To be curious about the reasons for or against "abstract art" is to play the "abstractionists'" game, the same game. They either have the answers to their questions or are interested in discovering further answers, but never ask themselves effective questions that are astonishing enough to stand up as questions and nothing but questions.

To say "this or that is inexplicable" is undoubtedly easy when it is easy and when one goes on to further verbal exploits with the same contempt (which one unwittingly feels) for what one says or thinks. It's no longer this easy if that which is inexplicable is forceful enough to demand our undivided attention, and thereby forbid our misplaced interest in some would-be explanation.

I hope you are going to write against "abstract art" in view of the inexplicable element that truly concerns us, sufficiently for us not to respond with curiosity or indifference.
——*Letter from René Magritte to Paul Bougoignie, undated*

Bosch

I am often asked if I feel I am the heir to the great Belgian painters. Why specifically Belgian? In my opinion, Belgian painting is only one episode among many in the overall history of art. And Bosch is singled out. . . . Hieronymus Bosch lived

in a world of folklore, of hallucinations. I, by contrast, live in the real world.

——Remarks by René Magritte reported by Claude Vial, Femmes d'Aujourd'hui, no. 1105, 1965

Braque

The large Georges Braque exhibition at the Brussels Palais des Beaux-Arts deserves to be brought to our readers' attention. It is of unquestionable historical interest and illustrates an experiment that is important to grasp fully.

Braque is a "Cubist" painter.

In art history, it may be useful to make a summary distinction between two periods, that of classical art and that of modern art.

Modern art began about 1800. Such painters as Courbet, Géricault, and Delacroix created images that no longer had the conventional character of classical compositions. Millet and Manet captured life itself with such a vigor that to the eyes of their contemporaries their painting looked like a provocation, and it drove to fury both art critics and a public devoted to sterile imitations of the past.

With Corot, researches began in which specifically pictorial concerns prevailed over the subject matter, which in turn became no more than a pretext for displaying the forms created by light and shadow.

The importance bestowed upon "appearance" became even more pronounced with the Impressionist painters. They aspired to capture the real colors of the subject at the very moment it was observed; this direct observation of reality enabled them to take notice of the nuances that had either escaped classical painters or had seemed unimportant to them. The "pointillists" were to go even further in their attempt to restore the special vibrations of certain atmospheres through the breakdown of colors.

Nonetheless, these various researches were necessarily limited. At best, they enabled the sensations produced by the external world's *appearance* to be given concrete form.

Cézanne went beyond this stage. In Cézanne, we find a concept of the universe that cannot be realized through this technique. This painter attempted to penetrate the very substance of the world and the essence of space. Cézanne's pictures also departed from the relative stylization of photographic reproduction. They questioned the pictorial representation of reality.

The "Cubists," among whom Georges Braque and Pablo Picasso appear to be the most eminent, responded to this challenge in an original way.

They flatly condemned all painting that purported to be a reflection of the universe.

Cubist pictures are objects with a life of their own, not *representations*. They justify themselves by the *disparity* they bring out between the painted object and the appearance of the real object. This appearance itself is held up to question, and one discovers that the intention of the Cubists was to seek out a new means of knowledge, rather than to induce aesthetic pleasure through new means.

Has their undertaking been a success?

While some doubt may still remain, an exhibition such as the one devoted to Georges Braque deserves to be considered with the greatest attention.

51. Letter from René Magritte to Harry Torczyner, September 18, 1965. See Appendix *for translation*

le 18 Septembre 1965

cher ami,

[Handwritten letter in French]

44

Finally, so as not to break with the customs of criticism, we should note that Braque uses a very limited number of colors, that he is especially devoted to contours and nuances, and that the variety of his grays, whites, and blacks frequently gives rise to surprising effects.

———René Magritte under the pseudonym Florent Berger, La Voix du Peuple (Belgian Communist Party organ), December 1, 1936

Dali

The 5000-kilo block of marble [balanced] on a bayonet is well within the style of the traditional artist who sees things "on a grand scale."* A few years ago, I dealt with a related subject without resorting to the *quantity* that impresses the empty headed. The 5000 kilos of rock will impress these idiots and, owing to the nature of their minds, they will comprehend nothing but the weight of the stone.

———Letter from René Magritte to Mirabelle Dors and Maurice Rapin, May 9, 1956

*During an interview, Salvador Dali had announced the construction of a sculpture made up of a five-ton block balanced on a bayonet.

Dali is superfluous: his flaming giraffe, for example, is a stupid caricature, an unintelligent bid—because it is facile and useless—to outdo the image I painted showing a piece of paper in flames and a *burning key,* an image I subsequently refined by showing only one flaming object—a trumpet (the title of it is *L'invention de feu* [*The Invention of Fire*]).

Moreover, Dali has given proof for some time that he really belongs to that vile group of individuals who drop in on the pope and value historical-religious painting without having any religious feelings whatsoever to justify this kind of behavior—which is an indication of the superficiality that is always so rampant everywhere nowadays.

———Letter from René Magritte to André Bosmans, March 1959

52. *Le bain de cristal (The Glass Bath).* 1946. Oil on canvas, 19⅝ x 13¾" (50 x 35 cm). Collection M. and Mme. Berger-Hoyez, Brussels, Belgium

De Chirico

He is actually the first painter to have thought of making painting speak of something other than painting.

———Letter from René Magritte to André Bosmans, March 27, 1959

I saw Chirico on television. He . . . made witty replies to the journalist questioning him. (He was probably trying to seem "down to earth" when he explained his paintings' Greek settings.) I noticed . . . the landscape with the men in the "foreground." All the same, I wondered whether Chirico's occasional outbursts of hilarity weren't signs that he was slightly gaga?

———Letter from René Magritte to André Bosmans, April 8, 1964

Delvaux

As for D[elvaux], I don't share your benevolence: he is a thousand percent *artiste-peintre* with the professional eccentricities and self-assurance that go along with it. I know him well enough to know that he's naïve, basically pretentious, respectful of and a believer in the most bourgeois "order." His success is due solely to the quantities of *naked women* he turns out continuously on immense panels. To him, they are "nudes" like those the academy professors tell us were the most sublime subjects of heroic classical painting.

———Letter from René Magritte to Maurice Rapin, February 28, 1958

Dubuffet

. . . it's getting easier to understand Dubuffet: one wrong note after another, his value based exclusively on imbecilic snobbery. He could go even further and exhibit used toilet paper arranged according to his "fancy" under glass; that would make some aesthetes drool.

———Letter from René Magritte to Louis Scutenaire, 1949–1950

Ensor

The reactions prompted by the James Ensor exhibition are extremely interesting in themselves. First, there is the critical reception, which is unanimous in declaring James Ensor to be an artist of the highest rank and of considerable influence. Yet this same body of criticism has given a cool reception to Ensor's early pictures (*Le chou* was condemned for "moral turpitude" in 1880, *L'après-midi d'Ostende* was refused by the Salon de Bruxelles in 1881, and so on). This criticism has, of course, played its habitual role, that of defending vociferously, whenever called upon, the outmoded values prevailing at the time, and the young Ensor treated [these values] with casual disrespect. Nowadays, the general consensus has changed: it seems that Ensor is some kind of summit. Ensor has had to display a certain freedom, of course, in order to seek a new pictorial climate. The French Impressionists pursued the same goals: to limit painting's professed ob-

jectives and to plumb them more deeply. Like his French friends, Ensor has achieved pictures in which color has given way to plays of subtlety or violence. The subjects are insignificant, serving as mere pretexts for unsymmetrical compositions and the decorative interplays of a colorist. It is apparent that here, by contrast to the work of Millet, Courbet, or Manet, a new way of understanding the world has not been introduced. An unenlightened euphoria and childish humor have dominated the development of James Ensor's work, and it represents fairly accurately one notion of happiness ascribed to by the bourgeoisie of 1900. A certain inconsequential nostalgia can be extrapolated from the vestiges of his disappearing world, but we must not confuse it with an exalted feeling about life.

A different kind of interest is also being shown on the occasion of this Ensor exhibit: the interest of the art dealers and speculators on the lookout for a "good deal."

The preface of the exhibition catalogue informs us that "doubtful" attributions will soon be eliminated as the result of investigations. Ensor's pictures will thus become solid investments. Poor old James Ensor! They made you a baron, and now the pictures in which you celebrated your youth have become the sorry objects of common speculation.

Finally, the interest of the visitors to the Ensor retrospective must be noted: they wander with great seriousness in front of the vegetables, the vases of flowers, the drunken Christs, and the other subjects Ensor enjoyed painting, without wondering if the seriousness they vaunt isn't somewhat out of place.

Were it possible to forget the gossip and the legend that disfigure James Ensor, a large exhibition of his works such as this one might possibly clear the artistic atmosphere that is still somewhat darkened by the Nazi occupation. However, it appears that we must go on living under this cloud.
——René Magritte, "Homage à James Ensor," Le Drapeau Rouge, no. 20–21, October 1945

Ernst

Max Ernst's painting represents the world that exists beyond madness and reason. It has nothing to teach us, but it relates directly to us, and that is why it can surprise and enchant us.

Max Ernst clearly does not resemble the traditional artist for whom "thinking big" or "small" seems to be indispensable to his happiness or suffering. All kinds of interests are evinced for traditional painting: historical, documentary, political, etc.

If we make a distinction between Max Ernst's pictures in which virtuosity commands the professional attention of technicians, and those whose style depends on the diligent imitation of an idea, there is still only one interest that truly applies to both: an interest made up of astonishment and admiration. The odd feeling that Max Ernst's pictures are "well painted" means that we are under their spell, rather than in the presence

of a manifestation of respect toward some definition of "fine painting."

Max Ernst possesses the "reality" that is able to awaken—if it be asleep—our trust in the marvelous, which cannot be isolated from the real-life situation in which it appears.
——Letter from René Magritte to Patrick Waldberg, 1958, in Waldberg, Max Ernst, Paris, 1958

Imitation Art

. . . a slice of bread and jam displayed in a painting exhibition can really only fill the role of an "imitation" picture.

Bread and jam shown in an exhibition undoubtedly suggest the opposition "imitation" picture—true picture. But this relies on the usual frivolity of the viewing public, to whom it never occurs that a picture could be an imitation. I have never personally encountered this *explicit* notion of an imitation picture. One often has occasion to speak of bad painting, stupid painting, and so on, but the term "imitation" seems to be freer of ambiguity. It is worth popularizing, whereas formulas such as figurative art, nonfigurative art, etc., are not, given the confusion to which they give rise. "Imitation picture" probably has no chance of succeeding, because in order to be "fashionable" imitation is just what is called for. "Figurative art" is the equivalent of cooking with food, while nonfigurative art is nonfood cooking.
——Letter from René Magritte to André Bosmans, July 20, 1960

Impressionism

Unlike "Sunday painters" or Paris Salon painters, the Impressionists brought to painting a needed and intelligent new form, which was to create a contrast between living ideas and dead ideas. Today, the general public still prefers the dead idea and has not yet really absorbed the living idea of the Impressionists.
—René Magritte, La Lutte des Cerveaux, 1950

Kandinsky

Le toile vide (The Empty Canvas). Kandinsky's emptiness has nothing to do with the "invisible" painting, as I once called it. To my mind, the "invisible" is the removal of the habitual meaning of the things that are visible in the picture, by means of which our mystery comes to dominate us completely.

Kandinsky's "emptiness" can easily be achieved.

Our mystery dominates us. We can do nothing to make it appear.
——Letter from René Magritte to Maurice Rapin, March 31, 1958

54. *Un Picasso de derrière les fagots (A Picasso from the Finest Vintage).* 1949. Painted bottle, height 12⅜" (31.5 cm). Private collection, United States

53. Letter from René Magritte (written in London) to
Louis Scutenaire and Irène Hamoir, February 18, 1937.
See Appendix *for translation*

Matta

Matta is a young man who comes from South
America. I think he has a little Indian blood in his
veins. He does paintings which are a thousand
times better than those of Miró. He has many
ideas. He received a religious education and he
lives in a flat in a white house.
——*Letter written in English from René Magritte (London) to Louis
Scutenaire, March 12, 1937*

Miró

I don't think I'm very "bright," but I manage. I don't
at all envy those who feel or who felt up to defying
the whole world. If I happen to come across evi-
dence of this heroic posture (a reproduction of a
picture by M—, for example), I am astonished that
the involuntarily comic aspect of this venerable
champion of "the liberation of Mankind" is still not
recognized.
——*Letter from René Magritte to Mirabelle Dors and Maurice Rapin,
January 24, 1957*

Picabia

Yes, Picabia's pictures move, they are hands
that caress girls for a specific length of time.
Picabia's white hair gives an impression of eternal
youth. Unbelievable though this may seem. But
that gives pleasure to those few of us who love
pleasure, *even in painting,* and who are deter-
mined to alleviate the boredom of the same old
artistic stories.

We must not think, then, when standing before
Picabia's paintings, of "revelations" in coffee
grounds or of "prophecies" that require too much
patience to be verified. Picabia thinks the way one
ought to think. In 1946, he is confronting an en-
croaching past with the movement and flashes of
vivid light, by which one looks at life in all its awe-
inspiring loneliness.

One summer evening, he carried off a pretty
young bride on her wedding day and taught her
the impossible. Everything was fine. Every trans-
formation goes very well, for that matter. It is
enough to prefer the girl who runs laughing down
the street to the gloomy charm of old photo-
graphs. It is enough to prefer freshness and the
murmur of the forest to the dust of ancient manu-
scripts. It is enough to want to make pleasure
prevail despite the spectacle offered us by a
world teeming with ruins and silly anxieties.

Picabia's pictures move; they escape from
fixed ideas. They are as superficial as the joyous
life of lovers and leave to themselves, one might
say, those who miss the "profundities" of the
blackout and the music of the cannon. They inau-
gurate this reign of pleasure that ought to be
brought within the limits of our lives.
——*René Magritte, "La Peinture Animée, La Vérole du Pape F.P.,"
preface for a Picabia exhibition, 1946*

Are you familiar with this picture by Picabia (re-
jected by the salons)? One needn't describe it,
but rather the "manner" in which the picture was
created: Picabia "shat" on a white canvas and
stuck a calling card in the turd. I think it will be
hard for him to outdo himself!
——*Letter from René Magritte to Louis Scutenaire, June 13, 1948*

Picasso

As for Picasso, who discovered a new intelligence
of painting, he owes his adoption by the partisans
of confusion to his negative aspect, that is, to a
completely superficial appearance of intellectual
scandal.
——*René Magritte, La Lutte des Cerveaux, 1950*

Pop Art

Pop Art is "inspired" (twenty-five years after the
fact) by Dadaism.
——*Letter from René Magritte to R. Giron, September 3, 1964*

The Pop artists are very pleasant, very nice, but
. . . I'm sorry, they've taught me nothing new,
nothing. It seems to me they lack the intelligence
required to achieve the works everyone is waiting
for. The regeneration of painting will not come
from them!

. . . Yes, I know I'm called the father of Pop Art, Op Art, and all kinds of other "arts" . . . But Pop Art is nothing but another version—an infinitely less audacious one—of the good old Dadaism of fifty years ago! Modern painting went through an evolution that ended with Picasso. Everything touted today as novelties is only a variation on what was already done many years ago.

How will painting evolve from here on? Well . . . any way it can!

. . . And Pop! Let's just say that it's not very serious, and that it's probably not even art? Or perhaps [it is] poster art, advertising art, a very temporary fashionable art. It is effective enough in the streets, I admit, on young girls' dresses.
——*Remarks by René Magritte reported by Claude Vial, Femmes d'Aujourd'hui, no. 1105, 1965*

They [Pop artists] say they like me a lot. But they are of their own time—neon, posters, technology. . . . Me, I feel I am into truth. . . . Then I feel that that should have been said. . . . I no longer feel either hope or despair. . . . There's nothing to be done.
——*Remarks by René Magritte reported by Jacques Miche, Le Monde, January 13, 1967*

They are into Neon, I am into Truth.
——*Remark by René Magritte reported by Maurice Rapin, Aporismes, 1970, p. 20*

Rauschenberg

To clear up a few misconceptions, I confess I know X and Z of the New York School only very slightly: I now know generally what Rausenberg [sic] "represents," thanks to a pile of rags hanging on Suzi's [Gablik] wall. Before this encounter he was a name along with one or two others that for me represented only the charmless confusion of the "avant-garde's" artistic mind.
——*Letter from René Magritte to Louis Scutenaire, December 24, 1965*

Rousseau

An example of the aberrations into which we are led by the snobbism of dead movements is provided by the fate reserved for the Douanier Rousseau.
——*René Magritte, La Lutte des Cerveaux, 1950*

Surrealism

. . . unlike the Surrealism of 1930, extramentalism is not a "fringe" activity, but seems able to "contain" everything friendly, inimical, etc. Perhaps political activity should be reconsidered?

I willingly gave up the word "extramentalism," not so much as a result of your arguments, but because of my own lack of political sense and because of confidence in your political judgment, which I believe to be good. The arguments have not stood up under further examination:

1. The anticipated schism was not an obstacle for the Surrealists at the time of their rupture with Dadaism.

2. Surrealism always meant Breton, and we never did anything to make the public connect us

with the word. (In the Charleroi Conference the word is not even mentioned.) When Breton lectures in Brussels, we let him go ahead without interfering, etc. Perhaps it is too late for us to get this venerable term back and make use of it, and we will probably have to work hard if we want the public to understand the term differently. Wouldn't it be simpler to use a new word and direct our energy elsewhere? New ideas call for a new vocabulary, and a new name would avoid confusion.

I have laid Surrealism to rest—my own for some time now, and Breton's with even greater reason.
——*Letter from René Magritte to Paul Nougé, September 1946*

You probably know that "for one reason or another" I'm no longer a Surrealist, my basic reason being the minimal pleasure I get from the kind of old wife's magic good Surrealists believe in.
——*Letter from René Magritte to Malet, January 31, 1948*

When we deliberately chose pleasure as life's supreme goal, we had already had the experience of twenty years of Surrealism, which at first produced startling objects effective enough to escape Dadaism's sterile confusion. Following a reactionary development, Surrealism now stands for the practice of ineffective magic, the cult of so-called exotic or esoteric mysteries, and the establishment of a myth extracted from the same cask used to distill holy beverages. The area available for the revelation of pleasure grew so confining that we could no longer allow ourselves to be destroyed in the Surrealist way.

Present-day Surrealists can conceive their activity only in terms of being for or against the Communist Party. Reactionary Surrealists choose idealism, revolutionary Surrealists prefer materialism. We, on the other hand, believe such preoccupations would paralyze the specificity of our activity. It is obvious to us that both the economic-political struggle being waged according to the tenets of dialectical materialism and our own activity and experiences are necessary, but that they are parallel, so it is ridiculous to confuse them and to want to see one suppressed or one impose its own method on the other.

We have neither the time nor the inclination to play at Surrealist art. We have an enormous task before us and must think up bewitching subjects that will arouse what remains of our instinct for pleasure. We should avoid ambiguity and distinguish ourselves from the Surrealists. For this reason, we are adopting the qualifying term "Amentalist," which we believe will have the advantage of constantly reminding us that the era of philosophical fanatics is breathing its last.
——*René Magritte, Manifeste d'Amentalisme, 1946, Le Fait Accompli, nos. 51–53, July-August 1971*

I feel the same disinterest for the "Surrealist" attitude, whose defect is apparent: faith in human pride, which is quite incapable (due to the stupidity it implies) of making good any of its promises. What some Surrealists have actually managed to do well *is not Surrealist*. . . .

A "Surrealist" treats painting in a "lordly" way;

he "dominates" the situation without ever doubting that he is himself *part of the situation* without free will, whatever it may seem.
——*Letter from René Magritte to Maurice Rapin, August 6, 1956*

"Surrealism" (like "Fantastic art") has only a very vague meaning, which is false if it is given a meaning other than the very limited one it has: Surrealist is what suits Breton, what he says is valid. (This doesn't mean he really thinks it is.) So I am not very "Surrealist." For me, the word also signifies propaganda (a dirty word), with all the idiocies necessary to propaganda's success.

I may be "in practice" considered a "Surrealist," but this is part of a stupid "game." I have shows with "Surrealists," such as Labisse, Couteau, etc. . . . It goes without saying that I do not participate in, nor am I a part of, this artistic-cultural Ballets Russes movement.
——*Letter from René Magritte to Maurice Rapin, July 3, 1957*

Some Romantics are admirable, and some Surrealists are nothingness incarnate. There is a mediocre way of thinking, not necessarily Romantic, which can be classical or Surrealist. This is the one that is impossible to destroy: it has no force, it is the value that has been given it.
——*Letter from René Magritte to Harry Torczyner, 1959*

If the word *chance* exists, its meaning is in effect the same as that of the word *order.* It can be demonstrated that chance obeys a certain order, that it is the order of order, that order is due to chance, that this is so by chance, etc. . . . The Surrealists have talked a lot of nonsense, and I fear that despite their genius they are not made of the stuff to realize it. "Automatic" writing naïvely encourages this banal pretension to devise a methodical way of "forcing thought to speak"—as if thought were a machine, as if the interesting quality in writing or painting weren't *always unpredictable.*
——*Letter from René Magritte to André Bosmans, January 13, 1959*

. . . there are no Belgian Surrealists, aside from Delvaux (if even!) and myself. The Belgian artists who pass for Surrealists have only vague or false notions about it—in other words, none at all.
——*Letter from René Magritte to Harry Torczyner, January 25, 1964*

The term *Surrealism* gives rise to confusion, and the term *Realism* is not suitable for the direct apprehension of reality. Surrealism is the direct knowledge of reality: reality is absolute, and unrelated to the various ways of "interpreting" it. Breton says that Surrealism is the point at which the mind ceases to imagine nothingness, not the contrary. That's fine, but if I repeat this definition I'm no more than a parrot. One must come up with an equivalent, such as: Surrealism is the knowledge of absolute thought.
——*Notes written by René Magritte at the Gladstone Hotel, New York, New York, December 16, 1965*

Tachisme/Action Painting*

Nothing very exciting is achieved by "action painting" [*tachisme*] or "automatic writing." "Detach-ment" is also easy to understand. These methods of painting or writing make short work of all the problems that arise when one is looking for something truly different. We are talking about "technique," a word that in itself suggests a way of "cutting" a Gordian knot, because technique, conscious thought, and unconscious thought are all ways of thinking that are mistaken for thought itself.

Of immediate concern to us is a painted or written language that does not leave us indifferent, not the knowledge that it is conscious or unconscious, spontaneous or deliberate. The level on which such opposites become meaningful may be as scientific as you like, but I can't accept that. To follow Boileau or the *Surrealist Manifesto* is to affirm that hope may be ridiculous and easily satisfied. There are things done spontaneously that have no grace, and carefully thought out things that do. This doesn't depend on the chance that always seems to come along when one believes in it.
——*Letter from René Magritte to Maurice Rapin, March 7, 1958*

*Action painting, the more gestural manifestation of Abstract Expressionism, was known in France and Belgium as "art tachiste." This name was derived from the "taches"—paint stains, spots, or splashes—that were characteristic of such paintings. Magritte here plays on the double meaning of the term "art tachiste," which is largely lost in translation.

Tanguy

The idea of showing Tanguy's paintings along with mine isn't bad . . . it's fine of itself, but it takes a museum curator's mentality to have thought it up, since such an exhibition would point up the clash (almost total) between Tanguy's ideas and my own. It is apparent to everyone (except a curator) that Tanguy always stuck to redoing the same painting. The modifications [apparent in] the countless versions are negligible. The curator's idea is good because it will demonstrate the opposite of what he believes. As far as he is concerned, there can be no question in his mind of either nuances or incompatible differences.
——*Letter from René Magritte to Harry Torczyner, September 30, 1961*

As for painters like Tanguy [or] Miró, I think they behave like priests: they always use the same recipe for invoking the God of the Catholics. Both of them have renounced (or are unaware of) the distinction between imaginary and imagined, and have settled on the imaginary, which never varies.
——*Letter from René Magritte to André Bosmans, November 13, 1965*

Van Gogh

I don't really respond to Van Gogh's paintings. I mention this because I've been asked to write something about this painter; I don't know if I'll manage to do it [since] I'm not very "enthused." There is, of course, the story of the ear, cut off and cleaned up, put in an envelope, and given as a gift to prostitutes. If I do write something, I'll try to convey what happened as being more important than the actual pictures that elicit the obligatory admiration of intellectuals.
——*Letter from René Magritte to G. Puel, March 8, 1955*

Philosophy

If society weren't ignorant of what we are like, don't you think it would find us suspicious? Society plays its role. We're surrounded by jokers who have forgotten what they're about. Yet we have to take society into account. It uses poor judgment, but it is isolated. Otherwise. . . .
——*Letter from René Magritte to Marcel Lecomte, September 1928*

There is an established "beauty" that is like a self-satisfied person with a solid income; there's another kind of beauty that sears our souls. I love this beauty that has no protection or strength except its own force and charm. For me, thought and language cannot be reduced to their function (as alleged by sociologists), which would involve the social structure and bring about changes in it. Thought and language clearly possess this function as far as orthodox sociologists and philologists are concerned. I don't feel obliged to think as they do, nor have I any desire to do so!
——*Remarks by René Magritte quoted by Maurice Rapin, Aporismes, 1970*

It's as though we were in a cave without ventilation.
——*Remark by René Magritte reported by Louis Scutenaire,* René Magritte, *1942, p. 36*

Life is supposed to be better appreciated through displeasure, uncertainty, pain, terror. We find "completely natural" the unceasing efforts that continue to be made to turn the world into a torture chamber. We don't protest because the mind has been twisted into thinking as follows: we believe that tragic lighting is better suited to reveal life, and that this is how we come into contact with the mystery of existence. Sometimes we even believe that we are successful, thanks to this illumination, this objectivity. This objectivity becomes greater as the terror becomes more vivid.
——*René Magritte, notes written to Marcel Mariën regarding the* Manifeste de L'extramentalisme, *1946*

We mustn't fear daylight just because it almost always illuminates a miserable world.
——*René Magritte,* Le Surréalisme en Plein Soleil, *October 1946*

When we consider philosophy, it's like considering painting or writing. We aren't thinking of what the professional philosophers, painters, or writers mean. Whence the danger of using the words *philosophy, painting,* etc.
　　Beauty is a promise of happiness (happiness for twentieth-century Westerners).
——*Letter from René Magritte to Paul Nougé, October-November 1946*

I consider valid the linguistic attempt to say that my pictures were conceived as material signs of freedom of thought.
——*René Magritte,* La Pensée et les Images, *catalogue of the Magritte exhibition, Brussels, May 1954*

A pictorial (or other) language impresses the yokels insofar as it is *dull.* Let me explain: the artist paints dull pictures so that they seem to mean something important. If the picture were to state clearly what the artist thought, we would recognize it as an open secret, as a banal idea or feeling. Thanks to obscurity, however, the untutored believes the picture to have some wonderful meaning.

What I paint is addressed to those who *"live" in the present,* or rather, *for* it. . . . An artist who paints for posterity has an intention that I do not have. In my opinion, he is doing something idiots understand very well—those who do not concern "living" men. The man who seems to be alive, whom one refers to as "alive," is an enigmatic reality that need not be lent a meaning that would *interpret* that reality as one that is concerned with posterity. We *see* that after a time reality abandons what we perceive in it, that it abandons its form and means of communication (death no longer speaks our language, since if it speaks we cannot hear it). I think of my pictures as being truly in touch with the living, but there is no reason for expecting these pictures to outlive the living, when the latter do not have a parallel ambition or [entertain] such facile notions.
——*Letter from René Magritte to Louis Scutenaire, February 24, 1955*

This business of the [art] public might also be clarified. (Van Gogh showed his pictures without saying anything to the "respectable" people who barely glanced at them. Now, everyone is more "sensitive" than those "respectable" folk, and everyone recognizes Van Gogh's greatness now that he is dead.) In this regard, I think that my painting has real interest only for those who are alive now. In the future, it will have nothing but some historical value (if it still has any value at all). Why do we care about creating works that will last, when man doesn't have similar ambitions for himself? This surrogate survival through one's work is nonsense.
——*Letter from René Magritte to G. Puel, March 8, 1955*

55. *Les vacances de Hegel (Hegel's Holiday).* 1958. Oil on canvas, 23⅝ x 19⅝" (60 x 50 cm). Galerie Isy Brachot, Brussels, Belgium

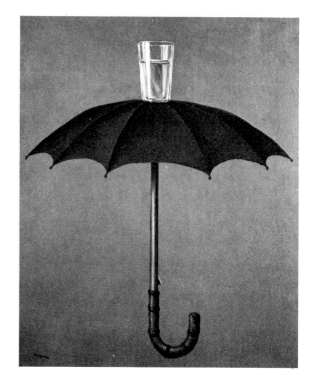

Mon dernier tableau a commencé par la question : Comment peindre un tableau dont le verre d'eau est le sujet ? J'ai dessiné de nombreux verres d'eau :

une ligne se trouvait toujours dans ces dessins.

Ensuite cette ligne s'est écrasée et

a pris la forme d'un parapluie ,

Puis ce parapluie a été mis dans le verre : et pour

finir le parapluie s'est ouvert et a été placé en dessous du verre d'eau :

Ce qui me semble répondre à la question initiale.
Le tableau ainsi conçu s'appelle :
 " Les Vacances de Hegel „

Je crois que Hegel aurait aimé cet objet qui a deux fonctions contraires : repousser et contenir de l'eau. Cela l'aurait sans doute amusé comme on le peut en imaginer ?

Bien amicalement à vous

René Magritte

The criterion that Valéry condemns doesn't yet exist, as far as I know. There is this need I mentioned to you in which an interest in the most difficult things and the passion for research are replaced by an interest or desire for the result.
—*Letter from René Magritte to G. Puel, May 22, 1955*

VARIETIES OF SADNESS*

Dinos: But doesn't the All High know all things?
Agathos: And it is the *only thing* (since he is the All Highest) that should remain unknown to Himself.
——*Edgard* [sic] *Poe*

Freedom is the possibility to be, and not the obligation to be.

The sad heart can beat, it can cease to beat; it makes acquaintance with freedom. Sadness knows freedom; it imposes nothing.

Freedom is an "old acquaintance" that we bear as badly as sadness and being. The will intervenes to control or stop palpitations. All the feelings that judge, serve, represent, deny, or utilize freedom *are not distracted by sadness,* are not led astray as to the extent of their ignorance of freedom.

Ignorance is surely not total save in [a state of] absolute nothingness.

In a world that puts a price tag on usefulness, we tolerate freedom, sadness, and being, which are duly motivated by their obedience to the laws of chance, necessity, or experience. We respect sadness, but want to alleviate it: "Travel is an effective diversion for moral afflictions," said Larousse, whose gargantuan labors were indicative of a normal insanity, a tenacious will to "banish dark thoughts." There are many ways to "alleviate sadness": learned discoveries teach us, among other things, that love is hate, that sadness stems from a childhood complex, etc. However energetic the search for error or truth, the entertaining outcome outweighs all other aspects.

Caricatures of sadness command respect. . . . The knowledge of freedom prescribes nothing useful. Rather, it distinguishes with some difficulty between the useful and the useless.

Respect turns into suffering when certain faces express arrogance, brutality, cruelty, or the other emotions that would impose their wills, no matter the abjectness that may result. This spontaneous or methodical will is stupid insofar as it is unfamiliar with freedom and lacks sadness.

Like love, honest emotions can be distracted by sadness. They counter the knowledge of freedom with no disinterested or passionate motives. They are happy, they can suffer the most acute unhappiness.

"Unmotivated and inconsequential" emotions such as nostalgia, congeniality, pity, boredom, charm, and humor are variations of unedifying sadness.

Edgard [sic] Poe wrote "The Genesis of a Poem." He tells us that one kind of logical method decides on the treatment to be inflicted on a "theme" chosen for its *utility:* NEVERMORE! Obviously, *no one* believes the utility of NEVERMORE! to be more than marginal, more than a negligible quantity. NEVERMORE! is only suitable for assisting in something such as, for example, the conception of a poem. Poe humorously brings his discourse into line with the truth in popular opinion, which attributes to sadness the power of leading the will down solemn or merry paths. Truth does not contradict the truth of the heart or mind.

"The Raven" and "The Genesis of a Poem" express the sadness that has never abandoned poets of freedom.
——*René Magritte, 1955*

*An earlier, shorter version, Two Variations of Sadness, was contained in a letter to Louis Scutenaire, 1955

Being the "master of one's fate" can't be accomplished without automatic recourse to the faculty of comparing oneself to a master of fate or maintaining a privileged relationship with fate. To believe in fate, one has to compare future time with past time, and believe in both past and future.
——*Letter from René Magritte to Mirabelle Dors and Maurice Rapin, March 13, 1956*

I think a lot about . . . the impossibility of perceiving anything other than ideas, feelings, or sensations. What we imagine to be *links* between these things are in turn only an idea or feeling, and to my knowledge nothing can be seriously considered a *link, relationship, cause* or *effect.*

In rereading Nietzsche, I find exactly the same idea, but expressed with a word that revolts me—*atomism:* "Our conscience (as we call it) is composed of atomic phenomena," meaning separate, autonomous, isolated, indivisible things. He also stresses what I already thought: we can predict nothing; everything that happens is an "effect" whose "cause" is beyond what happens to us, beyond our horizon. He goes on at great length about our civilization, its decadence. He isn't very attractive here. But his disciples seem to have misunderstood him precisely to the extent they were "concerned" with social questions. The Nazis "were fond of" Nietzsche, Beethoven, Wagner, as though, had they been alive, they wouldn't have gone straight to the gas chamber.
——*Letter from René Magritte to Mirabelle Dors and Maurice Rapin, June 19, 1956*

The fact of living is of great importance for everyone, but the life of someone else doesn't have the same importance. . . .

Since death is absolute nothingness, it will be an absolute comfort to us mortals. The moral question will not come up in the absolute absence of "point of view" (lack of "conscience"). Since it is absolute nothingness, then, death would be a program of absolute comfort that is attained no matter what means are employed to achieve it. The idea that death is absolute nothingness is not contradicted by the idea that we live in mystery. Mystery is not penetrated by this supposition. On the contrary, it appears to respect the idea of mystery, and thus should be respectfully considered.
——*Letter from René Magritte to Paul Colinet, 1957*

It's "normal" to think sometimes of putting an end to what we call life. It would be possible, like other possibilities we occasionally think about without "following through."

All the same, there is something so uninteresting about blowing one's brains out that such a project couldn't hold our interest for long, and once you've given it up you're impervious (as I am, I think) to things that may appear sensational but that are in the end more or less nothing.
——*Letter from René Magritte to Maurice Rapin, February 18, 1958*

57. Letter from René Magritte to Paul Colinet, 1957.
See Appendix *for translation*

58. *Variante de la tristesse (Variation of Sadness)*. 1955. Oil
on canvas, 19⅞ x 23⅜″ (50.5 x 59.5 cm). Private collection,
Chicago, Illinois

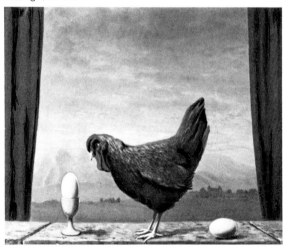

I am planning to paint a picture on the idea of the
chicken with a boiled egg. (I'm wondering if the
egg should be decapitated or intact?) Nocturnal
and sunlit variations are a possibility.
—*Letter from René Magritte to Paul Colinet, 1957*

59. *La statue volante (The Flying Statue)*. 1927. Oil on can-
vas, 23⅝ x 19⅝″ (60 x 50 cm). Private collection, Belgium

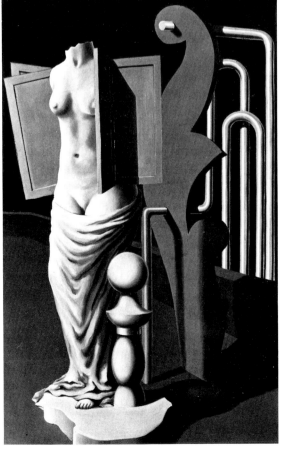

Words have all kinds of meanings. Take the word *serious,* for example: "serious" people such as scientists, businessmen, strategists, etc. A French biologist (Rostand) states with the scientist's solemnity: "Once past childhood, we should know that nothing is serious." This superiority, which does not lack serious irony, illustrates the seriousness of "serious" people, and is a prime example of the stupidity of specialists who try to "deal with everything." Poets can reclaim this word *serious* by giving it a *truly* serious meaning. Poetry is a more serious "business" than science, strategy, finance, or another supposedly serious thing.

The poet can seriously judge what is not poetic. The scholar, the man of war, the empire builder, cannot seriously judge poetry.

The meaning of the word *logic* has never to my mind followed the scholastic rules of reasoning when it designates that which should join images together so that a poem can be what we have the right to expect of it. I don't put any more stock in the word *logic* than in any other. Poetic "meaning," "rigor," "enlightenment," or "logic" are all the same. The important thing is the poem, in which nothing is unimportant, and which is able to give the feeling of something truly "serious."
——*Letter from René Magritte to André Bosmans, May 1959*

. . . I *jokingly* said that clever people would reproach the "heaviness" of what I might write to elucidate an idea. . . . It's what one says that counts above all; the way one says it is important only if it is suited to saying exactly what must be said.
——*Letter from René Magritte to André Bosmans, July 20, 1960*

After a discussion about my text *La Voix du Mystère (The Voice of Mystery),* I'm afraid that the mystery I'm talking about may be confused with the one priests propagandize. Someone told me

that they would be able to convince me that I'm a "believer" as they understood the term. . . .

Is it perhaps a question of distinguishing between Nothingness and the Nirvana touted by Eastern priests? But this is a difficult matter. In "distinguishing" Nothingness, we already define it and give it a form it couldn't possibly, as Nothingness, have.

I believe that what we don't yet know about Nothingness is necessary.
——*Letter from René Magritte to André Bosmans, September 25, 1961*

If someone likes you for your good qualities, it's only your good qualities they like.
——*Letter from René Magritte to André Bosmans, March 1962*

I chose "idea" to differentiate between thought composed of words (speech) and thought composed of another language (music, painting, mathematics, etc.).

What is appealing about ideas is that they are so often questionable. It seems that the sum is not greater than the part ad infinitum, which accounts for that immediate effectiveness [of ideas] that suffices for our happiness.
——*Letter from René Magritte to André Souris, December 7, 1963*

The first feeling I remember is when I was in a cradle, and the first thing I saw was a chest next to my cradle. . . . The world presented itself to me in the guise of a chest.
——*Remarks by René Magritte, reported by Jean Neyens, January 1965*

I don't know the reason (if there is one) for living or dying.
——*Letter from René Magritte to Chaim Perelman, March 22, 1967*

"We never see but one side of things," Victor Hugo said, I believe. . . . It's precisely this "other side" that I'm trying to express. . . .
——*René Magritte, 1967, quoted in* Lectures pour Tous, *Pierre Cabane, Paris, no. 167, November 1967*

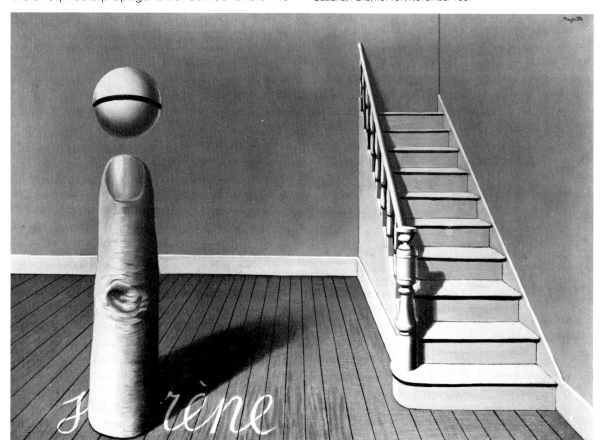

60. *L'usage de la parole (The Use of Words).* 1932. Oil on canvas, 19⅝ x 29½" (50 x 75 cm). Collection M. and Mme. Louis Scutenaire, Brussels, Belgium

Politics

Man's will is being enlisted to engage in the accomplishment of a utopian task.

The consent of the workers is obtained by employing threats and words that seem to point out indispensable realities.

The world is blinded by this blackmail, and yet it manifests a legitimate concern—quickly allayed, to be sure, by the vague hope that its desires will somehow be fulfilled.

As long as we have the means to do so, we Surrealists cannot discontinue the activity that puts us in direct opposition to the myths, ideas, feelings, and behavior of this ambiguous world.
—*Letter from René Magritte to Louis Scutenaire, December 12, 1932*

The Communist point of view is my own. My art is valid only insofar as it opposed the bourgeois ideal in whose name life is being extinguished.
—*René Magritte, Les Beaux Arts (Brussels), no. 164, May 17, 1935, p. 15*

I distrust this folk art the Fascists have chosen to promote. Art-for-the-people is spurious because it is based on a superficial point of view. I too am part of the people. What a painter must do is to see mankind in workman's overalls. This is what Courbet did when he painted *Les Casseurs de Pierre (The Stone Breakers)*, which caused a scandal among gallery-goers because its subject was new. For that matter, I have often met with greater understanding from the working class than from the most refined aesthetes. As for the snobs, they have wildly applauded Surrealist projects because they have to be "with it." Today, they are being lulled by the deplorable singsong of Existentialism, and tomorrow. . . .
—*René Magritte, Clarté, December 16, 1945*

At present artists cannot survive unless they allow their works to be exploited. A painter who turns down a contract with a dealer or who refuses to sell his pictures to collectors on the pretext that he

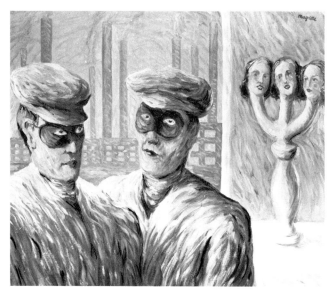

61. *L'intelligence (Intelligence).* 1946. Oil on canvas, 21¼ x 25⅝" (54 x 65 cm). Collection M. and Mme. Louis Scutenaire, Brussels, Belgium

has the right to greater returns has no way of acquiring those greater returns; he lacks that effective means available to other professions—the strike. A strike by professional painters or poets would create hardship for no one.

The only way poets and painters have of struggling against the bourgeois economic system is to give their works a content that rejects the bourgeois ideological values that underlie the bourgeois economic system.

In actuality, the only writers and painters working toward this goal in Belgium (along with scientists in their respective field) are the signatories of this letter, and their public adherence to the Communist cause is being met with real hostility and mistrust on the part of the Communist Party. Indeed, their efforts are never discussed when the Communist press takes up cultural problems (not a word in *Le Drapeau Rouge* about the works that have been submitted to it by Nougé, Scutenaire, Mariën, and Magritte; on the other hand, the bourgeois press exhibits its perspicacity in doing them the honor of considering them enemies), but rather it seems to be the rule that only representatives of bourgeois thought are given much consideration.

The articles in *Le Drapeau Rouge* devoted to contemporary art exhibits mention:

1) Ensor (who showed in Germany during the Occupation) and other "stars" established by the bourgeoisie.

2) Dead artists, the fact of their death having aroused some "rather belated" interest, and apparently being sufficient to confer exceptional value on their works.

3) An anarchical group of experiments by "young" [painters], from which nothing can be extrapolated at this juncture.

 * * * *

The Party refused, it says, to take a stand on these questions: in fact, if the Party has no confidence in the content of these works, it is because that content is nonexistent as a force of opposition to bourgeois thought. Nevertheless, the Party wants to get some use out of artists who are *incapable of inventing new emotions,* and requires them to engage in political agitation. Yet since artists cannot go on strike, the absurdity of artists' political agitation is only too obvious.

The only *correct* attitude the Party can take with regard to the aesthetic question, *and which it is refusing to take,* is that of requiring an artist to give his works a revolutionary content. This is our conviction, and it prevents us from attending the meetings at Antwerp, which will be held with the absurd notion of seeking ways for artists to engage in political agitation.
—*René Magritte et al.,Lettre au Parti Communiste de Belgique, 1946*

Have I discovered something? I thought that the idea *progress doesn't exist* was dangerous to our health, since it prevents a greater contact with reality: good and bad things (for us as well as others, for the dead and the yet unborn) that continually happen, struggle, are replaced, and so on.

The notion of progress facilitates cerebral suppurations such as: "The dunce cap is an advance over the tricorn," "The revolver is an advance in the art of killing," "Death and suffering in an ultramodern hospital is an advance," etc.

The idea of progress is linked to the belief that we are coming closer to absolute good, which permits a lot of today's evil to emerge.
—*Letter from René Magritte to Paul Nougé, August 14, 1946*

All my latest pictures are leading me to the simplified painting I have sought for so long. In short, it is the increasingly rigorous research into what is, to me, the essential in art: a purity, a precise image of mystery that, having abandoned all extraneous conjecture, is decisive. . . . It seems that in this way I express what was overwhelming about *Le viol (The Rape)* with forms identical to those in nature. The reading of it becomes internalized.

——Letter from René Magritte to Claude Spaak, undated

On the other hand, in order to attract the interest of the artistic, political, and literary population, this title was chosen because of the "sensitivity" to current events that makes these cultivated individuals so impressionable. Having thus gained the attention of this group for the few moments it is capable of maintaining a semblance of thought, one notices that on their level—the level of unskilled art—folk objects are the equivalent of the so-called secrets of alchemy in another area.

Just as propaganda for alchemy could only be made with an ignorance of today's scientific knowledge, so the arguments for folk art can only be explained by the reprehensible ignorance of spiritual things shared by the cultural specialists who are responsible for or support this shameful enterprise.

Whereas the least objective of minds would readily judge the call for a return to alchemy to be an attempt to destroy scientific progress and a desire to return to the adoration of icons or to the fear of forbidden fetishes in the hope of rediscovering a so-called age of gold, a parallel and large-scale endeavor in favor of folk art is now underway and is being supported by both those who are for reaction and those who seek change in the world economic system.

The agreement these opponents have reached on the benefits of folklore is unusual and significant enough to merit examination.

The fact that the Catholic and revolutionary

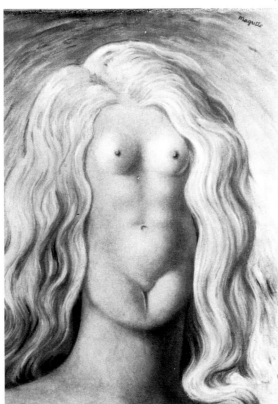

62. *Le viol (The Rape).* 1945. Oil on canvas, 25⅝ x 19⅝" (65 x 50 cm). Collection Mme. René Magritte, Brussels, Belgium

Le viol (The Rape). This painting was part of a 1947 show organized by Communist intellectuals and sympathizers at *Le Drapeau Rouge* offices, rue des Casernes, Brussels, and was lost subsequent to the exhibition. It was found by Pierre Alechinsky, who returned it to Madame Magritte after Magritte's death.

newspapers are united in this affair leads one to believe that what divides them exists on another level than that of cultural matters, and that there is nothing to keep them from agreeing on "minor questions."

In short, these political foes give little importance to the feelings a man has about life and the enhancement of those feelings by artistic means. What divides them makes them alike. These foes are made of the same stuff: second-rate stuff that has nothing to do with either the noble spirit of the alchemists or with the enthusiasm of unknown folk artists. Alas! This stuff is the stuff of inertia, an inertia made monstrous by its permanence and its extent!

There are some men here on earth who know what true intellectual honesty is and who want no part of this inertia nor expect any help from it. The countless others are indifferent, passive, clumsy calculators, or dishonest. Their number is not enough to make them right.

In the artistic sphere in 1949, we are called upon to dismiss the case involving the fraudulent attempts to revive feudal obscurantism based on folk material. Also, to refuse to respect the myriad selfish hopes one could place on this kind of undertaking.

Simple honesty demands that such attempts—doomed, in any case, to failure—be called by their rightful name: the sign of contemptibility.

——René Magritte, Nous N'Avons Pas Choisi Le Folklore, 1949

NOTE FOR THE COMMUNIST PARTY

The workers have been exposed to paintings under poor conditions as a result of initial confusion in regard to artistic activity and political action. While the political struggle must, under present circumstances, concentrate on the demand for our rights to, for example, adequate nourishment and minimum comforts, the battle being waged by revolutionary artists can now be understood as a response to a maximum need: the conquest of the mind's wealth, a conquest that must never be abandoned.

In their encounter with artists, the workers were only permitted to contemplate those pictures strictly limited to the plastic expression of political ideas or sentiments; and the architects of the Party's cultural policy are making the error of leading the workers to believe that this is the only kind of painting for which they are suited.

Although the pictorial translation of political ideas is useful for illustrating Party posters, it does not automatically follow that the artist's only valid role is to paint pictures that in more or less lyric terms express the social struggle, and that the workers must forgo the pleasure of looking at pictures that can enrich their minds without teaching them class consciousness.

Class consciousness is as necessary as bread; but that does not mean that workers must be condemned to bread and water and that wanting chicken and champagne would be harmful. If they are Communists, it is precisely because they hope to attain a better life, worthy of man.

For the Communist painter, the justification of artistic activity is to create pictures that can represent mental luxury, a luxury for Communist society

quite different from the useless, ostentatious, tasteless luxury of the existing exploiting classes.

To want systematically to exclude this luxury from the socialist world is to condone a sordid and culpable establishment of mediocrity, at least insofar as the mind is concerned.

A better life cannot be conceived without some real luxury. It cannot be achieved without political struggle and the difficult struggle waged by revolutionary artists, those who do not limit their efforts solely to the expression of political ideas or to the representation of familiar scenes in the life of the working class for the purpose of edification.
——*René Magritte*, Note Pour Le Parti Communiste, *April 24, 1950*

Revolt is a response of active man that need not be legitimized by more or less comprehensible motives.

Revolt against the world of today signifies the refusal to participate willingly in activities dominated by hoodlums and imbeciles. It likewise signifies the will to act against this world and to seek ways of changing it.
——*René Magritte, "La Révolte en Question,"* Le Soleil Noir *(Paris), no. 1, February-March 1952, p. 68*

PEACEFUL EVENING*

As a patriarch and small landowner
I don't like strangers
who shamelessly and without permission trample
the arable soil which I work with my hands.
One fine evening after the family meal,
I was told that an Englishman, his wife, and daughter
were camping on my property
without having advised or consulted me.
At first it was the vision of a slip-clad woman,
allowing a glimpse of soft curly hair,
that arose in my imagination,
and then the idea of spying on her from behind a bush.

You already know what happened next:
my rough laborer's hand
took my carbine, fired, and hit her
with great accuracy on her exposed parts.
I left my empty shells lying in the dew;
my educated son says he collected them
and changed the position of the bodies
while I slept peacefully in my bed.
Thanks to my cleverness and experience,
I had a good laugh on the police
until the moment during the reenactment [of the crime],
when I was no longer able to maintain my cover-up.
——*René Magritte, 1952*

*Written at the time of the Dominici affair, to be sung to the tune of "Le Chant du Départ"

Progressive atheists and Fascist Catholics are not very interesting. While on the way to Antwerp yesterday, I passed near the camp at Breendonc [sic] (the Belgian Buchenwald), and the memories this camp brought back are far from being able to provide any rationale for the universe. As for the progressive atheists you mention, who dream of horsewhipping the whole world, they are obviously incapable of making anything but trouble. We don't have to do anything about such "engagés" so long as they leave us more or less in peace. However, when "culture" is at stake, their titles—Catholics, Fascists, atheists, progressíves, etc.—are reason enough for one to be disgusted at the prospect of collaborating with them. For them, it's not enough to take a "quick turn round the floor with a modicum of elegance." They wouldn't hesitate to stop you if it were necessary.
——*Letter from René Magritte to G. Puel, May 22, 1955*

One idea that's occurred to me—I don't know what it's "worth." What we call a "work of art" is usually "defended" with the same tenacity with which one would defend—to cite the same example—the subway if it came under attack. Painters are born, live, and die "for painting" (preferably abstract) as they would "for France." The idea occurred to me that what is to be defended cannot be defined as easily as can old or fashionable "pictorial values." It seems to me that it is the vision of the world that must be defended, *because it cannot be separated from the viewer.*
——*Letter from René Magritte to Mirabelle Dors and Maurice Rapin, January 23, 1956*

L'impromptu de Versailles (Versailles Impromptu): Homage to Violette Nozières, who poisoned her incestuous father
——*René Magritte, in* Violette Nozières, *Brussels: Éditions Nicolas Flamel, 1933*

L'impromptu de Versailles

63. *L'impromptu de Versailles (Versailles Impromptu).* Illustration for *Violette Nozières,* Brussels: Édition Nicolas Flamel, 1933

Psychoanalysis

64. Letter from René Magritte (written in London) to Louis Scutenaire and Irène Hamoir, March 12, 1937

65. *Le modèle rouge (The Red Model)*. c. 1935. Pencil drawing, 12⅜ x 9″ (31.5 x 23 cm). Collection Melvin Jacobs, New York, New York

66. *Le modèle rouge (The Red Model)*. 1935. Oil on canvas, 22 x 18″ (55.9 x 45.8 cm). Musée National d'Art Moderne, Centre National d'Art et Culture Georges Pompidou, Paris, France

12th March, 1937.

Dear Friends,

I am, at the moment, seated before my coffee, and Mrs. Paige is in front of me, and in front of Mrs. Paige is a typewriter. Before commencing the letter, we have verified the date on the calendar. At last, speaking of serious things, yesterday the young Matta brought me to the home of two psychoanalysts but let us not speak too quickly, it is necessary to put things clearly.

First, Matta is a young man who comes from South America. I think he has a little Indian blood in his veins. He does painttings which are a thousand times better than those of Miro. He has many ideas. He received a religious education and he lives in a flat in a white house. That for Matta!

Second, Dr. Matté is also a young South American. At first he was a surgeon, but then he became interested in the work of our friend, Freud. He also lives in a flat, only iit is in a street where all the doctors live. At the moment he treats young boys of five years and his treatment consists in painting with these young boys. It seems that the brushes represent the sexes (masculine) for the boys. This young doctor is very much interested evidently (that goes without saying) by sur-realism.

Third, Dr. Vits is a man of about 50 years of age, andhe has no hair. He finds Brussels very erotic but London not the least so (according to Mrs. Paige New York is in this respect like London). He left Germany for the reason that Hitler is making thought impossible in Germany. Obviously, he is a doctor who treats fatal diseases. On the whole, he is sympathetic.

Now you know with whom I passed yesterday evening. They questioned me on the subject of my painting and they now understand the interpretations of my paintings. Thus, they think my picture, "The Red Model" is a case of castration. You will see from this how it is all becoming very simple. Also, after several interpretations of thiskind, I made them a real psychoanalytical drawing (you know what I mean):'canon bibital' etc. Of course, they analyzed these pictures with the same coldness. Just between ourselves, its terrifying to see what one is exposed to in making an innocent picture.

I received the account of your journey . It seemed to me a little complicated, but as I am a good boy, I do not mind.

I want you to do whatever you can to make my absence less distressing to my wife, I thank you in advance and I send you my regards 'bibitals'.

Magritte

The problem of shoes demonstrates how the most frightening things can, through inattention, become completely innocuous. Thanks to *Le modèle rouge (The Red Model),* we realize that the union of a human foot and a shoe is actually a monstrous custom.
——*René Magritte, La Ligne de Vie, lecture, November 20, 1938*

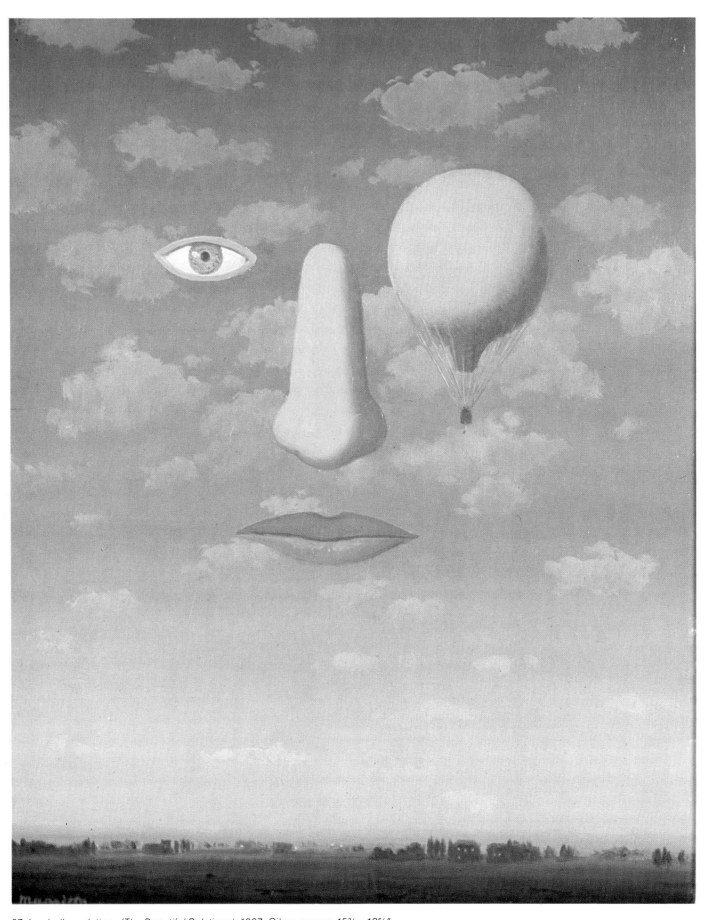

67. *Les belles relations (The Beautiful Relations)*. 1967. Oil on canvas, 15¾ x 12⅝"
(40 x 32 cm). Collection M. and Mme. Pierre Scheidweiler, Brussels, Belgium

68. Study for *La durée poignardée (Time Transfixed)*. 1935. Pencil drawing, 11¾ x 9⅞" (30 x 25 cm). Private collection, Brussels, Belgium

69. *La durée poignardée (Time Transfixed)*. 1939. Oil on canvas, 57½ x 38¾" (146 x 98.5 cm). The Art Institute of Chicago, Chicago, Illinois

I apologize for the delay in answering your letter of April 25th, although it wasn't my fault. I had to wait for a translation of what you wrote in English.

The question you ask concerning the conception of the painting *La durée poignardée (Time Transfixed* doesn't seem to be a very accurate translation) can be given an exact answer insofar as *what I was thinking of*. As for trying to explain *why* I thought of painting the image of a locomotive and *why* I was convinced this painting should

be executed, I cannot know nor do I wish to know. Even the most ingenious psychological explanations would have validity only with regard to a "possible" interest in an understanding of an intellectual activity that posits relationships between what is thought and what has nothing to do with thought. Thus, I decided to paint the image of a locomotive. Starting from that possibility, the problem presented itself as follows: how to paint this image so that it would evoke mystery—that is, the mystery to which we are forbidden to give a meaning, lest we utter naïve or scientific absurdities; mystery *that has no meaning* but that must not be confused with the "non-sense" that madmen who are trying hard to be funny find so gratifying.

The image of a locomotive is *immediately* familiar; its mystery is not perceived.

In order for its mystery to be evoked, another *immediately* familiar image without mystery—the image of a dining room fireplace—was joined with the image of the locomotive (thus I did not join a familiar image with a so-called mysterious image such as a Martian, an angel, a dragon, or some other creature erroneously thought of as "mysterious." In fact, there are neither *mysterious* nor unmysterious creatures. The power of thought is demonstrated by unveiling or evoking the mystery in creatures that seem familiar to us [out of error or habit]).

I thought of joining the locomotive image with the image of a dining room fireplace in a moment of "presence of mind." By that I mean the moment of lucidity *that no method can bring forth*. Only the power of thought manifests itself at this time. We can be proud of this power, feel proud or excited that it exists. Nonetheless, we do not count for anything, but are limited to witnessing the manifestation of thought. When I say "I thought of joining, etc., . . ." exactitude demands that I say "presence of mind exerted itself and showed me how the image of a locomotive should be shown so that this presence of mind would be apparent." Archimedes' "Eureka!" is an example of the mind's unpredictable presence.

The word *idea* is not the most *precise* designation for what I thought when I united a locomotive and a fireplace. *I didn't have an idea;* I only thought of an *image*.

The power of thought or "presence of mind" manifests itself in different ways:

—For the painter, thought becomes manifest in *images* (for the exacting painter, and not the painter who has "ideas" or who "expresses" his "sublime" emotions).

—For Bergson, thought manifests itself in *ideas*.

—For Proust, it manifests itself in *words*.

I am very exacting, and in conceiving a painting I avoid "ideas" or "expressing emotions." Only an image can satisfy these demands.

La durée poignardée is only an image. Because of that it testifies to the power of thought—to a certain extent. While looking at this painting, you think of Bergson and Proust. That does me honor and demonstrates that an image *limited strictly to its character as an image* proves the power of thought just as much as Bergson's *ideas*

or Proust's *words*. *After* the image has been painted, we can think of the relation it may bear to ideas or words. This is not improper, since images, ideas, and words are *different* interpretations of the *same* thing: thought.

However, in order to state what is *truly necessary* about an image, one must refer exclusively to that image.

This is what I have tried to write to you—clumsily, and in French, which I fear will be much less clear than if I had been able to put it into English for you.

In any case, I hope you will not doubt my good-will to answer you as well as possible.

Very cordially,
René Magritte

P.S.—The title *La durée poignardée* is itself an image (in words) joined to a painted image.

The word *durée* was chosen for its poetic truth—a truth gained from the union of this word with the painted image—and not for a generalized philosophical sense or a Bergsonian sense in particular.

NOTE:

I think the following points should be clear:

1. Psychological theories "explain" nothing. They are possible *thanks to thought.* They give expression to thought—*but they do not make thought possible.* Thought exists without psychology. It is thought that illuminates what it sees: ideas, images, emotions, sensations, and psychology!—not vice versa.

2. "Presence of mind" (or the power of manifest thought) can be found in Bergson, in Proust, in other men.

Hegel, for one, experienced this presence of mind. But, in his old age, when he found the sight of the starry sky banal, *which is true* (along with the sight of a locomotive), he overlooked as a philosopher the fact that the starry sky imitated in an image would no longer be banal if this image were to evoke mystery, thanks to the lucidity of a painter who could paint the banal image of the starry sky in such a way that it appeared in all its evocative force.

Hegel saw only a "given" image, without the intervention of thought. I believe Hegel only gave validity to the manifestation of thought *through ideas.* He might perhaps have allowed himself to be distracted while looking at images; it might have been a kind of vacation for him. Would my picture entitled *Les vacances de Hegel (Hegel's Holiday)* have amused Hegel? Would another, older picture, *Le travail caché (The Hidden Work),* perhaps have "taught" him that images are as valid as ideas? This painting actually shows the trite spectacle of a starry sky . . . (The stars spell out the word *DESIRE.)*

Philosophers attempt to concern themselves with art. But so far as I know, none of them tell us about what is *inside* art.

When will the philosopher construct a system that powerfully conveys mystery? (Although philosophers make brilliant *attempts* at theories about mystery.)

——*Letter from René Magritte to Hornik, May 8, 1959, in André Bosmans archive*

70. *Le dormeur téméraire (The Reckless Sleeper).* 1927. Oil on canvas, 43¼ x 33½" (110 x 85 cm). The Tate Gallery, London, England

71. *Paysage (Landscape).* 1926. Oil on canvas, 39⅜ x 28⅜" (100 x 72 cm). Private collection, Brussels, Belgium

[Here's] something pretty amusing: On a television program, a doctor was telling how the art of lunatics differed from that of the Surrealists. He commented on a patient's drawing and later regretted his words. He was interpreting it (according to the sacrosanct habit of seeing everything as a symbol), and in his scientific ardor he forgot scientific discretion to such an extent that he said, "And this is a symbol of the female sex organ, *with all its disgusting attributes.*" He realized after it was too late that he had expressed his own opinion rather than that of the author of the drawing, and that maybe he would be mistaken for a homosexual. Even if one could have corrected the tape, the imprudent psychiatrist must have been made keenly aware of the dangers inherent in interpretation.
——*Letter from René Magritte to Harry Torczyner, August 18, 1961*

Psychoanalysis only allows interpretation of that which lends itself to interpretation. Fantastic Art and Symbolic Art present it with numerous occasions for intervention. With respect to these Arts, there is often the question of more or less apparent delirium.

Art, as I conceive it, is resistant to psychoanalysis. It evokes the mystery without which the world would not exist, that is, the mystery one should not mistake for some sort of a problem, however difficult.

I see to it that I paint only images that evoke the world's mystery. To make this possible, I have to be wide-awake, which means I have to cease to identify myself completely with ideas, sentiments, and sensations. (Dreams and madness, on the contrary, are propitious to absolute identification.)

Nobody in his right mind believes that psychoanalysis could elucidate the mystery of the universe. The very nature of the mystery annihilates curiosity. Nor has psychoanalysis anything to say about works of art that evoke the mystery of the universe. Perhaps psychoanalysis is the best subject to be treated by psychoanalysis.
——*Statement by René Magritte (Brussels), May 21, 1962, in* The Vision of René Magritte, *exhibition catalogue, Walker Art Center, Minneapolis, Minnesota, September 16–October 14, 1962.*

. . . the Surrealists' taste for dream narratives is of no interest to me. Maybe the judgment that "my paintings are dreams" contributes to my indifference. I never put any stock in this judgment. I don't mean to say that dreams aren't interesting to doctors; that is their business (like penicillin).
——*Letter from René Magritte to André Bosmans, May 8, 1962*

The title is *Gradiva* (even if I mistakenly put *Gravida,* as you spell it). *Gradiva* is a novel by . . .! forget the name, with an analysis by Freud. I'd also forgotten I had given the drawing a title. Maybe that would be significant to a Freudian specialist.*
——*Letter from René Magritte to Harry Torczyner, October 29, 1965*

*Magritte is referring to *Gravida* (a pregnant woman), as distinguished from *Gradiva,* the title of a story by Wilhelm Jensen, which was the subject of Freud's first psychoanalytic study of a literary work, *Illusions and Dreams in Jensen's "Gradiva."*

72. *Personnage méditant sur la folie (Person Meditating on Madness).* 1928. Oil on canvas, 21¼ x 28¾" (54 x 73 cm). Collection M. and Mme. Louis Scutenaire, Brussels, Belgium

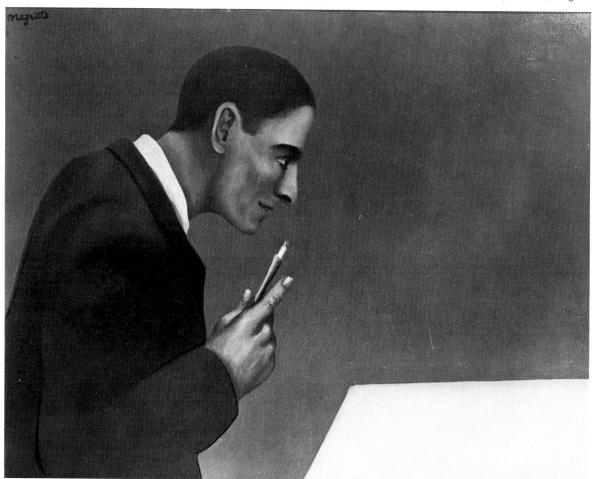

Sciences

Poets were able to enjoy Jules Verne's *Journey to the Moon,* and they will pay no attention to such a voyage as is presently being planned by serious people, generals, journalists, financiers, etc. . . .
——*Letter from René Magritte to André Bosmans, January 10, 1958*

I am, of course, unable to appreciate science, not being a scientist. That doesn't imply contempt for it, merely lack of interest. It seems to me that skepticism consists not only in withholding judgments, but above all in avoiding error and consequently in thinking of truth as something inaccessible (which is already an infidelity to skepticism, since truth is what is being judged).

It happens that scientific conquests and the more or less precise goals of scientific endeavor don't interest me at all. As for the value of science and its capabilities, I am maintaining a spontaneous "scientific" discretion, which may be uninformed, but which is nevertheless final.

I believe everything is always possible, but there is only mediocrity in anything one might desire of the possible. For example, it's possible that one day we may see a squared circle or live centaurs. In what way can hope for a particular possibility force us to esteem some science that may enable us to realize those possibilities?
——*Letter from René Magritte to Maurice Rapin, May 7, 1958*

The "illustration" of the themes of science, scientific research, mankind can to my mind be nothing more than a joke (albeit an innocent one). I painted an image entitled *La présence d'esprit (Presence of Mind),* which exactly fit (without "illustrating") the ideas and emotions relevant to the varied possibilities of the theme. Thus, the painting *La présence d'esprit* shows the sky, earth, a bird, a man, and a fish—in other words, all aspects of the world with which science is concerned (it researches what they are, at least for the science-minded). This image, *La présence d'esprit,* does not prejudge what they represent for the scientifically inclined, nor for those subject to any discipline whatsoever: commercial, political, military, or anything else. It shows aspects of the world with which all kinds of people are concerned, including scientists, in their own way. If we accept this [proposition], I believe we can hold that these aspects of the world interest mankind in general. . . .

The "idea" of mankind . . . can in turn be "presented" in the painting due to the fact that a man depicted in it "symbolizes" the "unity of man." Furthermore, the picture is called *La présence d'esprit*—that which is absolutely indispensable to any program that is to encompass "science, scientific research, and mankind."
——*Letter from René Magritte to Harry Torczyner, July 1960*

73. *La présence d'esprit (Presence of Mind).* 1960. Oil on canvas, 45⅝ x 35″ (116 x 89 cm). Collection Pirlet, Cologne, Germany

74. Study for *La présence d'esprit (Presence of Mind).* 1960. Drawing, 5⅞ x 4½″ (15 x 11.5 cm). Private collection, New York, New York

75. *Un peu de l'âme des bandits (A Little of the Bandits' Soul)*.
1960. Oil on canvas, 25½ x 19¾" (65 x 50 cm). Location unknown

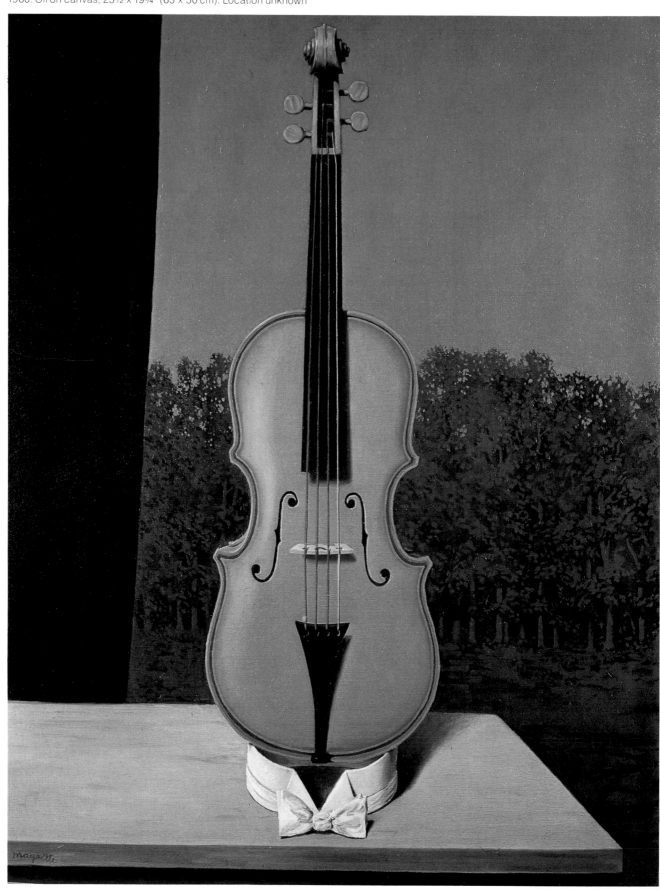

BY MYSTERY POSSESSED

"The visible presented by the world is rich enough to constitute a language evocative of mystery," Magritte told us. The division of the painting; the painting within the painting; the dismemberment of the image; the use of words; the juxtaposition of unrelated objects set in the sky, on the ocean, or on earth—all these inventions of his mind had no purpose other than to mark out and to make remarked this empire, possessed by mystery. It is this ultimate confrontation with mystery that Magritte's work forces upon us, whence its power and its spell.

He was concerned with the problems of similarity and of resemblance; finding for them a simple and perfect solution gave him intellectual pleasure. "Peas share a relationship of similarity...only thought has resemblance," he wrote to Michel Foucault. In fact, analogy and *rapprochement* are mental operations. In his variations on one of his best-known themes, *L'empire des lumières (The Empire of Lights),* Magritte gives us a precious example of these inspired games. From the time he discovered his path and adopted his particular gait, he never again deviated from his pictorial style. One can say that his other modes of expression—Cubist, Impressionist, and Fauvist (which lasted only for a moment, the moment of the exhibition "The Black Period")—are merely interludes in his life as a deliberate magician.

Magritte never hesitated to represent the human figure as an object, but he was not attracted by the self-portrait or portrait. He did not like using a mirror to reflect either his person or his personality. Nevertheless, out of friendship he consented to paint a few portraits of friends, thereby giving them the satisfaction of observing themselves in a false mirror.

Mystery—without which no world, no thought, would be possible—corresponds to no doctrine, and does not deal with possibilities. Thus, a question such as "How is mystery possible?" is meaningless because mystery can be evoked only if we know that any possible question is relative only to what is possible.

Some mediocre or absurd things do not really cast doubt on the concept of mystery; nothing beautiful or grandiose can affect it. Judgment as to what is, was, or will be possible does not enter into the concept of mystery. Whatever its manifest nature may be, every object is mysterious: the apparent and the hidden, knowledge and ignorance, life and death, day and night. The attention we give to the mystery in everything is deemed sterile only if we overlook the higher sensibility that accompanies that attention, and if we grant a supreme value to what is possible. This higher sensibility is not possible without freedom from what we call "the laws of the possible."

Freedom of thought alert to mystery is always possible if not actually present, whatever the nature of the possible: atrocious or attractive, mean or marvelous. It has power to evoke mystery with effective force.
——*René Magritte, "La Voix du Mystère,"* Rhétorique, no. 4, January 1962, p. 1

Resemblance—which can be made visible through painting—only deals with figures as they appear in the world: people, curtains, weapons, stars, solids, inscriptions, etc. . . . spontaneously united in the order wherein the familiar and the strange are restored to mystery.

What one must paint is the image of resemblance—if thought is to become visible in the world.
——*René Magritte, catalogue of the Magritte exhibition,* Paris, Galerie Rive Droite, 1960

MAGIC CATALOGUE

Naming Things

76. Notes for an illustrated lecture given by René Magritte at Marlborough Fine Art (London) Ltd., February 1937; published in facsimile in the catalogue of the exhibition *Magritte* held at Marlborough Fine Art (London), October–November 1973, pp. 21–23. *See Appendix for translation*

Mesdames et Messieurs,

La démonstration que nous allons faire ensemble tendra à montrer quelques caractères propres aux mots, aux images et aux objets réels.

(1) Un mot peut remplacer une image:

 Chapeau HAT.

(2) Une image peut remplacer un mot. Je vais le démontrer en me servant d'un texte d'André Breton où je remplace un mot par une image:

 Si seulement IF ONLY THE SUN WOULD SHINE TONIGHT.

[de Jean Scutenaire] On ne peut pas ONE CANNOT GIVE BIRTH TO A FOAL
 WITHOUT BEING ONE ONESELF.

 de Paul Eluard:
 Dans les plus sombres yeux se ferment les plus clairs.
 THE DARKEST EYES ENCLOSE THE LIGHTEST.

[de Paul Colinet] Il y a THERE IS A SPHERE PLACED ON YOUR
 SHOULDERS.

 de David Gascoigne

[de Mesens] Masque de veuve WIDOW'S MASK FOR THE WALTZ.

 de Humfrey Jennigs THE FLYING
 OF EDUCATION

- 2 -

(3) Un objet peut remplacer un mot:
 Le pain du crime. THE BREAD OF CRIME.

(4) Une forme quelconque peut remplacer un mot

 Les naissent THE ARE BORN IN WINTER.

(5) Un mot peut faire l'office d'un objet:
 Ce bouquet THIS BOUQUET IS TRANSPARENT

(6) On peut désigner une image ou un objet par un autre nom que le sien:

L'oiseau O THE BIRD
La montagne THE MOUNTAIN
Voici le ciel BEHOLD THE SKY (skaie)

(7) Il existe une affinité secrète entre certaines images. Elle vaut également pour les objets représentés par ces images. Recherchons ensemble ce qui doit être dit. Nous connaissons l'oiseau dans une cage. L'intérêt est éveillé davantage si l'oiseau est remplacé par un poisson ou un soulier.

 Ces images sont curieuses. Malheureusement elles sont arbitraires et accidentelles.

- 3 -

Il est possible pourtant d'obtenir une image nouvelle qui résistera mieux à l'examen du spectateur. Un grand oeuf dans la cage parait être la solution requise.

Occupons nous maintenant de la porte. La porte peut s'ouvrir sur un paysage vu à l'envers.

Le paysage peut être représenté sur la porte.

Essayons quelque chose de moins arbitraire: à côté de la porte faisons un trou dans le mur qui est un autre porte aussi.

Cette rencontre sera perfectionnée si nous réduisons ces deux objets à un seul. Le trou se place donc tout naturellement dans la porte et par ce trou l'on voit l'obscurité.

Cette image pourrait de nouveau s'enrichir si l'on éclairant la chose invisible cachée par l'obscurité que l'obscurité nous cache. Notre regard veut toujours aller plus loin, veut voir enfin l'objet, la raison de notre existence.

Texte de la Demonstration faite par René Magritte, à Londres, à la London Gallery, le février 1937.

Un objet ne tient pas tellement à son nom qu'on ne puisse lui en trouver un autre qui lui convienne mieux :

Il y a des objets qui se passent de nom :

Un mot ne sert parfois qu'à se désigner soi-même :

Un objet rencontre son image, un objet rencontre son nom. Il arrive que l'image et le nom de cet objet se rencontrent :

Parfois le nom d'un objet tient lieu d'une image :

Un mot peut prendre la place d'un objet dans la réalité :

Une image peut prendre la place d'un mot dans une proposition :

Un objet fait supposer qu'il y en a d'autres derrière lui :

Tout tend à faire penser qu'il y a peu de relation entre un objet et ce qui le représente :

Les mots qui servent à désigner deux objets différents ne montrent pas ce qui peut séparer ces objets l'un de l'autre :

Dans un tableau, les mots sont de la même substance que les images :

On voit autrement les images et les mots dans un tableau :

Une forme quelconque peut remplacer l'image d'un objet :

Un objet ne fait jamais le même office que son nom ou que son image :

Or, les contours visibles des objets, dans la réalité, se touchent comme s'ils formaient une mosaïque :

Les figures vagues ont une signification aussi nécessaire, aussi parfaite que les précises :

Parfois, les noms écrits dans un tableau désignent des choses précises, et les images des choses vagues :

Ou bien le contraire :

René MAGRITTE.

77. *Les mots et les images (Words and Images).* Illustration in *La Révolution Surréaliste* (Paris), vol. 5, no. 12 (December 15, 1929), pp. 32–33. *See* Appendix *for translation*

Man/Object

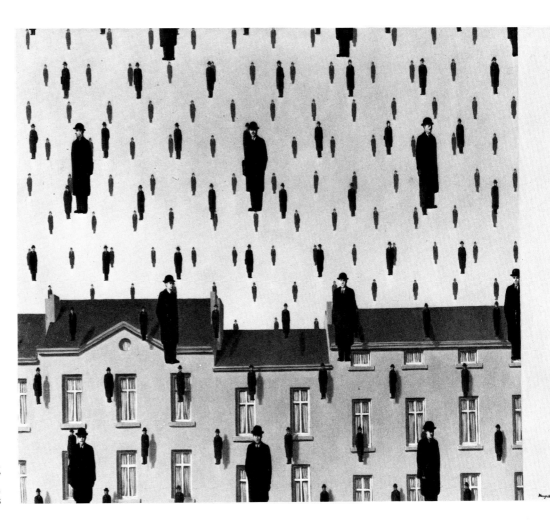

78. *Golconde (Golconda)*. 1953.
Oil on canvas, 31⅞ x 39⅜"
(81 x 100 cm). Private collection,
United States

79. *Le fils de l'homme (The Son of Man)*. 1964.
Oil on canvas, 45⅝ x 35" (116 x 89 cm). Collection
Harry Torczyner, New York, New York

80. *Décalcomanie (Decalcomania)*. 1966. Oil on
canvas, 37⅞ x 39⅜" (81 x 100 cm). Collection Mme.
Chaim Perelman, Brussels, Belgium.

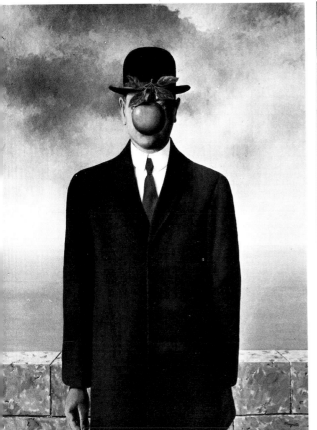

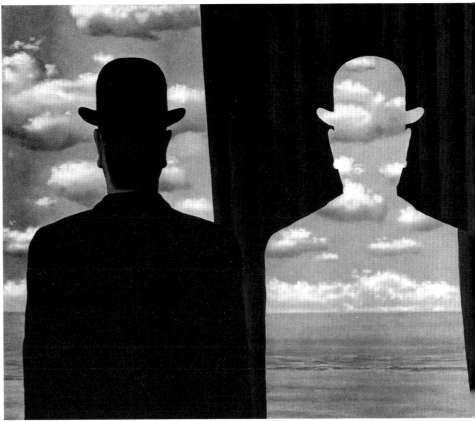

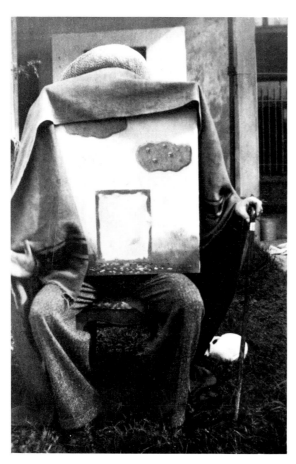

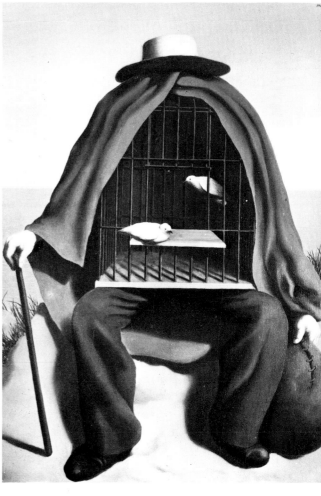

81. Photograph of René Magritte as *The Healer,* rue Essegham, Brussels, Belgium, 1937

82. *Le thérapeute (The Healer).* 1937. Oil on canvas, 36¼ x 25⅝" (92 x 65 cm). Collection Baron Joseph-Berthold Urvater, Paris, France

83. *Le thérapeute (The Healer).* n.d. Gouache, 18⅞ x 13⅝" (48 x 34.5 cm). Private collection, New York, New York

84. *Le libérateur (The Liberator).* 1947. Oi! on canvas, 39 x 31⅛" (99 x 79 cm). Los Angeles County Museum of Art, Los Angeles, California. Gift of William N. Copley

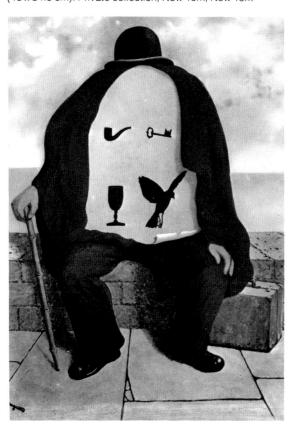

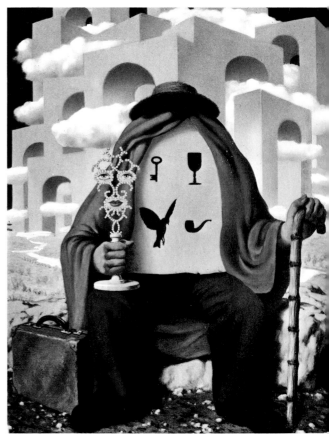

Pipe

"The famous pipe. How people reproached me for it! And yet, could you stuff my pipe? No, it's just a representation, is it not? So if I had written on my picture 'This is a pipe,' I'd have been lying!"
——*René Magritte, remarks reported by Claude Vial, "Ceci n'est pas René Magritte," Femmes d'Aujourd'hui, July 6, 1966, pp. 22–24*

Suggestion : Ce n'est pas un enfant mais un rat.

Fig. 289.

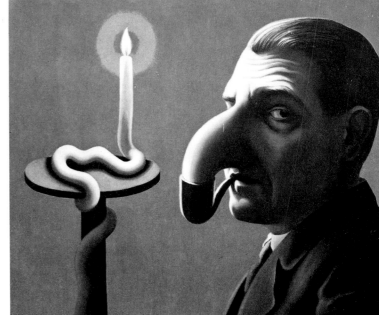

85. *Suggestion: Ce n'est pas un enfant mais un rat (Suggestion: This is Not a Child, But a Rat)*. Illustration in *La Nouvelle Médication Naturelle* by F. E. Bilz (edition translated from German), 1899, fig. 289

86. *La lampe philosophique (The Philosopher's Lamp)*. 1935. Oil on canvas, 23⅝ x 19⅝" (60 x 50 cm). Private collection, Brussels, Belgium

87. *Ceci n'est pas une pipe (This is Not a Pipe)*. 1928–1929. Oil on canvas, 23¼ x 31½" (59 x 80 cm). Collection William N. Copley, New York, New York

Ceci n'est pas une pipe.

Rose

According to the method that I think is exclusively my own, I have been looking for about two months for the solution to what I call "the problem of the rose." At the end of my search, I realize that I have probably known the answer to my question for a long time, but dimly, in the same way as everyone else. This knowledge, which is apparently organic and not conscious, has been there at the beginning of every search I've undertaken. The first sign I instinctively dashed off on paper when I decided to resolve the rose problems is this one:

and that oblique line diverging from the stem of the flower has required long, hard research for me to unravel its meaning. Of the many objects I imagined, I recall these:
the line is the pole of a green flag

88. *La boîte de Pandore (Pandora's Box).* 1951. Oil on canvas, 18¼ x 21⅝" (46.5 x 55 cm). Yale University Art Gallery, New Haven, Connecticut

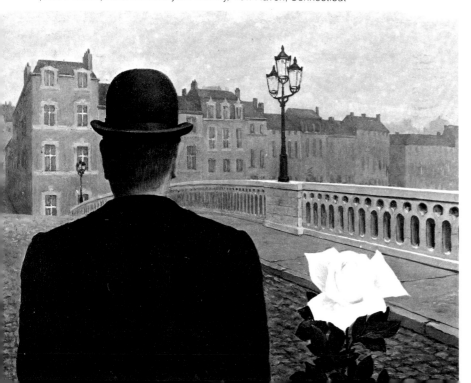

the line is a tower of a feudal castle

or an arrow:

finally, I hit on it: it was a dagger, and the rose problem was pictorially solved as follows:

Finally, after the search is concluded, it's easy to "explain" that the rose is perfumed air, but it is also cruelty, and reminds me of your "patricidal rose." I also recall this passage of forbidden images by Nougé: "We perceive the rose's faint perfume by means of a heartrending memory."
And a curious fact—in 1942 or 1943 I made a picture with the cover of the first volume of *Fantômas,* but replacing the murderer's bloody knife with a rose.
——*Letter from René Magritte to Paul Colinet, November 27, 1957*

The presence of the rose next to the stroller signifies that wherever man's destiny leads him he is always protected by an element of beauty. The painter hopes that this man is heading for the most sublime place in his life. The rose's vividness corresponds to its important role (element of beauty). The approach of nightfall suits withdrawal, and the bridge makes us think something will be overcome.
——*Letter from René Magritte to Mr. and Mrs. Barnet Hodes, undated, 1957*

Bell

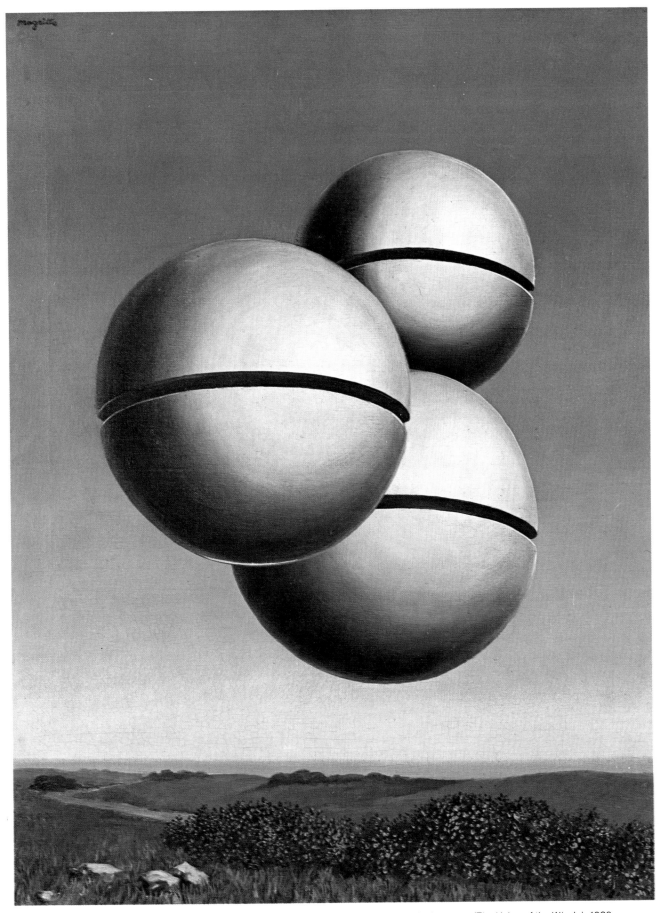

I'd prefer to believe that the iron bells hanging from our fine horses' necks grew there like poisonous plants on the edge of precipices.
——*René Magritte, "La Ligne de Vie,"* Combat, vol. 3, no. 105, December 10, 1938

89. *La voix des vents (The Voice of the Winds)*. 1928. Oil on canvas, 25⅝ x 19⅝" (65 x 50 cm). Private collection, United States

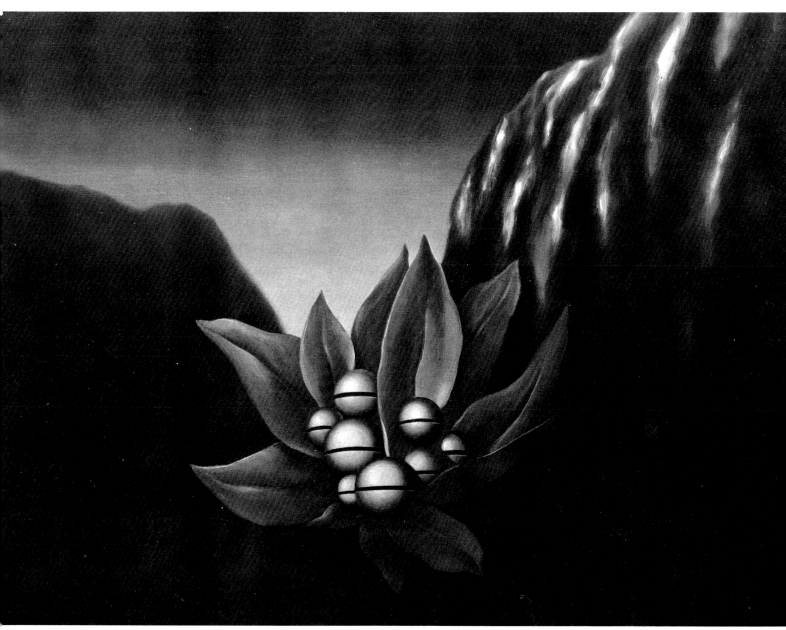

90. *Les fleurs de l'abîme I (Flowers of the Abyss I)*. 1928.
Oil on canvas, 21⅝ x 28¾″ (55 x 73 cm). Private collection,
New York, New York

91. *Grelots roses, ciels en lambeaux (Pink Bells, Tattered Skies)*. 1930. Oil
on canvas, 28¾ x 39⅜″ (72 x100 cm). Collection Baron Joseph-Berthold
Urvater, Paris, France

Room

Late-nineteenth-century authors are not devoid of charm: Lorrain's *Mr. de Baugrelon,* for example, is highly to be recommended. Once I called a picture *Le tombeau des lutteurs (The Tomb of the Wrestlers)* in memory of a book by Cladel* I read in my youth and that I've completely forgotten. I felt the title fit the idea of a huge red rose filling the space of a room.
——*Letter from René Magritte to André Bosmans, July 23, 1960*

le 19 Août 1950

Bien cher ami,

Je reçois votre lettre du 16 août et les documents "spéciaux". Je vous en remercie et vais me mettre en rapport avec les direction du Mayfair, dont le nom me semble avoir quelque chose de Hollandais.

J'apprends avec plaisir quel accueil "Le Tombeau des lutteurs" a reçu chez vous. La date 1944 confirme qu'à cette époque, la peinture que je concevais—en essayant de l'accorder à l'esprit de l'impressionnisme—n'était pas toujours (en 1954) accordée à cet esprit, "ma manière habituelle" était, parfois, au contraire, toujours là pour témoigner que j'y reviendrais définitivement. Des tableaux de 1944 ont en effet, tel que "Le Tombeau des lutteurs" été peints dans "ma manière habituelle", redevenue depuis exclusivement la seule qui me semble vraiment nécessaire pour peindre sans fantaisie ni originalité des idées suffisamment "sublimes" pour qu'elles doivent se passer d'autre chose que d'une description précise. Je crois fermement qu'une belle idée est déservie par une expression "intéressante" : l'intérêt étant pour l'idée. Celles qui ont besoin pour "passer", d'éloquence par exemple, sont incapables à valoir par elles-mêmes.

Ceci fait partie de mes convictions, qui sont la plupart du temps fort mises à l'épreuve, par les interprètes de tout poil qui veulent y mettre "du leur" en récitant des poèmes, en peignant des tableaux, etc.

J'attendrai, à présent, que vous soyez délivré des chaînes qui vous attachent à votre bureau et que vous puissiez envisager un petit tour en Belgique.

Bien à vous et à votre famille à qui ma sympathie est acquise spontanément.

René Magritte

92. Letter from René Magritte to Harry Torczyner, August 19, 1960. *See Appendix for translation*

75

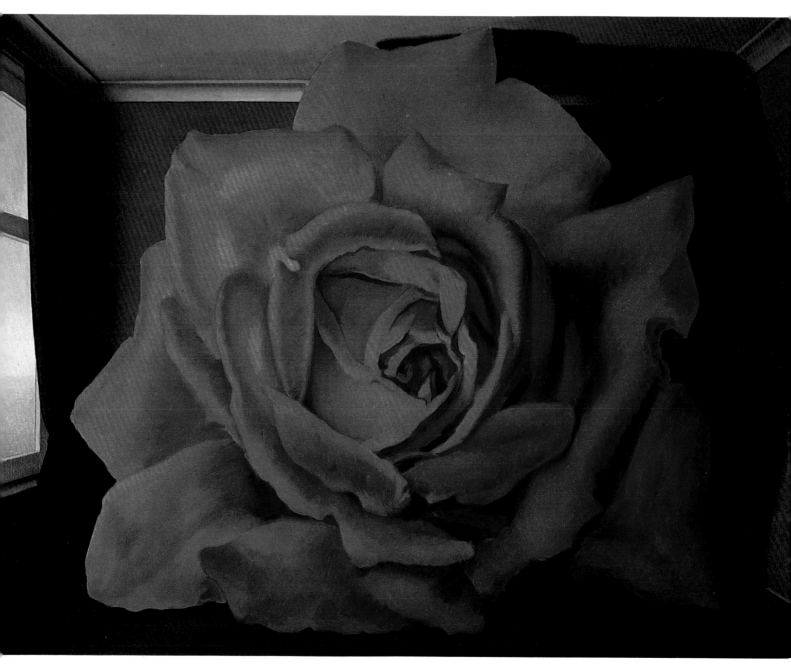

93. *Le tombeau des lutteurs (The Tomb of the Wrestlers)*.
1960. Oil on canvas, 35 x 46⅛″ (89 x 117 cm). Collection
Harry Torczyner, New York, New York

94. *Le tombeau des lutteurs (The Tomb of the Wrestlers)*.
n.d. Drawing, 3⅞ x 5½″ (10 x 14 cm). Private collection,
New York, New York

94

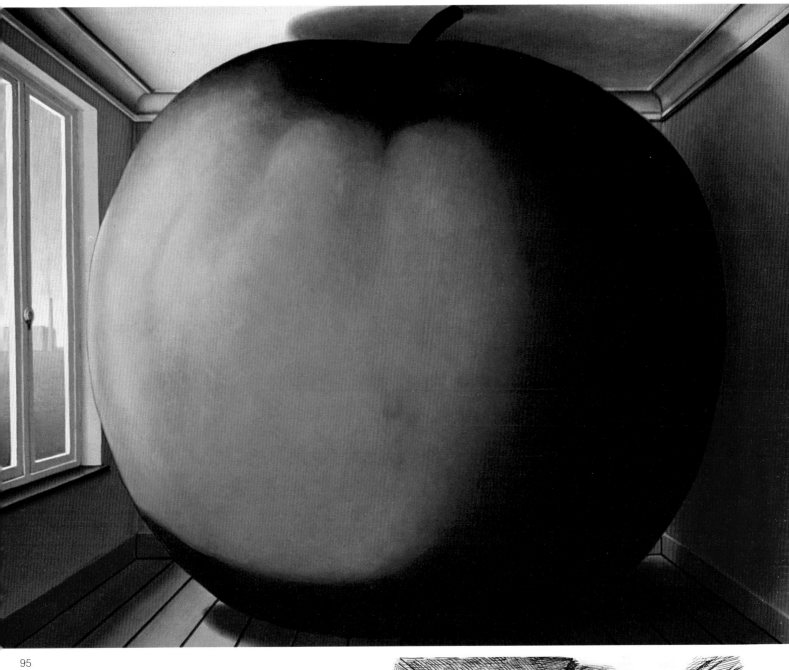

95

95. *La chambre d'écoute I (The Listening Room I)*. 1953.
Oil on canvas, 31½ x 39⅜″ (80 x 100 cm). Collection
William N. Copley, New York, New York

96. *La chambre d'écoute (The Listening Room)*. n.d.
Drawing. Private collection, United States

96

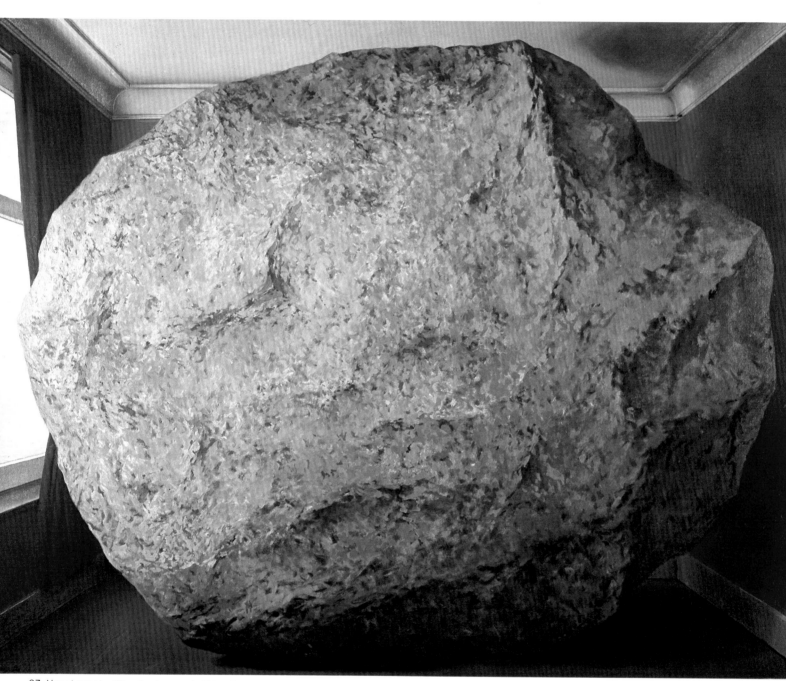

97. *L'anniversaire (The Anniversary)*. 1959. Oil on canvas, 35¼ x 45⅞″ (89.5 x 116.5 cm). Art Gallery of Ontario, Toronto, Canada

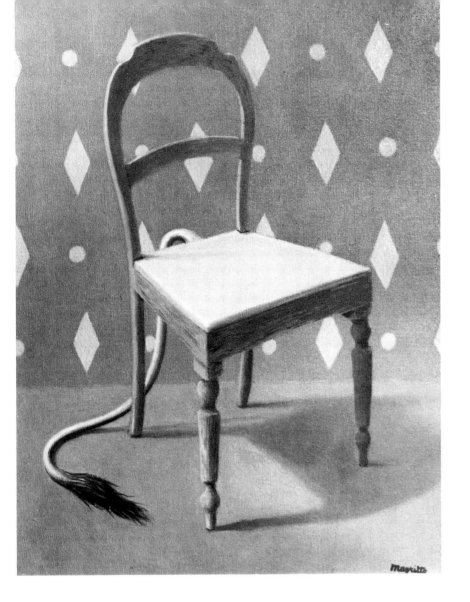

Chair

My current "problem" consists in wondering how to show a chair (as subject) in a painting, and in speaking to you specifically about chairs and mimosas. My question must be answered by discovering the thing, the object destined to be joined with a chair. (For the cage, it's an egg; for an umbrella, a glass of water; for a door, an opening one can pass through, etc.)
——*Letter from René Magritte to André Bosmans, July 23, 1958*

I'm happy with my chair, and with the title, which I feel fits it; it's called *Une simple histoire d'amour (A Simple Love Story)* (just to make it worse in the eyes of the comfortably "installed").
——*Letter from René Magritte to Harry Torczyner, September 20, 1958*

My chair with the tail appears in the film.* Some people comfortably "installed" (in chairs) have understood *Une simple histoire d'amour* in various ways, but they have all burst out laughing (astonishing to think that a chair could get such a rise out of people).
——*Letter from René Magritte to Harry Torczyner, September 1958*

*A motion picture made by Dr. Eugene Lepesckin, Burlington, Vermont.

98. *Une simple histoire d'amour (A Simple Love Story)*. 1958. Oil on canvas, 15¾ x 11¾" (40 x 30 cm). Galleria La Medusa, Rome, Italy

99. *Une simple histoire d'amour (A Simple Love Story)*. n.d. Gouache. Private collection, United States

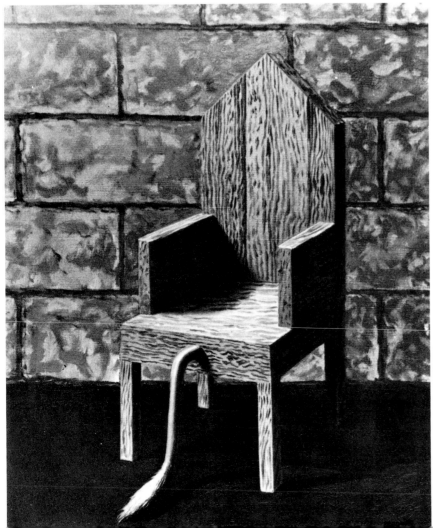

J'attends de vos nouvelles, comme nouvelles je ne vois rien de mieux que de vous faire connaître la solution trouvée à ce problème de peindre un tableau avec une chaise comme sujet. J'ai cherché longtemps avant de savoir que la chaise devait avoir une queue (qui est plus "parlante" que les timides pattes d'animaux qui servent parfois de pieds aux chaises) Je suis très satisfait de cette solution. Qu'en pensez vous?

100. Letter from René Magritte to Harry Torczyner, July 1958. *See* Appendix *for translation*

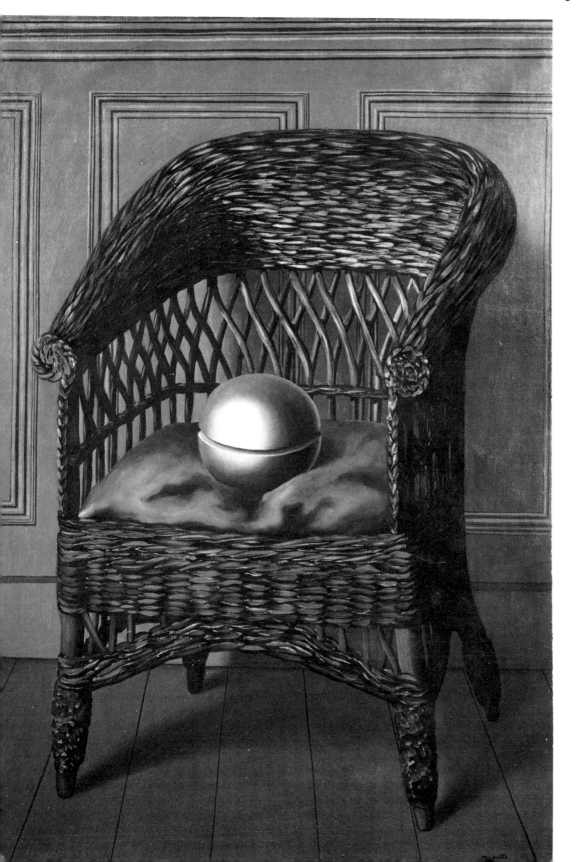

101. *L'automate (The Automaton).* 1928. Oil on canvas, 39⅜ x 31½" (100 x 80 cm). Moderna Museet, Stockholm, Sweden

Tree

102. *Campagne III (Countryside III).* 1927. Oil on canvas, 28⅞ x 21¼″ (73.5 x 54 cm). Galerie Isy Brachot, Brussels, Belgium

103. *Le dernier cri (The Last Scream).* 1967. Oil on canvas, 31½ x 25⅝″ (80 x 65 cm). Collection Dr. Jean Robert, Brussels, Belgium

104. *Passiflore (Passionflower).* 1936. Oil on canvas, 17¾ x 21⅝″ (45 x 55 cm). Collection M. and Mme. Louis Scutenaire, Brussels, Belgium

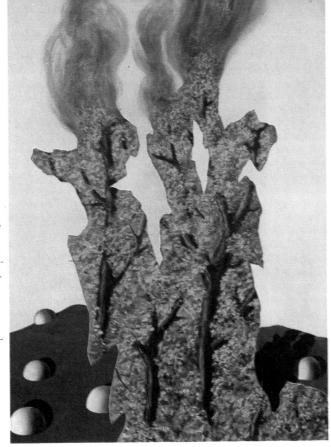

102

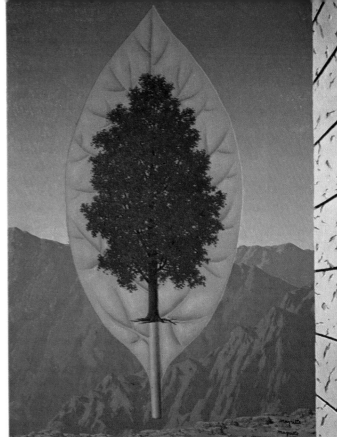

103

104

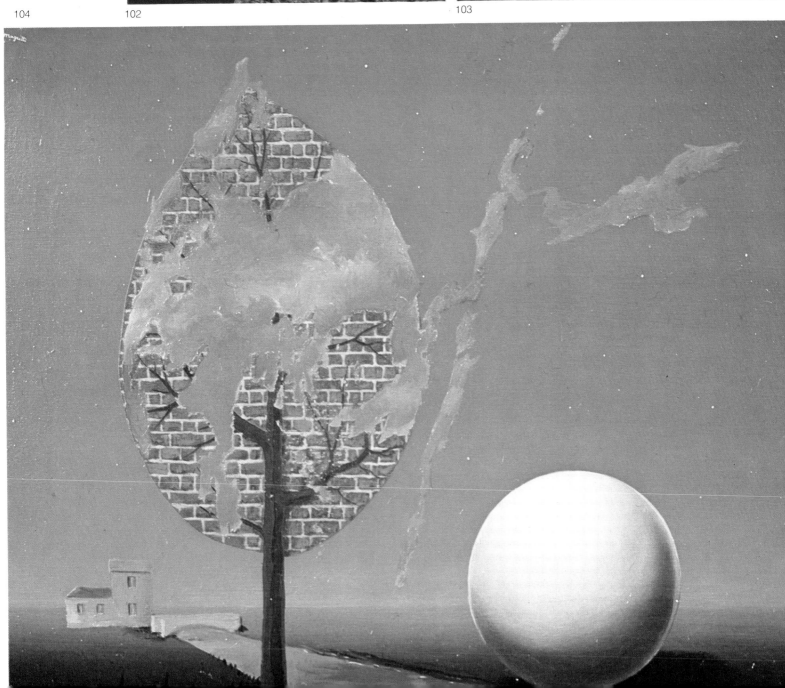

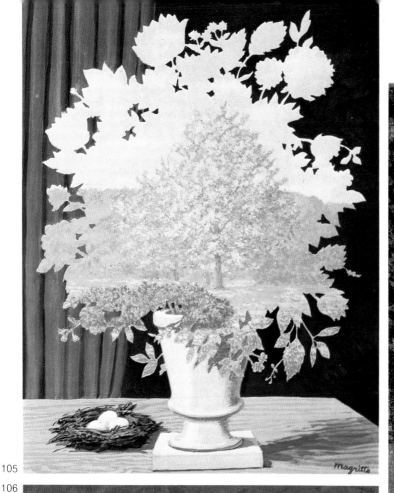

105

106

105. *Le plagiat (Plagiarism)*. 1960. Gouache, 12⅝ x 9⅞" (32 x 25 cm). Private collection, New York, New York

106. *Le pays des miracles (The Country of Marvels)*. c. 1960. Oil on canvas, 21⅝ x 18⅛" (55 x 46 cm). Private collection, Brussels, Belgium

107. *La voix du sang (The Call of Blood)*. 1961. Oil on canvas, 35⅜ x 39⅜" (90 x 110 cm). Private collection, Brussels, Belgium

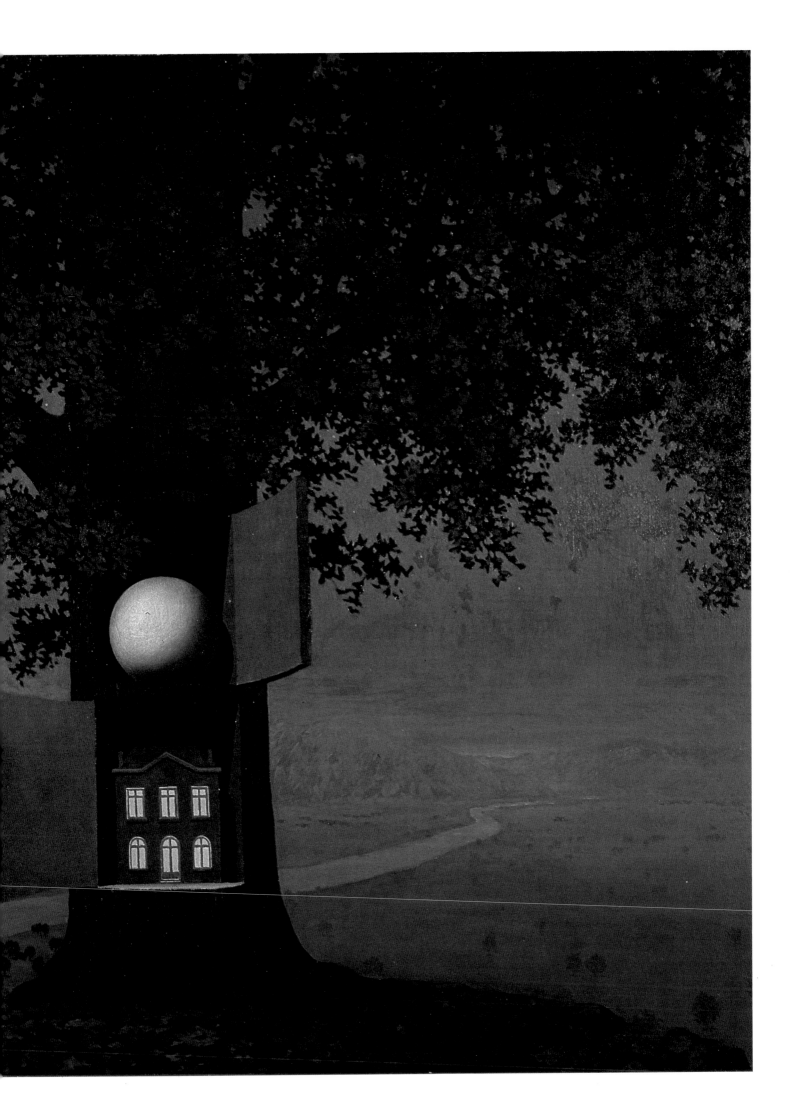

Cloud

108. *Le souvenir déterminant (The Deciding Memory)*. 1942. Oil on canvas, 25⅜ x 19⅞" (64.5 x 50.5 cm). Private collection, New York, New York

109. Untitled. 1964–1965. Engraving for *Aube à l'Antipode* by Alain Jouffroy, Édition Soleil Noir, 1966

110. *Les marches de l'été (The Progress of Summer)*. 1938. Oil on canvas, 23⅝ x 28¾" (60 x 73 cm). Private collection, Paris, France

108

109

110

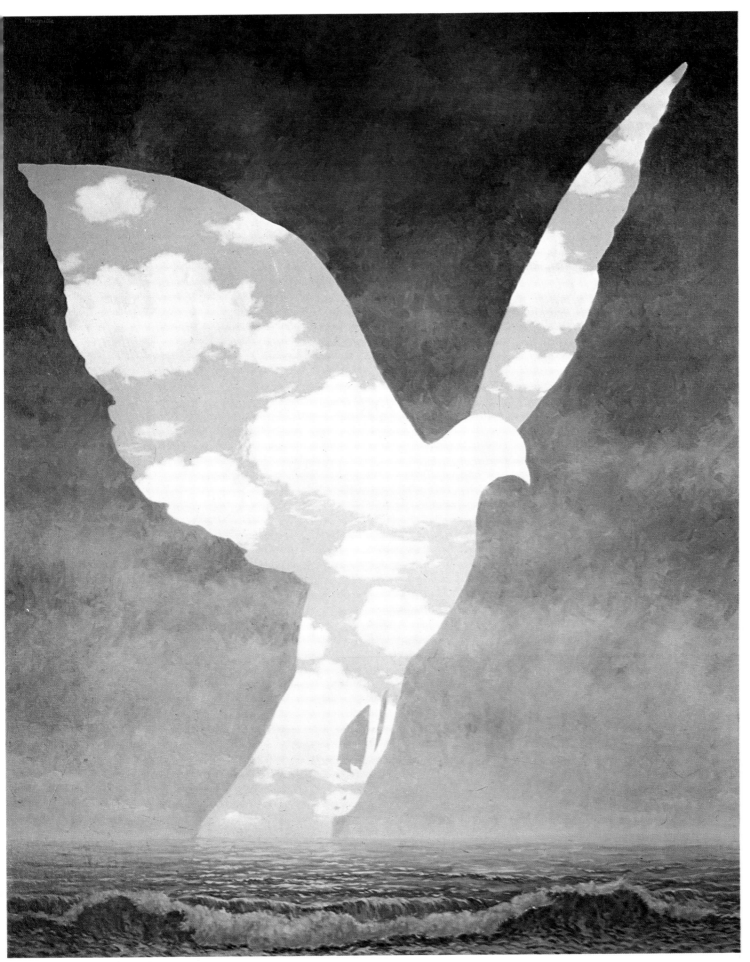

111. *La grande famille (The Large Family)*. 1947. Oil on canvas, 39⅜ x 31⅞"
(100 x 81 cm). Collection Nellens, Knokke-Le Zoute, Belgium

Bottle

112

113

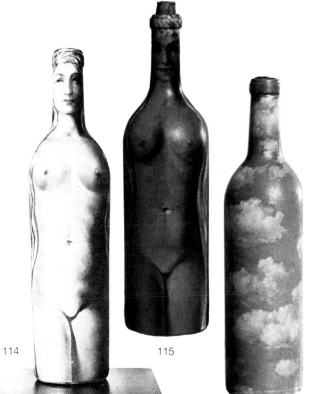

114 115 116

Curtain

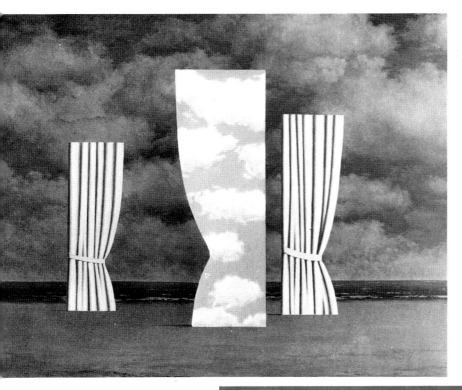

The work that I am thinking about painting . . . will be a combination of curtains, of which one will be painted as a sky, another as a fire, another as a forest, and another as a house. They will be placed against a dark background. *Les goûts et les couleurs (Tastes and Colors)* seems a good title for this painting, and in any case it's as good as the title for the painting of the tree and the leaves, which is now called—as you know—*L'arc de triomphe (The Arch of Triumph)*.
—Letter from René Magritte to André Bosmans, April 24, 1962

117. *L'ovation (The Ovation)*. 1962. Oil on canvas, 34⅝ x 45¼" (88 x 115 cm). Private collection, New York, New York

112. Painted bottle. n.d. Height 11⅜" (29 cm). Collection M. and Mme. Marcel Mabille, Rhode-St.-Genèse, Belgium

113. *L'explication (The Explanation)*. 1954. Oil on canvas, 31½ x 23⅝" (80 x 60 cm). Private collection, New York, New York

114. *La dame (The Lady)*. 1943. Painted bottle, height 12" (30.5 cm). Collection Hoursi Siva, New York, New York

115. *La dame (The Lady)*. n.d. Painted bottle, height 12⅝" (32 cm). Collection Mme. René Magritte, Brussels, Belgium

116. *Ciel (Sky)*. n.d. Painted bottle, height 11¾" (30 cm). Collection Mme. René Magritte, Brussels, Belgium

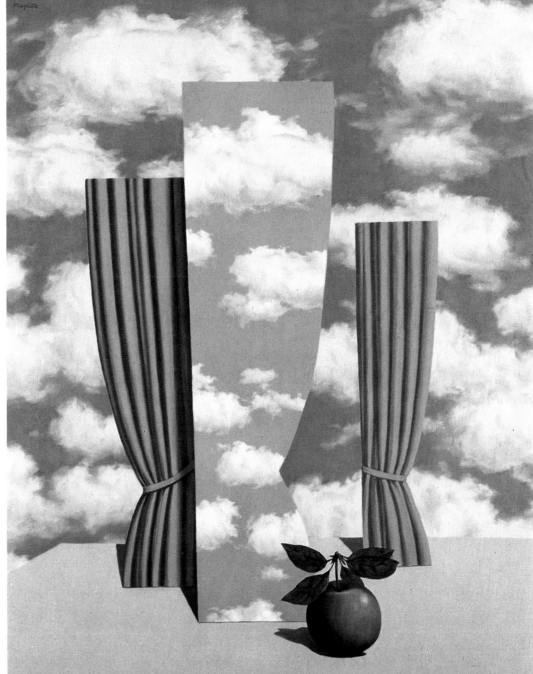

118. *Le beau monde (The Beautiful World)*. c. 1960. Oil on canvas, 39⅜ x 31⅞" (100 x 81 cm). Private collection, Brussels, Belgium

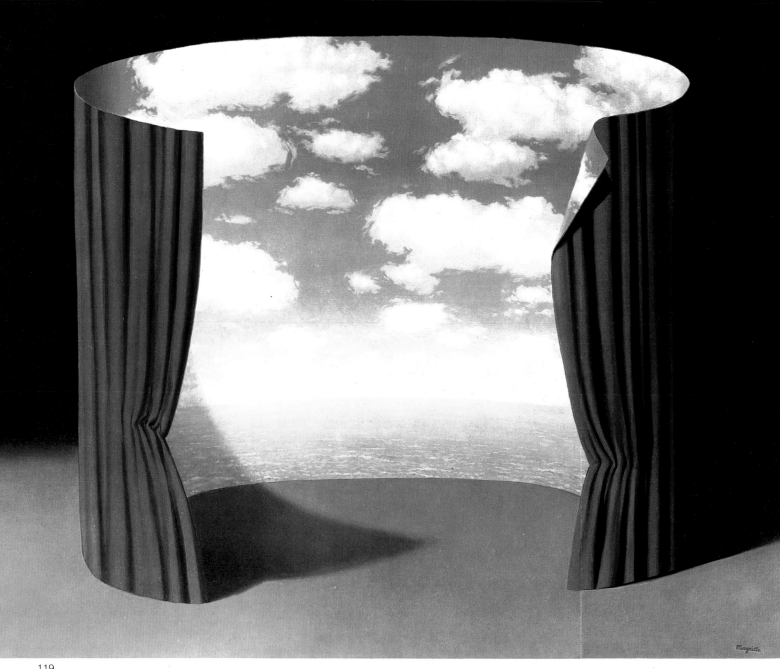

119

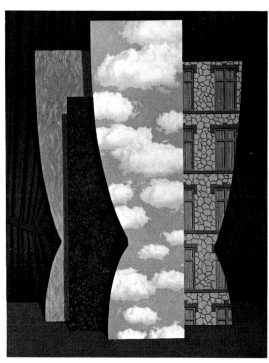

119. *Les mémoires d'un saint (The Memoirs of a Saint).* 1960. Oil on canvas, 31½ x 39⅜" (80 x 100 cm). Collection Menil Foundation, Houston, Texas

120. *Les goûts et les couleurs (Tastes and Colors).* 1962. Oil on canvas, 51⅛ x 38⅛" (130 x 97 cm). Private collection, Milan, Italy

121. *La peine perdue (Wasted Effort).* 1962. Oil on canvas, 39 x 31¼" (99 x 79.5 cm). Private collection, New York, New York

120

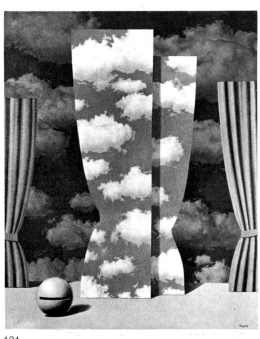

121

Sun/Moon

Je viens de peindre la lune sur un arbre dans les couleurs gris-bleu du soir. Suzanne a trouvé un très beau titre: "Le seize septembre". Je crois que "c'est bien",, donc qu'à partir du "16 Septembre" il n'y a rien à fonder.

122. Letter from René Magritte to Mirabelle Dors and Maurice Rapin, August 6, 1956. *See* Appendix *for translation*

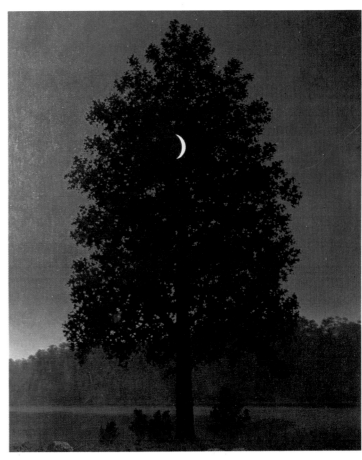

123. *Le seize septembre (September Sixteenth).* 1957. Oil on canvas, 63⅝ x 51⅛" (161.5 x 130 cm). Collection Menil Foundation, Houston, Texas

124. *Le banquet (The Banquet).* 1957. Oil on canvas, 19⅝ x 23⅝" (50 x 60 cm). Collection William Alexander, New York, New York

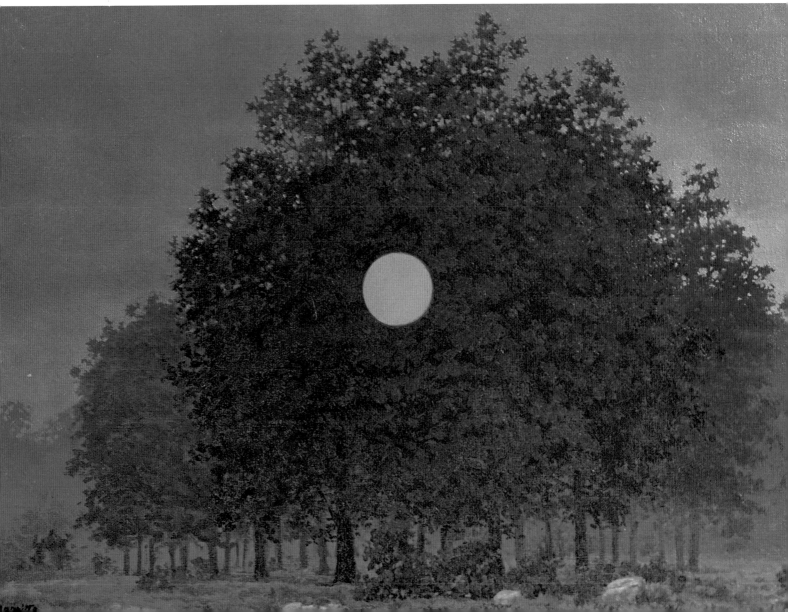

125

126

"Le Banquet"

127

125. *L'au-delà (The Beyond)*. 1938. Oil on canvas, 28⅜ x 19⅝" (72 x 50 cm). Private collection, Brussels, Belgium

126. *La voie royale (The Royal Road)*. 1944. Oil on canvas, 29½ x 18⅛" (75 x 46 cm). Private collection, Zurich, Switzerland

127. Study for *Le banquet (The Banquet)*. 7⅞ x 10¼" (20 x 26 cm). Collection Harry Torczyner, New York, New York

In answer to the sun, I have come up with: a tomb. There's a gravestone on the ground, and the sun lights the sky, earth, and tomb. This is today's answer and will perhaps be inadequate in the future. Actually, by taking the sun as the point of departure for the voyage we are making, by taking the sun as our origin, it isn't yet possible for us to envisage any ending for this voyage beyond death. This is a present certainty, and the picture's title, *L'au-delà (The Beyond)*, recreates an affective content for the term.
——*From a lecture by René Magritte, 1939*

After *La fée ignorante (The Ignorant Fairy)*, I've painted a picture in which one sees the moon hidden by a tree at night. Here in Brussels, they are felling trees on the boulevards and avenues (not forgetting to fell a lot of old houses that are now being replaced by horrid constructions). "Progress" has not yet "improved" Wilfingen, I believe; you're lucky!
——*Letter from René Magritte to E. Junger, June 5, 1956*

The subject that you asked about on Sunday, as to whether or not it had already attracted my attention, has become uppermost in researching the problem of the sun. It was death, indeed, so that it is not possible for fruitless doubts to arise. In passing, I point out to you that the truism "The sun shines for all" is coincidentally illustrated here.
——*Letter from René Magritte to Paul Colinet, Friday the 13th, 1957*

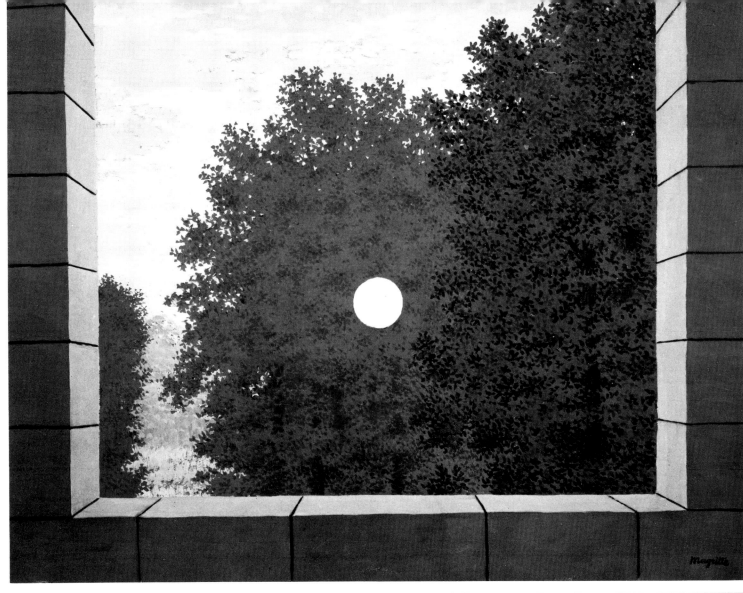

128. *Le banquet*
(The Banquet). 1956.
Gouache, 14⅛ x 18½″
(36 x 47 cm).
Private collection,
United States

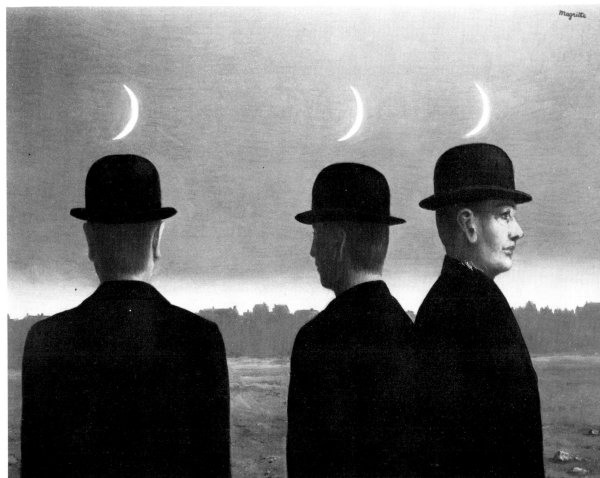

129. *Le chef d'oeuvre*
ou les mystères de
l'horizon (The Master-
piece or The Mysteries
of the Horizon). 1955.
Oil on canvas, 19½ x
25⅝″ (49.5 x 65 cm).
Collection Arnold
Weissberger,
New York, New York

Bain de vapeur en chaise nattée couché.

Fig. 523.

130

Flaming Object

La découverte du feu (The Discovery of Fire) allowed me the privilege of experiencing the same feeling that was felt by the first men who created flame by striking together two pieces of stone.

In turn, I imagined setting fire to a piece of paper, an egg, and a key.

——*René Magritte, La Ligne de Vie, lecture, November 20, 1938*

131

130. *Bain de vapeur en chaise nattée couché (Steam Bath Using Caned Chairs).* Illustration in *La Nouvelle Médication Naturelle* by F. E. Bilz (edition translated from German), 1899, vol. 2, p. 1777, fig. 523. Archives Pierre Alechinsky, Bougival,. France

131. *Les fanatiques (The Fanatics).* 1945. Oil on canvas, 23⅝ x 19⅝" (60 x 50 cm). Collection Nellens, Knokke-Le Zoute, Belgium

132. *L'échelle de feu (The Ladder of Fire).* 1933. Oil on canvas, 21¼ x 28⅞" (54 x 73.5 cm). Private collection, England

133. *L'échelle de feu (The Ladder of Fire).* 1939. Gouache, 10⅝ x 13⅜" (27 x 34 cm). Collection Edward James Foundation, Chichester, England

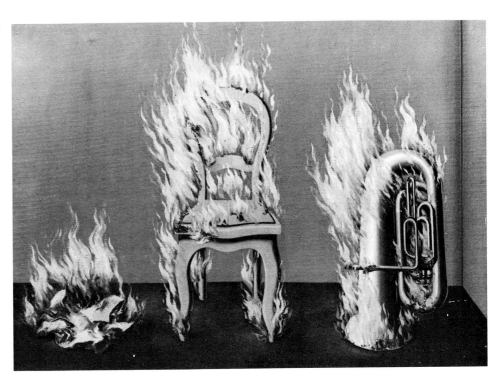

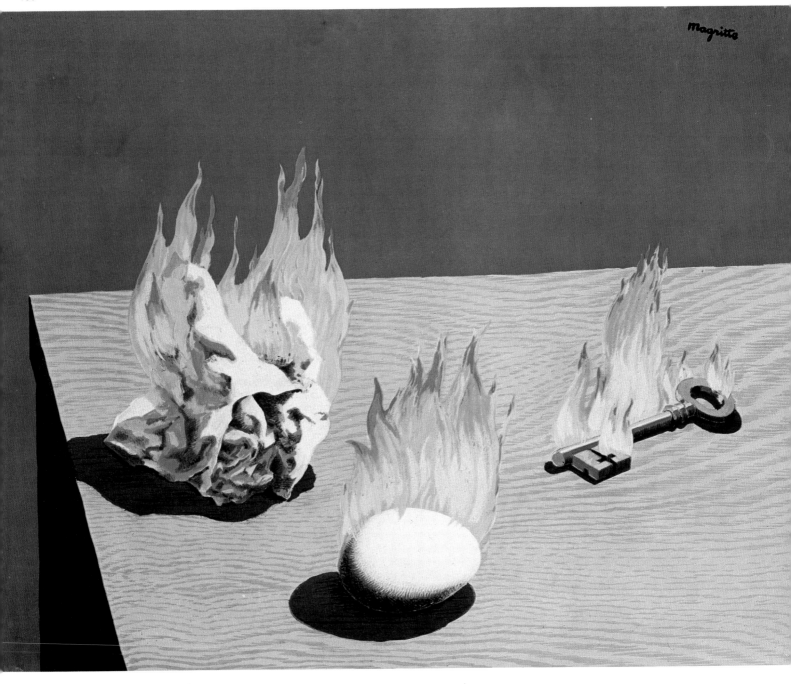

Word

134. *Les six éléments
(The Six Elements).*
1928. Oil on canvas,
28⅜ x 39⅜" (72 x 100
cm). Philadelphia
Museum of Art, Phila-
delphia, Pennsylvania.
Louise and Walter
Arensberg Collection

135. *Le palais des
rideaux (The Palace
of Curtains).* 1934. Oil
on canvas, 11 x 16½"
(28 x 42 cm). Collection
Pierre Alechinsky,
Bougival, France

136. *Les reflets du temps
(The Reflections of Time).*
1928. Oil on canvas
remounted on cardboard,
22½ x 30¼" (57 x 76.5 cm).
Collection Dr. Robert Mathijs,
Brussels, Belgium

136

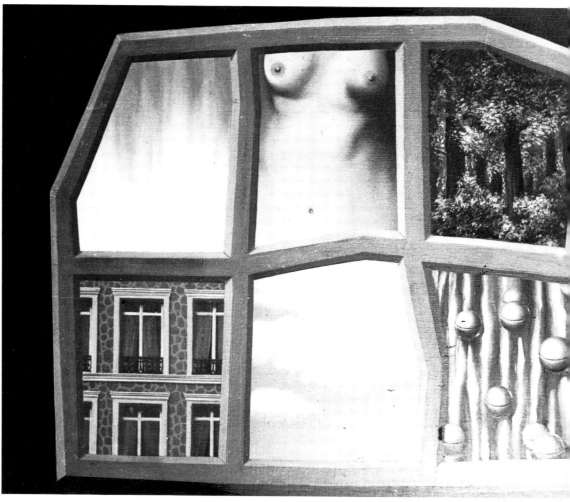

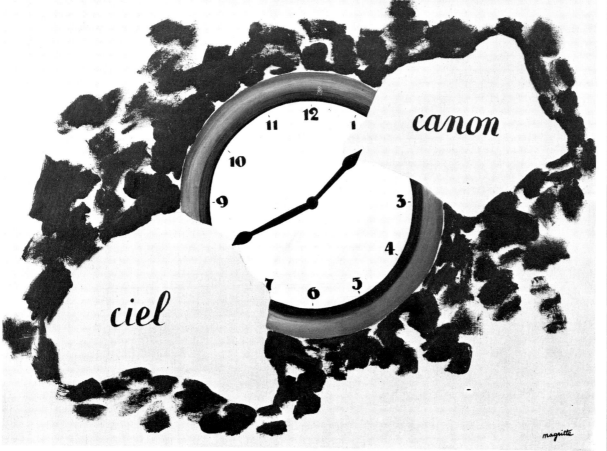

137. *Le sens propre (The Proper Meaning).* 1928–1929. Oil on canvas, 28¾ x 21¼"
(73 x 54 cm). Collection Robert Rauschenberg, New York, New York

138. *Le masque vide (The Empty Mask)*. 1928. Oil on canvas, 28¾ x 36¼"
(73 x 92 cm). Garrick Fine Arts Inc., Philadelphia, Pennsylvania

Apple

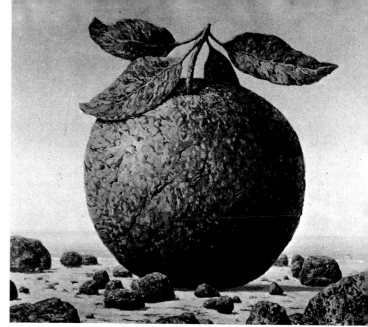

139

140

139. Untitled drawing.
n.d. 6¾ x 7¼″ (17 x 18.5
cm). Collection Joshua
Nahum Musher,
New York, New York

140. *La grande table
(The Large Table).*
1959. Oil on canvas,
21⅝ x 25⅝″ (55 x 65
cm). Collection Mme.
Sabine Sonabend,
Brussels, Belgium

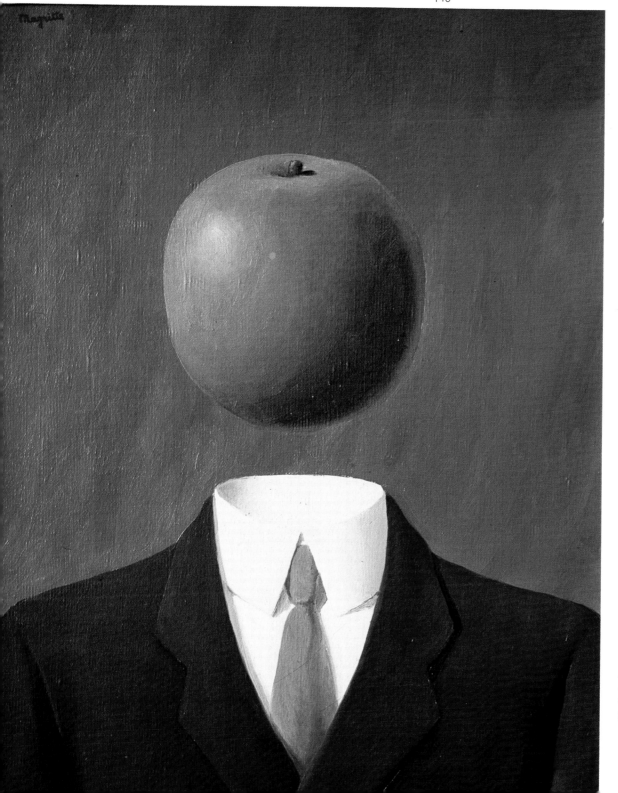

141. *L'idée (The Idea).*
1966. Oil on canvas,
16⅛ x 13″ (41 x 33 cm).
Location unknown

Bilboquet

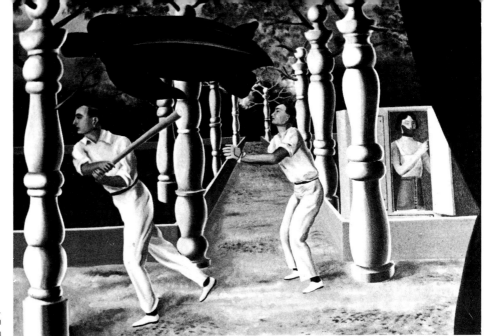

142. *Le joueur secret (The Secret Player).* 1926.
Oil on canvas, 59⅞ x 76¾" (152 x 195 cm). Collection
Nellens, Knokke-Le Zoute, Belgium

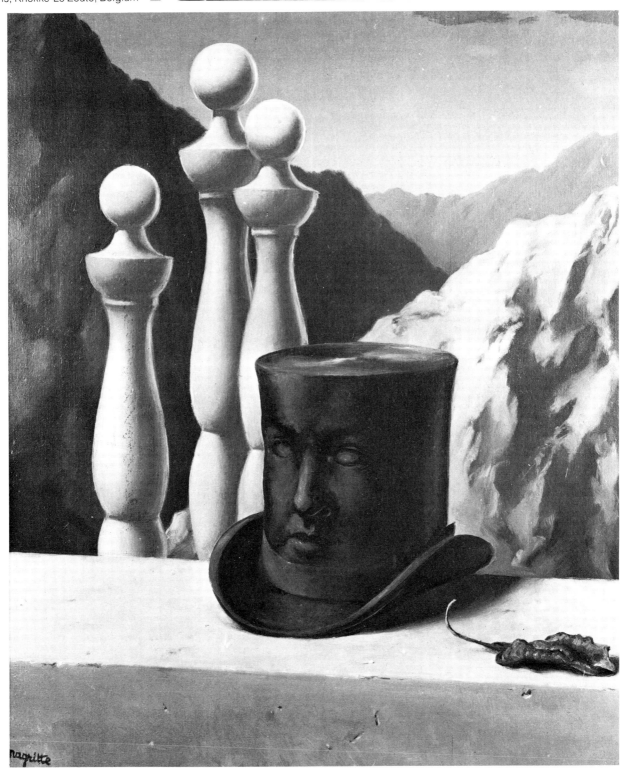

143. *Le beau ténébreux
(Dark and Handsome).*
1950. Oil on canvas,
22⅞ x 18⅞"(58x48cm).
The Israel Museum,
Jerusalem, Israel

Anthropoid Bilboquet

144. *Les rencontres naturelles (Natural Encounters)*. 1945. Oil on canvas, 31½ x 25⅝"
(80 x 65 cm). Collection M. and Mme. Louis Scutenaire, Brussels, Belgium

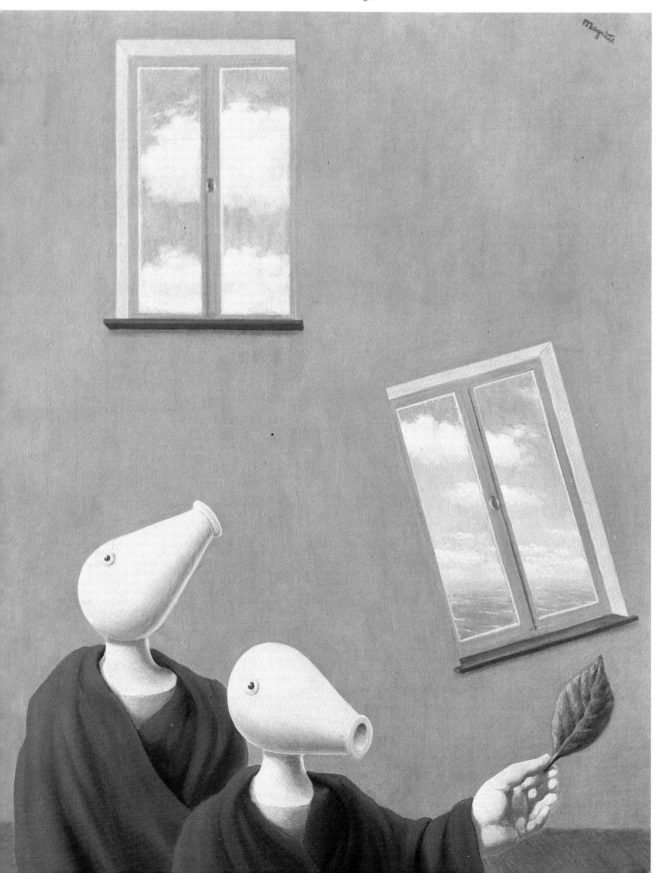

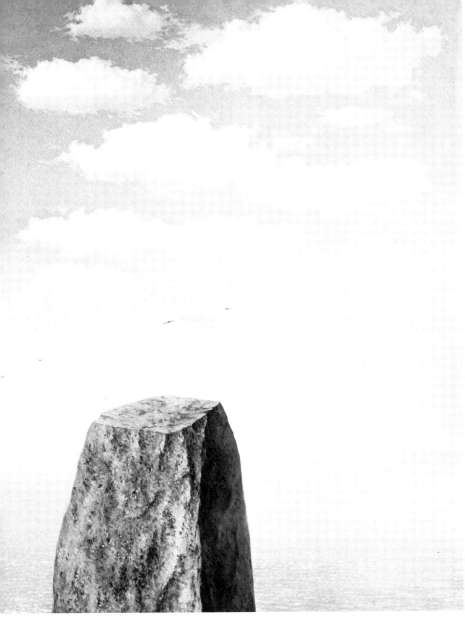

Stone and Rock

Now if, for example, weight can play a part in poetry, it is evoked by a stone (as in *La bataille de l'Argonne* [*The Battle of the Argonne*]). What is evoked is weight, *not its laws;* it is evoked *without physics.* The sensation, feeling, or idea of weight is enough for poetry; *laws would be too much,* and there would be too much as soon as physics intervened. The appearance of the word "physics" asserts a belief in the interest physics has for poetry. Now; interest in physics, while valid for an engineer or a physicist, means that there's no longer any question of poetry. If the physicist grants a greater spiritual importance to physics than to poetry, then the question of truth arises.
——*Letter from René Magritte to André Bosmans, July 24, 1961*

By confronting us with a massive rock in midair*—something we know cannot happen—we are somehow forced to wonder *why* doesn't the rock come plunging down into the sea? We know, of course, that it should. But *why* should it? . . . What fails to happen in the painting reminds us of the mystery of what actually does happen in the real world.

Space, time, and matter are dramatized here in suspended animation. The force of gravity, which we dismiss as commonplace in our daily lives, becomes powerful and awesome here. We can step on an ordinary stone any day without giving it a second thought, but the stone in the painting is compelling. The artist has made it extraordinary. It reminds us that all stones are extraordinary. . . . It is a wonderful picture to remind us that the world of our senses, the world of stones and castles, of oceans, clouds and waves, is the world that we must study before we can comprehend the more subtle world of atoms and molecules, of which the world of our senses is composed. Even more important, perhaps, it has the power to evoke a feeling of wonder. This is the ingredient that can make both a painting and physics exciting.
——*Letter from Albert V. Baez, physicist, to Harry Torczyner, September 8, 1963*

*The author is referring to *Le château des Pyrénées.*

145

145. *Les origines du langage (The Origins of Language).* 1955. Oil on canvas, 45⅞ x 35⅜" (116.5 x 90 cm). Collection University of St. Thomas, Houston, Texas

146. Untitled drawings. c. 1959. Private collection, New York, New York

146

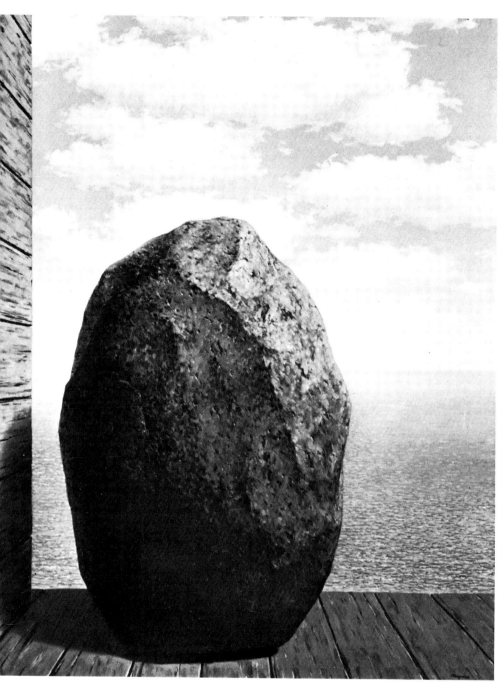

149. *Le château des Pyrénées*
(The Castle of the Pyrenees).
1959. Oil on canvas, 78¾ x 57⅛"
(200 x 140.5 cm). Collection Harry
Torczyner, New York, New York

147. *Le trou dans le mur (The Hole in the Wall).* 1956.
Oil on canvas, 39⅜ x 31½" (100 x 80 cm). Collection
Hans Neumann, Caracas, Venezuela

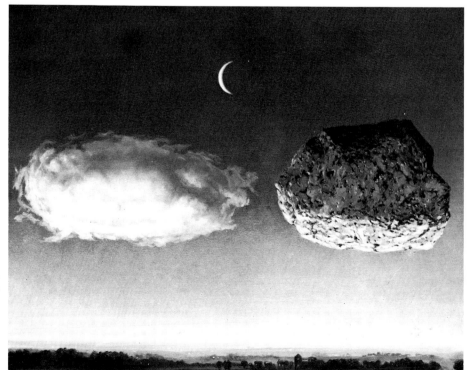

148. *La bataille d'Argonne (The Battle of the Argonne).*
1959. Oil on canvas, 19½ x 24" (49.5 x 61 cm).
Collection Tazzoli, Turin, Italy

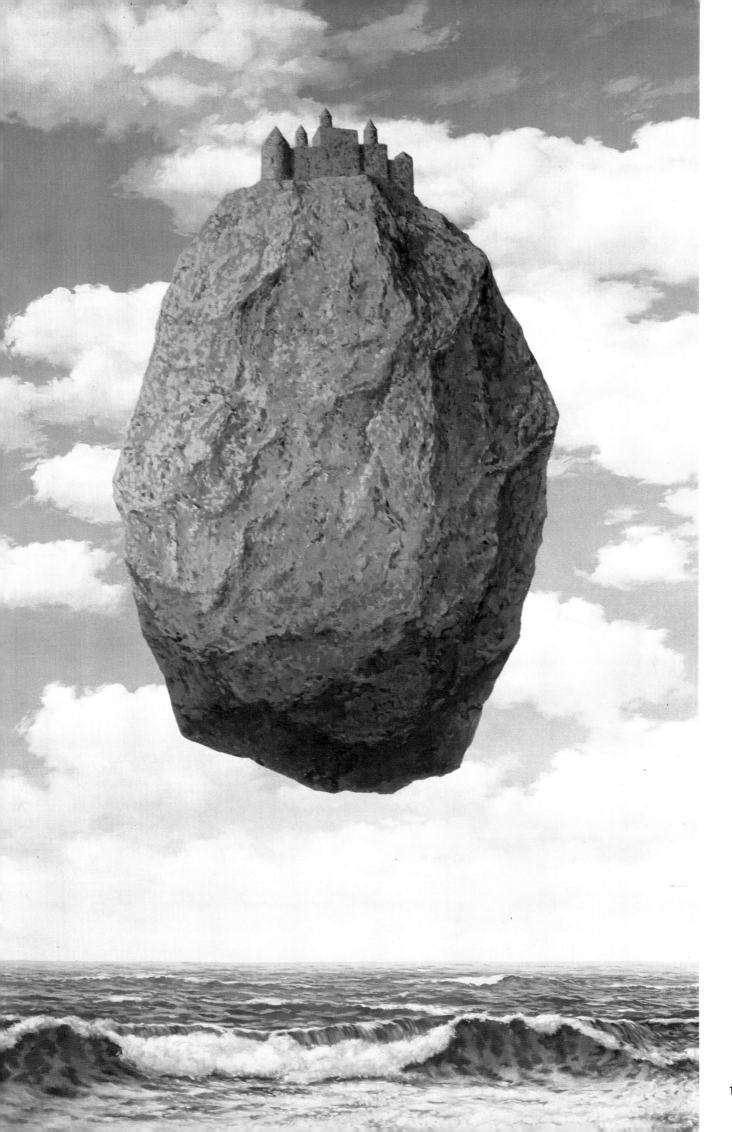

Easel

The problem of the window gave rise to *La condition humaine (The Human Condition).* In front of a window seen from inside a room, I placed a painting representing exactly that portion of the landscape covered by the painting. Thus, the tree in the picture hid the tree behind it, outside the room.

For the spectator, it was both inside the room within the painting and outside in the real landscape. This is how we see the world. We see it outside ourselves, and at the same time we only have a representation of it in ourselves. In the same way, we sometimes situate in the past that which is happening in the present. Time and space thus lose the vulgar meaning that only daily experience takes into account.

——*René Magritte,* La Ligne de Vie II, *February 1940*

150. *La condition humaine (The Human Condition).* 1934. Oil on canvas, 39⅜ x 31⅞" (100 x 81 cm). Private collection, Paris, France

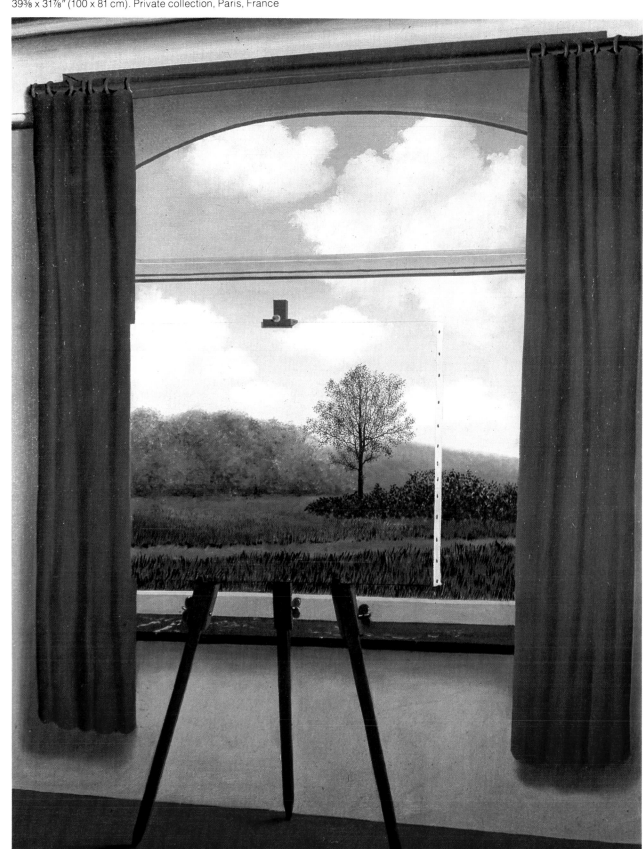

Object

151. *Fromage sous cloche (Cheese under Bell Glass).* n.d. Collection M. and Mme. Marcel Mabille, Rhode-St.-Genèse, Belgium

152. *La métamorphose de l'objet (Metamorphosis of the Object).* 1933. Study for an ashtray. Gouache, 3⅞ x 3⅞″ (10 x 10 cm). Private collection, Brussels, Belgium. *See* Appendix *for translation*

153

154

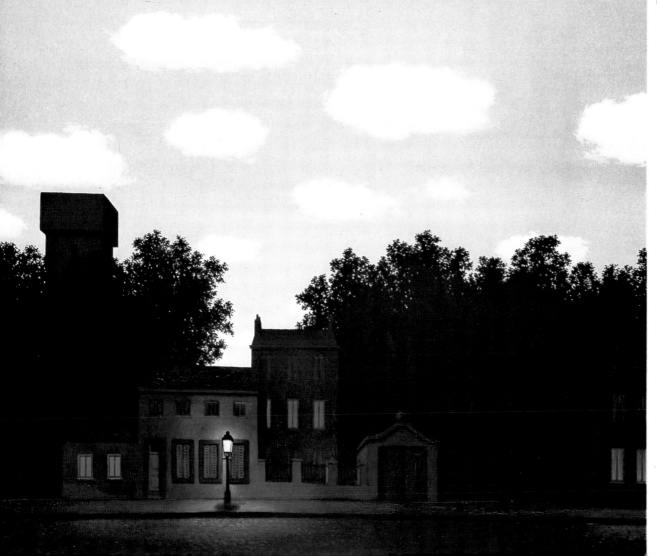

153. *L'empire des lumières (The Empire of Lights)*. 1953. Oil on canvas, 14⅝ x 17¾" (37 x 45 cm). Collection Arnold Weissberger, New York, New York

154. *L'empire des lumières II (The Empire of Lights II)*. 1950. Oil on canvas, 31⅛ x 39" (79 x 99 cm). The Museum of Modern Art, New York, New York. Gift of Dominique and John de Menil,1951

155. *L'empire des lumières (The Empire of Lights)*. 1948. Oil on canvas, 39⅜ x 31½" (100 x 80 cm). Private collection, Brussels, Belgium

156. *Le salon de Dieu (God's Drawing Room)*. 1958. Oil on canvas, 16⅞ x 23¼" (43 x 59 cm). Collection Arnold Weissberger, New York, New York

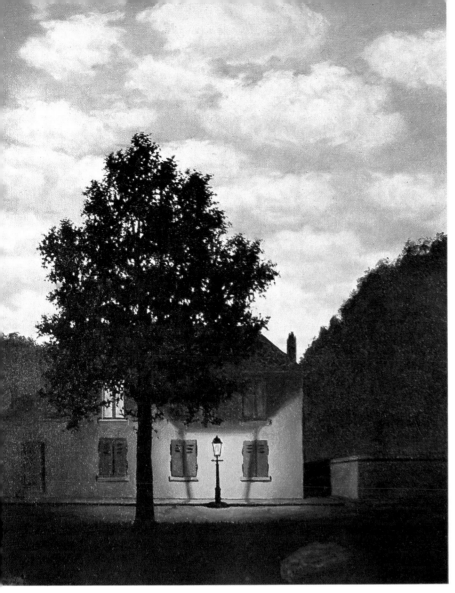

Sky/Landscape

For me, the conception of a picture is an idea of one thing or of several things that can become visible through my painting.

It is understood that all ideas are not conceptions for pictures. Obviously, an idea must be sufficiently stimulating for me to undertake to paint faithfully the thing or things I have ideated.

The conception of a picture, that is, the idea, is not visible in the picture: an idea cannot be seen with the eyes.

What is represented in a picture is what is visible to the eyes, it is the thing or things that must have been ideated.

Thus, what is represented in the picture *L'empire des lumières (The Empire of Lights)* are the things I ideated, i.e., a nighttime landscape and a sky such as we see during the day. The landscape evokes night and the sky evokes day.

I find this evocation of night and day is endowed with the power to surprise and enchant us. I call this power: poetry.

If I believe this evocation has such poetic power, it is because, among other reasons, I have always felt the greatest interest in night and in day, yet without ever having preferred one or the other.

This great personal interest in night and day is a feeling of admiration and astonishment.
——René Magritte, late April 1956

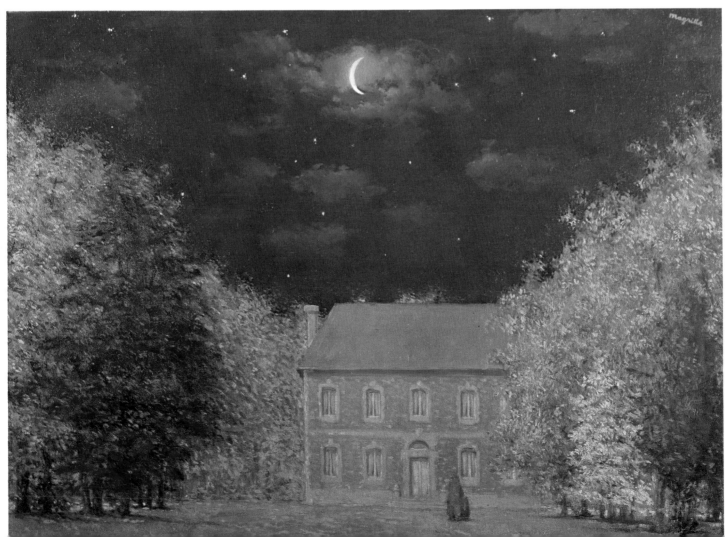

INTERMISSION

Cubist Period

I'm neither a "Surrealist" nor a "Cubist" nor a "'Patawhatever,'"* even though I have a fairly strong weakness for the so-called Cubist and Futurist "schools." Were I really an *artiste-peintre*, I would waver between these two disciplines. Were I an innocent intellectual, I would be content with what Surrealism entails in a large, very large part of unimportant matters.
——*Letter from René Magritte to André Bosmans, April 1959*

* Pataphysics ("Patawhatever") is a philosophy invented by Alfred Jarry, which was taken up by the Surrealists and Dadaists

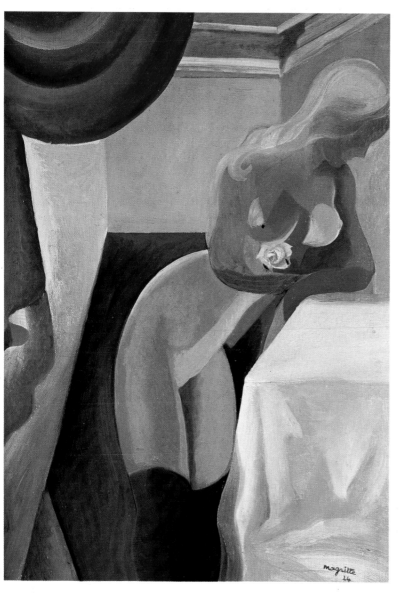

157. *Jeune fille (Young Woman)*. 1924. Oil on canvas, 21⅝ x 15¾" (55 x 40 cm). Collection Mme. René Magritte, Brussels, Belgium

158. *La baigneuse (The Bather)*. 1923. Oil on canvas, 19⅝ x 39⅜" (50 x 100 cm). Collection M. and Mme. Berger-Hoyez, Brussels, Belgium

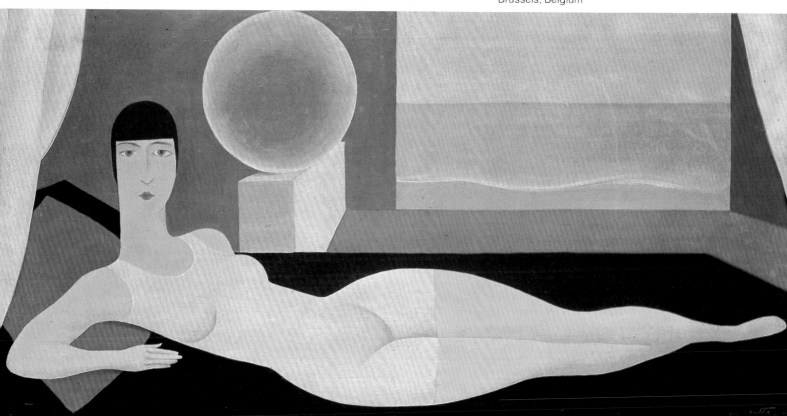

Renoir Period

159. *Les heureux présages (The Good Omens)*. 1944. Oil on canvas, 15¾ x 23⅝" (40 x 60 cm). Collection M. and Mme. Berger-Hoyez, Brussels, Belgium

For the period I call "Surrealism in full sunlight," I am trying to join together two mutually exclusive things:

1) a feeling of levity, intoxication, happiness, which depends on a certain mood and on an atmosphere that certain Impressionists—or rather, Impressionism in general—have managed to render in painting. Without Impressionism, I do not believe we would know this feeling of real objects perceived through colors and nuances, and free of all classical reminiscences. The public has never liked the Impressionists, although it may seem to; it always sees these pictures with an eye dominated by mental analysis—otherwise, we must agree that freedom runs riot.

and, 2) a feeling of the mysterious existence of objects (which should not depend upon classical or literary reminiscences), which is experienced only by means of a certain clairvoyance.

Some of the paintings of this period have succeeded in uniting these two mutually exclusive things. I gave up—why? It's not too clear—perhaps out of a need for unity?
——*Letter from René Magritte to G. Puel, March 8, 1955*

. . . pictures of "Surrealism in full sunlight." Pictures we say—to laugh and to stop laughing—are from my "Black Period," given the futility of having shown them to the public up to now.
——*Letter from René Magritte to Mirabelle Dors and Maurice Rapin, March 30, 1956*

160. *La moisson (The Harvest)*. 1944. Oil on canvas, 23⅝ x 31½" (60 x 80 cm). Collection M. and Mme. Louis Scutenaire, Brussels, Belgium

161

162

Fauvist Period

This is probably my last holographic ejaculation for you from Paris. Taking stock, we come to the result zero, as our friends warned us. (Zero if the results are indeed measurable.) Spiritually, however, I have made a few acquisitions: for example, I think (provisionally) that what distinguishes us from the genial way of thinking (in spite of ourselves, since it would be out of the question to want to distinguish oneself at any price) is for example our total lack of belief in substance and in form. Those who are very active here seem to cling to form, the only bone they have left to gnaw on. Thus this shit Baron Mollet, who honeyed up to me and now tells everyone that *Les pieds dans le plat (The Faux Pas)* wasn't suitable for Paris (true, it doesn't suit, but not in the way this cretin thinks). The basics: feelings are "basically" totally boring, except when they are experienced in daily life (outside literature).

The whole thing makes me think that my "business" of making pictures boils down to mere fabrication, like making old furniture, for example. Surrounding this enterprise are other forms of craftsmanship, such as writing, theater, etc. . . . that is what makes up the art world—but its substance and form don't interest me.

There are some visitors to the exhibition (the young girls have a tendency to laugh, but they restrain themselves since it's unbecoming in art galleries), visitors who make the usual asshole remarks: "It's less profound than it was," it's "Belgian wit," you can feel it's not "Parisian," "What brush work!", "What a lovely torso" (for the "psychologist"), etc. . . . There's a review in *Arts*, which you can buy for yourselves in Brussels. I'm incapable of buying the issue and sending it to you. I feel nauseated just thinking of it. As for sales, that too is Zero up until now; perhaps it will change, nothing is permanently decided. Also, for pleasure, we go for walks in the Bois de Vincennes, which is near to our quarters so we can avoid trips and noises. Another source of pleasure is that there are some good charcuteries here. I'm expecting a visit from Iolas in a day or two. Even if he doesn't come or is late, I'm taking off on Thursday. If you'd like, we could see each other Friday at my place, as usual.

——*Letter from René Magritte to Irène Hamoir and Louis Scutenaire, May 17, 1948*

161. *Le prince charmant (Prince Charming)*. 1948. Gouache, 17¾ x 12⅝" (45 x 32 cm). Collection M. and Mme. Louis Scutenaire, Brussels, Belgium

162. *Le galet (The Pebble)*. 1948. Oil on canvas, 39⅜ x 31½" (100 x 80 cm). Collection Mme. René Magritte, Brussels, Belgium

TOWARD PLEASURE

For Magritte, inspiration was very simply the recognition of a subject worthy of being represented in painting. He did not begin with an idea, but, on the contrary, he arrived at an idea that had to be able to stand up to his criticism and to impose itself upon him. Sometimes, this inspiration was slow to come. Bad luck. He refused to provoke or to hasten its arrival through imagination. Inspiration permitted him to evoke mystery by uniting in one image the visible offered by the world.

Once painted, this image had to be given a name, like a newborn child that must be baptized. A strange and indissoluble bond exists between each newborn and its name. A name is annunciatory, revelatory, serving neither to define nor to interpret its bearer. So it is with the titles given Magritte's pictures. Sometimes he asked advice by letter, or he would convoke an actual family council. His circle of close friends would then gather under his presidency to decide on a name. Sometimes Magritte would decree that a work was to bear the title of one of his favorite books.

What mattered to him was discovering what must be painted, not the way to paint. In order to discover an answer to his research, Magritte had to solve a series of problems and relentlessly to pursue his mental calculations.

He followed his pictorial "Lifeline" obstinately, faithfully, and not without a certain austerity; and with characteristic lucidity and sense of moderation, he has explained to us why his images demand no explanation.

163. *Le chant de la violette (The Song of the Violet)*. 1951. Oil on canvas, 39⅜ x 31⅞" (100 x 81 cm). Private collection, Brussels, Belgium

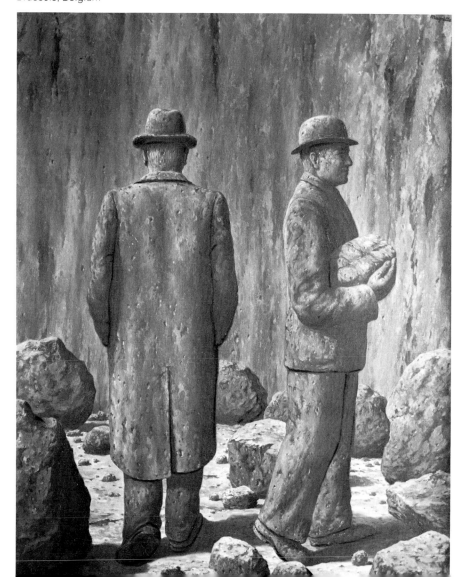

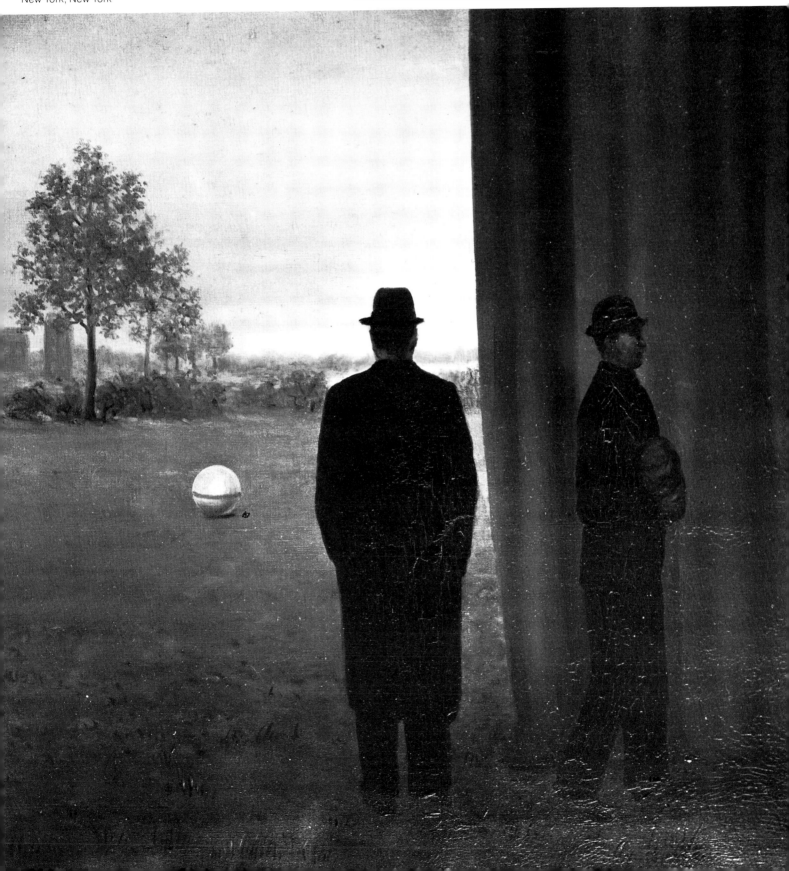

164. Photograph of René Magritte, Brussels, Belgium, 1934

165. *A la rencontre du plaisir (Toward Pleasure)*. 1950. Oil on canvas, 19¼ x 23″ (49 x 58.5 cm). Collection Harry Torczyner, New York, New York

POETIC ATTRIBUTIONS

The flesh statue of a young woman holding a rose made of flesh in her hand. Her other hand is leaning against a rock. The curtains open onto the sea and a summer sky.
——*René Magritte, June 22, 1946, in* Fait Accompli, *nos. 111–113, April 1974*

166. *Les fleurs du mal (The Flowers of Evil).* 1946. Oil on canvas, 31½ x 23⅝" (80 x 60 cm). Collection M. and Mme. Berger-Hoyez, Brussels, Belgium

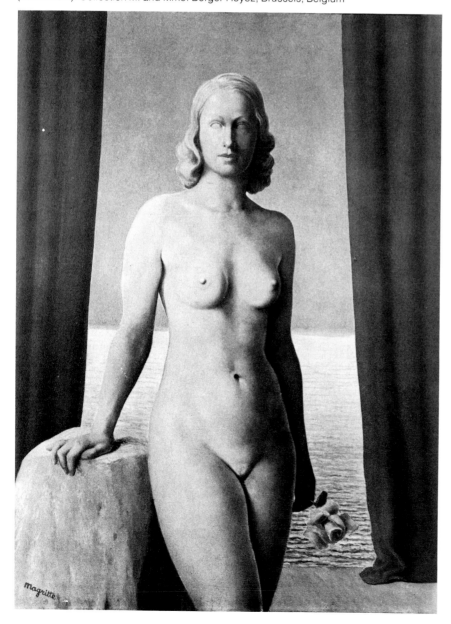

Les Fleurs du Mal

Unexpected images sometimes appear to me when my eyes are open or closed, and they become the models of pictures I like to paint.

In depicting the image that appeared to me one day, I painted *Les fleurs du mal (The Flowers of Evil).* It was the unexpected image of a statue made of flesh, a woman made completely of flesh, holding in her hand a rose made of flesh, in front of the sea I had seen between two red curtains.

The title *Les fleurs du mal* goes with the picture just as a noun corresponds to an object without either illustrating or explaining it.

It would be useless to posit some mental process of which I am ignorant and to charge it with having determined the content of what I call an "unexpected image." It would be just as easy to assert that latent memories of Baudelaire's poems were, unbeknownst to me, the origin for the painting *Les fleurs du mal.*
——*René Magritte, address given upon being made a member of the Académie Picard, April 5, 1957*

A title "justifies" the image by completing it. Nietzsche also said "there is no thought without language." Could the painting that affects us be a language without thought? Because it is evident that pictures representing ideas—justice, for example—fail to affect us.
——*René Magritte,* Paroles Datées, *June 19, 1956, in* Les Brouillons Sacrés, *I, Paris, November 1956*

The titles of my paintings accompany them like the names attached to objects without illustrating or explaining them.
——*Letter from René Magritte to Barnet Hodes, 1957*

Titles . . . become "eloquent" as names for paintings on condition that they fit exactly. Their meaning has strength and charm thanks to the paintings, and paintings acquire greater precision by being well named.
——*Letter from René Magritte to André Bosmans, March 7, 1959*

Titles should be images that are precisely joined with the pictures. In fact, the titles I might call purely "intellectual" are not satisfactory at all. Titles that can suit any picture are hardly any better, such as *The Image Itself, Resemblance,* and others that are intelligent, but perhaps too much so.
——*Letter from René Magritte to Marcel Lecomte, June 13, 1960*

The titles go with my paintings as well as they can. They are not keys. There are only false keys.
——*From an interview with René Magritte by Guy Mertens,* Pourquoi Pas, *1966*

The Domain of Arnheim

For the development of *La fontaine de jouvence (The Fountain of Youth),* I can say that it began about 1933–1934; I was trying to paint a mountain and thought of giving it a bird's shape and calling this image *Le domaine d'Arnheim,* the title of one of Poe's stories. Poe would have liked seeing this mountain (he shows us landscapes and mountains in his story).

Fortune faite (The Fortune Made) and *La fontaine de jouvence* are stones bearing such inscriptions as "Coblenz," "Roseau" (or the date in *Les verres fumés* [*The Dark Glasses*]) "à boire," "à manger" *(to drink, to eat)* as in *Fortune faite.* These stones can be seen as a little piece of *Le domaine d'Arnheim.*

To be more thorough, I mustn't forget to say that between *Le domaine d'Arnheim* and *La fontaine de jouvence* came *Le sourire (The Smile),* which was a very old stone—without the bird's head— bearing a date of five figures.

——*Letter from René Magritte to André Bosmans, April 6, 1959*

Literary Sources

Many of Magritte's images are known to have derived their titles from happy memories of reading:

- *L'Au-Delà* (F. Grégoire)
- "The Domain of Arnheim" (Edgar Allan Poe)
- *Les Fleurs du Mal* (Charles Baudelaire)
- *Gaspard de la Nuit* (Bertrand)
- "La Géante" (Charles Baudelaire)
- *Treasure Island (L'Ile du Trésor)* (Robert Louis Stevenson)
- *Les Liaisons Dangereuses* (Choderlos de Laclos)
- *Souvenirs du Voyage* (J. A. Gobineau)
- *Visions of a Castle of the Pyrenees* (Ann Radcliffe)

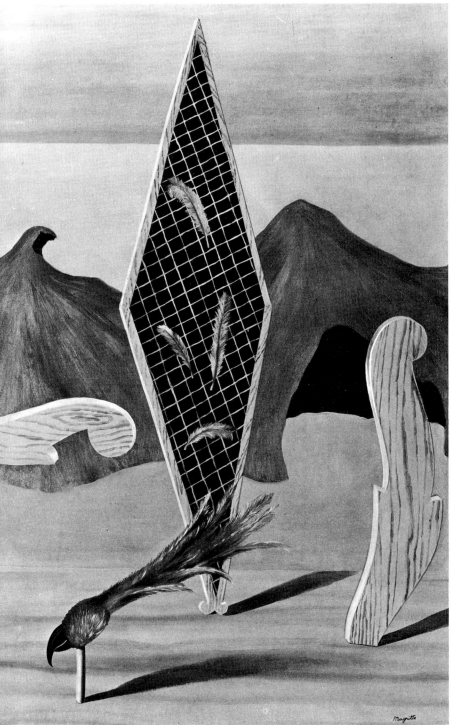

167. *Les épaves de l'ombre (The Shadow's Wreckage).* n.d. Oil on canvas, 47¼ x 31½" (120 x 80 cm). Musée de Grenoble, Grenoble, France

The first concept of a mountaintop shaped like a bird, which led to *Le domaine d'Arnheim* some thirty years later.

168. Untitled drawing. n.d. 4⅜ x 5⅞" (11 x 15 cm). Collection M. and Mme. Marcel Mabille, Rhode-St.-Genèse, Belgium

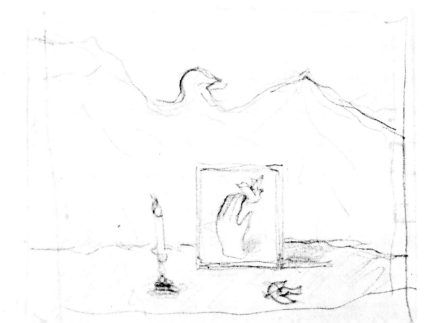

169. *Le domaine d'Arnheim (The Domain of Arnheim)*. 1962. Oil on canvas, 57½ x 44⅞" (146 x 114 cm). Collection Mme. René Magritte, Brussels, Belgium

170. *Fortune faite (The Fortune Made)*. 1957. Oil on canvas, 23⅝ x 19⅝" (60 x 50 cm). Location unknown

The Well of Truth

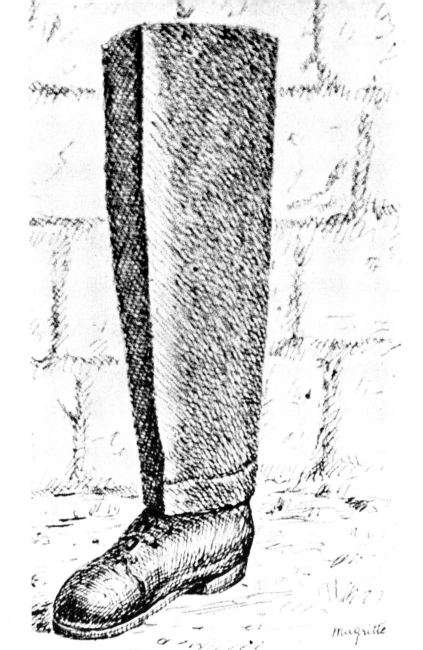

171

172

171. *Le puits de vérité (The Well of Truth)*. c. 1962–1963. Pen and ink drawing, 11⅜ x 8¼" (30 x 21 cm). Collection Mme. Sabine Sonabend-Binder, Brussels, Belgium

172. Photograph of René Magritte painting *Le puits de vérité (The Well of Truth)*, 1963

173. Pen sketch of *Le puits de vérité (The Well of Truth)* in a letter from René Magritte to Harry Torczyner, January 13, 1962. *See* Appendix *for translation*

173

J'ai envoyé il y a quelque temps à Suzi
le dessin d'un nouveau tableau (une
jambe de pantalon et un soulier) en
lui demandant comment
elle l'appelerait _ le
titre est trouvé enfin :

" L'Étalon „

(dans le sens de l'unité
immuable _ ou presque _
de mesure).

The Voyager

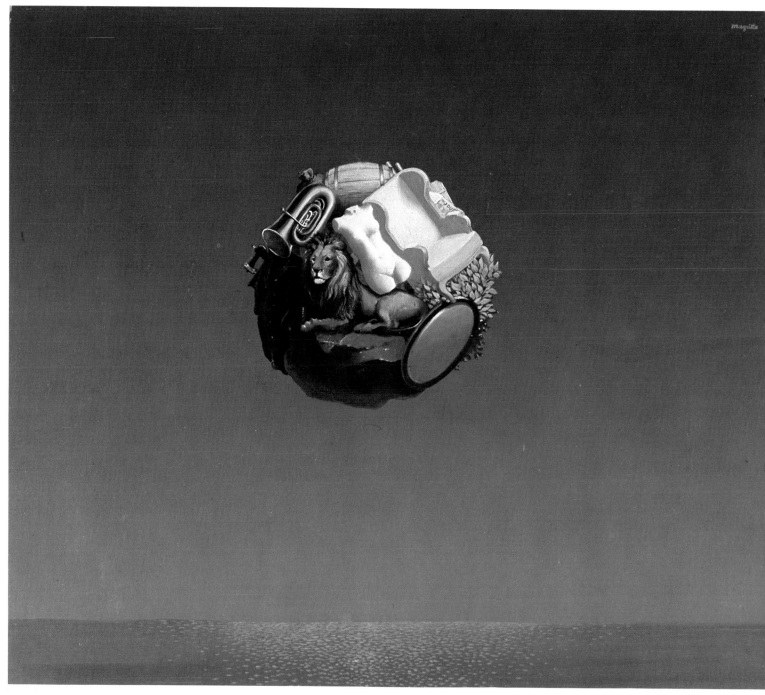

174. *Le voyageur (The Traveler)*. 1935. Oil on canvas, 21⅝ x 26″ (55 x 66 cm). Private collection, Brussels, Belgium

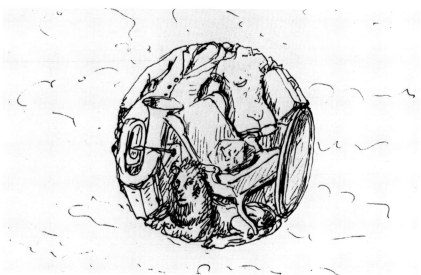

175. Ink drawing in a letter from René Magritte to Mirabelle Dors and Maurice Rapin, August 22, 1956

THE TRUE ART
OF PAINTING

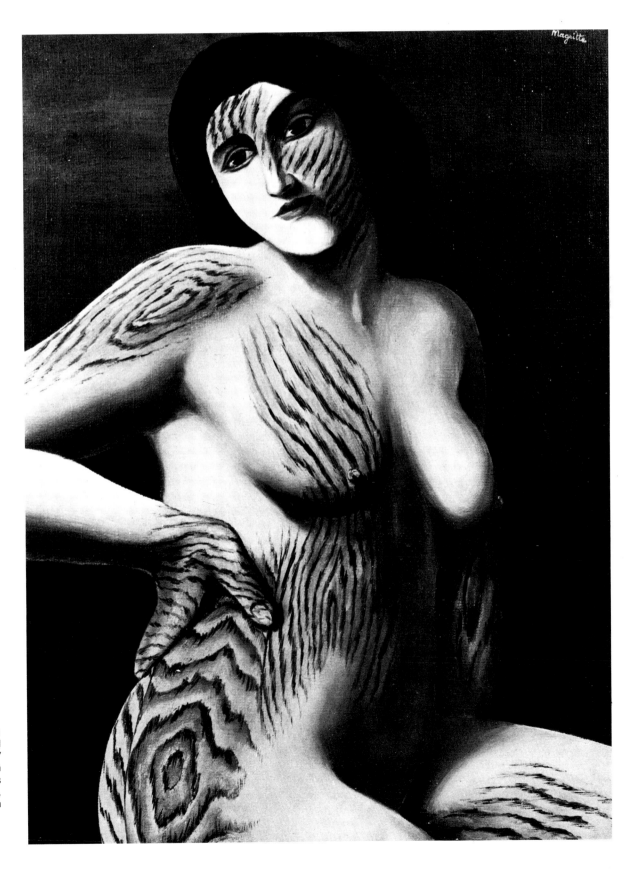

176. *Découverte
(Discovery).* 1927. Oil
on canvas, 25⅝ x 19⅝"
(65 x 50 cm). Collection
M. and Mme. Louis
Scutenaire, Brussels,
Belgium

I believe I've made an altogether startling discovery in painting: up until now I used combined objects, or perhaps the position of an object was enough to render it mysterious. But as a result of the research I have pursued here, I have found a new possibility things may have: that of *gradually* becoming something else—an object *melts* into an object other than itself. For instance, at certain spots the sky allows wood to appear. This is something completely different from a compound object, since there is no break between the two materials, no boundary. Using this means, I get pictures in which the eye "must think" in a way entirely different from the usual; the things are tangible, yet a few planks of ordinary wood grow imperceptibly transparent in certain areas, or a nude woman has parts that also become a different material.

——*Letter from René Magritte (Le Perreux-sur-Marne) to Paul Nougé, November 1927*

The Lifeline

Comrades, Ladies and Gentlemen.

That old question "Who are we?" receives a disappointing answer in the world in which we must live. Actually, we are merely the subjects of this so-called civilized world, in which intelligence, baseness, heroism, and stupidity get on very well together and are alternately being pushed to the fore. We are the subjects of this incoherent, absurd world in which weapons are manufactured to prevent war, in which science is used to destroy, to construct, to kill, to prolong the life of the dying, in which the most insane undertaking works against itself; we are living in a world in which one marries for money, in which one constructs palaces that rot, abandoned, by the sea. This world is still holding up, more or less, but we can already see the signs of its approaching ruin glimmering in the darkness.

It would be naïve and useless to restate these facts for those who are not bothered by them, and who are peaceably taking advantage of this state of affairs. Those who thrive on this disorder hope to consolidate it, and, the only means available to them being further disorders, they are contributing to its imminent collapse, albeit unwittingly, by replastering the crumbling structure in their so-called realistic way.

Other men, among whom I am proud to count myself, despite the utopianism they are accused of, consciously desire the proletarian revolution that will transform the world; and we are acting toward this end, each according to the means available to him.

Nevertheless, we must protect ourselves against this second-rate reality that has been fashioned by centuries of worshipping money, races, fatherlands, gods, and, I might add, art.

Nature, which bourgeois society has not completely succeeded in extinguishing, provides us with the dream state, which endows our bodies and our minds with the freedom they need so imperatively.

Nature seems to have been overly generous in creating for those who are too impatient or too weak the refuge of insanity, which protects them from the stifling atmosphere of the real world.

The great strength for defense is the love that binds lovers together in an enchanted world made precisely to their order, and which is admirably protected by isolation.

Finally, Surrealism provides mankind with a methodology and a mental orientation appropriate to the pursuit of investigations in areas that have been ignored or underrated but that, nonetheless, directly concern man. Surrealism demands for our waking lives a liberty comparable to that that we possess in dreams.

The mind possesses this freedom to a high degree, and as a practical matter new technicians must devote themselves to the task of destroying some complexes—such as ridicule, perhaps—and of looking for those slight modifications that must be made in our habits so that this faculty that we possess of seeing only what we choose to see might become the faculty of discovering at once the object of our desires. Daily experience, even hobbled as it is by religious, civil, or military moralities, is already achieving these possibilities to some degree.

In any case, the Surrealists know how to be free. As André Breton cries: "Liberty is the color of man."

In 1910, Chirico played with beauty; he imagined and achieved what he wanted: he painted *Le chant d'amour (The Song of Love),* in which we see boxing gloves together with the face of an antique statue. He painted *Melancholia* in a land of high factory chimneys and infinite walls. This triumphant poetry replaced the stereotyped effects of traditional painting. It was a total break with the mental habits characteristic of artists who were prisoners of talent, virtuosity, and all the minor aesthetic specialities. It meant a new vision in which the spectator rediscovered his isolation and listened to the world's silence.

In his illustrations to Paul Éluard's *Répétitions,* Max Ernst superbly demonstrated, through the shattering effect of collages made from old magazine illustrations, that one could easily dispense with everything that had given traditional painting its prestige. Scissors, paste, images, and some genius effectively replaced the brushes, colors, model, style, sensibility, and the divine afflatus of artists.

The labors of Chirico, of Max Ernst, certain works by Derain, *L'homme au journal (Man with Newspaper)* among others, in which a real newspaper is pasted into a figure's hands, Picasso's experiments, Duchamp's anti-artistic activity, which casually proposed using a Rembrandt as an ironing board: these are the beginnings of what is now called Surrealist painting.

In my childhood, I liked playing with a little girl in the old, abandoned cemetery of a small country town. We visited those underground vaults whose heavy iron doors we could lift and we reascended into the light, where an artist from the capital was painting in one of the cemetery's paths, picturesque with its broken stone columns amid piles of dead leaves. At that moment, the art of painting

seemed somehow magical, and the painter endowed with superior powers. Alas! I later learned that painting had little to do with real life, and that each attempt at freedom had always been foiled by the public: Millet's *Angelus* created a scandal when it appeared; the painter was accused of having insulted the peasants by representing them as he had. People wanted to destroy Manet's *Olympia,* and the critics reproached the painter for showing women cut into pieces because he had only shown the top half of a girl standing behind a bar counter, the bottom half being hidden by it. During Courbet's life, it was agreed that he showed very poor taste in vociferously showing off his spurious talent. I also saw that examples of this kind were infinite, and that they extended into every realm of thought. As for the artists themselves, most readily renounced their freedom and placed their art at the service of anyone or anything. Their concerns and ambitions were usually the same as those of any opportunist. In this way I acquired complete mistrust of art and artists, whether they were officially blessed or only aspired to be, and I felt I had nothing in common with such company. I possessed a point of reference that placed me elsewhere—it was that magic of art that I had known in my childhood.

In 1915, I tried to rediscover the stance that would enable me to see the world other than as others wanted to impose it upon me. I had mastered certain techniques of the art of painting, and, in isolation, I made attempts that were deliberately different from anything I knew in painting. I tasted the pleasures of freedom in painting the least conformist images. Then, by a singular chance, I was handed—with a pitying smile and probably the idiotic idea of having a good joke on me—the illustrated catalogue of an exhibition of Futurist paintings. I had before my eyes a powerful challenge to the good sense with which I was so bored. For me, it was like the light I had found again upon emerging from the underground vaults of the old cemetery where I had spent my childhood vacations.

In a state of real intoxication, I painted a whole series of Futurist pictures.

Yet, I don't believe I was a truly orthodox Futurist because the lyricism I wanted to capture had an unchanging center unrelated to aesthetic Futurism.

It was a pure and powerful feeling: eroticism. The little girl I had known in the old cemetery was the object of my reveries, and she became involved in the animated ambiences of stations, fairs, or towns that I created for her. Thanks to this magical painting I recaptured the same sensations I had had in my childhood.

The elements that entered into the compositions of my paintings were represented by means of flexible shapes and colors, so that those shapes and colors could be modified and shaped to the demands imposed by a rhythm of movement.

For example, the elongated rectangle representing the trunk of a tree was sometimes sectioned, sometimes bent, sometimes barely visible, according to the role it played. These completely free forms were not in disagreement with nature, which does not insist (in the case of the tree in question) on producing trees of a rigorously invariable color, dimension, and form.

These kinds of concerns gradually raised the question of the relationship between an object and its form, and between its apparent form and the essential thing it must possess in order for it to exist. I tried to find the plastic equivalents of this essential thing, and my attention turned away from the movement of objects. Then I painted pictures representing immobile objects shorn of their details and their secondary characteristics. These objects revealed to the eye only their essentials, and, in contrast to the image we have of them in real life, where they are concrete, the painted image signified a very lively perception of abstract existence.

This contrast was reduced; I ended up by finding in the appearance of the real world itself the same abstraction as in my paintings; for despite the complex combinations of details and nuances in a real landscape, I managed to see it as though it were only a curtain hanging in front of me. I became uncertain of the depth of the countryside, unconvinced of the remoteness of the light blue of the horizon; direct experience simply placed it at eye level.

I was in the same innocent state as the child in his cradle who believes he can catch the bird flying in the sky. Paul Valéry, it seems, experienced this same state by the sea, which, he says, rises up before the eyes of the spectator. The French Impressionist painters, Seurat among others, saw the world in exactly this way when they broke down the colors of objects.

Now I had to animate this world that, even when in motion, had no depth and had lost all consistency. I then thought that the objects themselves should eloquently reveal their existence, and I looked for the means to achieve this end.

The novelty of this undertaking made me lose sight of the fact that my earlier experiments, which had led to an abstract representation of the world, had become useless when this very abstraction became characteristic of the real world. In addition, it was still with my old manner of painting that I began to execute paintings with a new point of departure; this discord kept me from thoroughly exploiting the researches I was undertaking; my attempts up to this point to show the evidence, the existence of an object, had been hampered by the abstract image I was giving of that object. The rose I put on the bosom of a nude girl did not create the overwhelming effect I had anticipated.

I subsequently introduced into my paintings elements complete with all the details they show us in reality, and I soon realized, that when represented in this fashion, they immediately brought into question their corresponding elements in the real world.

Thus I decided about 1925 to paint only the superficial characteristics of objects because my researches could be developed under no other condition. I was actually renouncing only a certain manner of painting that had brought me to a point I had to go beyond. This decision, which caused me to break with a comfortable habit, was the

outcome of a lengthy meditation I had in a working-class restaurant in Brussels. My state of mind made the moldings of a door seem endowed with a mysterious existence, and for a long time I remained in contact with their reality.

That was when I used to meet my friends Paul Nougé, E. L. T. Mesens, and Jean [sic] Scutenaire. We were united by shared concerns. We met the Surrealists, who were violently demonstrating their disgust for bourgeois society. Since their revolutionary demands were the same as ours, we joined with them in the service of the proletarian revolution.

This was a setback. The politicians leading the workers' parties were in fact too vain and too lacking in perspicacity to appreciate the Surrealists' contribution. These people in high places were allowed to compromise seriously the proletarian cause in 1914. They also indulged in every cowardice, every baseness. In Germany, at a time when they still represented a perfectly disciplined worker population and when this power could have been exploited to crush easily that asshole Hitler, they gave in to him and his handful of fanatics. Recently, in France, Monsieur Blum helped the Germans and Italians murder the young Spanish Republic and, purportedly fearing a revolutionary situation, he seems to be ignoring the people's rights and prerogatives by giving way in his turn to a threatening reactionary minority. It should be noted in passing that a political leader of the proletariat has to be very courageous to dare declare his faith in the cause he defends. Such men are assassinated.

The subversive aspect of Surrealism has clearly worried the traditional labor politicians, who at times are indistinguishable from the most fanatic defenders of the bourgeois world. Surrealist thought is revolutionary on all levels and is necessarily opposed to the bourgeois conception of art. As it turns out, the leftist politicians ascribe to this bourgeois conception, and they want nothing to do with painting if it does not conform.

However, the bourgeois conception of art should be inimical to the politician who calls himself revolutionary and who should thus be looking toward the future, since [this conception's] characteristics are a cult dedicated exclusively to past achievements and a desire to halt artistic development. Further, the value of a work of art is gauged in the bourgeois world by its rarity, by its value in gold; its intrinsic value interests only a few old-fashioned innocents who are as satisfied by the sight of a wildflower as by the possession of a real or paste diamond. A conscientious revolutionary like Lenin judges gold at its true value. He wrote: "When we have achieved victory on a world scale, I think we will build public latrines in gold on the streets of some of the world's largest cities." A feeble-minded reactionary such as Clemenceau, the zealous lackey of every bourgeois myth, made this outrageous statement about art: "Yes, I won the World War, but if I am to be honored in future history, I owe it to my incursions into the realms of art."

Surrealism is revolutionary because it is the indomitable foe of all the bourgeois ideological values that are keeping the world in its present appalling condition.

From 1925 to 1926, I painted some sixty pictures, which were shown at the Centaur Gallery in Brussels. The proof of freedom they revealed naturally outraged the critics, from whom I had expected nothing interesting anyway. I was accused of everything. I was faulted for the absence of certain things and for the presence of others.

The lack of plastic qualities noted by the critics had actually been filled by an objective representation of things, which was clearly understood and comprehended by those whose taste had not been ruined by the literature that had been created around painting. I believed this detached way of representing objects corresponded to a universal style, in which one person's manias and petty preferences no longer played a part. For example, I used light blue to represent the sky, unlike the bourgeois artists who paint sky as an excuse to show their favorite blue next to their favorite gray. I consider such petty little preferences to be irrelevant, and these artists to be lending themselves to a most ridiculous spectacle, albeit with great seriousness.

Traditional picturesqueness, the only one granted critical approval, had good reasons for not appearing in my paintings: by itself, the picturesque is inoperable and negates itself each time it reappears in the same guise. Before it became traditional, its charm was derived from unexpectedness, the novelty of a mood, and unfamiliarity. But by repeating a few such effects, picturesqueness has become disgustingly monotonous. How can the public at each spring salon continue to look without nausea at the same sunny or moonlit old church wall? Those onions and eggs either to the right or to the left of the inevitable copper pot with its predictable highlights? Or the swan that since antiquity has been about to penetrate those thousands of Ledas?

I think the picturesque can be employed like any other element, provided it is placed in a new order or particular circumstances, for example: a legless veteran will create a sensation at a court ball. The traditional picturesqueness of that ruined cemetery path seemed magical to me in my childhood because I came upon it after the darkness of the underground vaults.

I was criticized for the ambiguity of my paintings. That was quite an admission for the ones who were complaining: they unwittingly reveal their timidity when, left to themselves, they no longer have the guarantees of some expert, the sanction of time, or any other guideline to reassure them.

I was criticized for the rarefied nature of my interests—a singular reproach, coming from people for whom rarity indicates great value.

I was also criticized for many other things, and finally for having shown objects situated in places where we never really find them. Yet this is the fulfillment of a real, if unconscious, desire common to most men. In fact, ordinary painting is already attempting, within the limits set for it, to upset in some small way the order in which it generally views objects. It has allowed itself some timid bravado, a few vague allusions. Given my desire to make the most ordinary objects shock if

at all possible, I obviously had to upset the order in which one generally places them. I found the cracks we see in our houses and on our faces to be more eloquent in the sky; turned wooden table legs lost their innocent existence if they suddenly appeared towering over a forest; a woman's body floating above a city advantageously replaced the angels that never appeared to me; I found it useful to envisage the Virgin Mary's underwear, and showed her in this new light; I preferred to believe that the iron bells hanging from our fine horses' necks grew there like dangerous plants on the edge of precipices. . . .

As for the mystery, the enigma my paintings embodied, I will say that this was the best proof of my break with all the absurd mental habits that commonly replace any authentic feeling of existence.

The pictures painted in the following years, from 1925 to 1936, were also the result of a systematic search for an overwhelming poetic effect through the arrangement of objects borrowed from reality, which would give the real world from which those objects had been borrowed an overwhelming poetic meaning by a natural process of exchange.

The means I used were analyzed in a work by Paul Nougé entitled *Les images défendues (Forbidden Images)*. Those means were, first, the displacement of objects, for example: a Louis-Philippe table on an ice floe, the flag on a dung heap. The choice of things to be displaced was made from among very ordinary objects in order to give the displacement maximum effectiveness. A burning child affects us much more than the self-destruction of a distant planet. Paul Nougé rightly noted that certain objects, devoid of any special affective content in themselves, retained this precise meaning when removed to unfamiliar surroundings. Thus, women's undergarments were particularly resistant to any sudden change.

The creation of new objects; the transformation of known objects; the alteration of certain objects' substance--a wooden sky, for example; the use of words associated with images; the false labeling of an image; the realization of ideas suggested by friends; the representation of certain day-dreaming visions—all these, in sum, were ways of forcing objects finally to become sensational.

In *Les images défendues,* Paul Nougé also remarks that the titles of my paintings are conversational commodities rather than explications. The titles are chosen in such a way that they also impede their being situated in some reassuring realm that automatic thought processes might otherwise find for them in order to underestimate their significance. The titles should provide additional protection in discouraging any attempt to reduce real poetry to an inconsequential game.

One night in 1936 I awoke in a room in which someone had put a cage with a sleeping bird. A wonderful aberration made me see the cage with the bird gone and replaced by an egg. There and then, I grasped a new and astonishing poetic secret, for the shock I felt had been caused precisely by the affinity of two objects, the cage and the egg, whereas previously this shock had been caused by the encounter between two completely unrelated objects.

From that moment, I sought to find out whether objects besides the cage could also disclose— by bringing to light an element characteristic of them and absolutely predestined for them—the same unmistakable poetry the union of the egg and cage had managed to produce. In the course of my experiments I came to the conviction that I always knew beforehand that element to be discovered, that certain thing above all the others attached obscurely to each object; but this knowledge had lain as if lost in the depths of my thoughts.

Since this research could only yield one right answer for each object, my investigations were like problem solving in which I had three givens: the object, the entity linked with it in the recesses of my mind, and the light under which that entity would emerge.

The problem of the door called for an opening one could pass through. In *La réponse imprévue (The Unexpected Answer),* I showed a closed door in a room; in the door an irregular-shaped opening revealed the night.

Painting *La découverte du feu (The Discovery of Fire)* granted me the privilege of sharing early man's feeling when he gave birth to fire by striking together two pieces of stone. In my turn, I imagined setting fire to a piece of paper, an egg, and a key.

The problem of the window gave rise to *La condition humaine (The Human Condition).* In front of a window seen from inside a room, I placed a painting representing exactly that portion of the landscape covered by the painting. Thus, the tree in the picture hid the tree behind it, outside the room. For the spectator, it was both inside the room within the painting and outside in the real landscape. This simultaneous existence in two different spaces is like living simultaneously in the past and in the present, as in cases of déjà vu.

The tree as subject of a problem became a large leaf whose stem was a trunk with its roots stuck straight into the ground. In remembrance of a poem by Baudelaire, I called it *La géante (The Giantess).*

For the house, I showed, through an open window in the façade of a house, a room containing a house. This became *L'éloge de la dialectique (In Praise of Dialectic).*

L'invention collective (The Collective Invention) was the answer to the problem of the sea. On the beach I laid a new species of siren, whose head and upper body were those of a fish and whose lower parts, from stomach to legs, were those of a woman.

I came to an understanding of the problem of light by illuminating both the bust of a woman painted in a picture and the painting itself with the same candle. This solution was called *La lumière des coïncidences (The Light of Coincidences).*

La domaine d'Arnheim (The Domain of Arnheim) is the realization of a vision Edgard [sic] Poe would have liked: it shows a vast mountain shaped exactly like a bird with spread wings. It is

seen through an open bay window on whose ledge sit two eggs.

Woman gave me *Le viol (The Rape)*. It is a woman's face comprised of parts of her body: the breasts are eyes, the navel the nose, and the sexual organs replace the mouth.

The problem of shoes demonstrates how the most frightening things can, through inattention, become completely innocuous. Thanks to *Le modèle rouge (The Red Model)*, we realize that the union of a human foot and a shoe is actually a monstrous custom.

In *Le printemps éternel (The Eternal Spring)*, a dancer has replaced the genitals of a Hercules lying by the sea.

The problem of rain led to huge clouds hovering on the ground within the panorama of a rainy countryside. *La sélection naturelle (Natural Selection)*, *Union libre (Free Union)*, and *Le chant de l'orage (The Song of the Storm)* are three versions of this solution.

The last problem I addressed myself to was that of the horse. During my researches, I was again shown that I had known unconsciously long beforehand the thing that had to be brought to light. Indeed, my first idea was a vaguely perceived notion of the final solution: it was the idea of a horse carrying three shapeless masses whose significance I did not understand until after a series of trials and errors. I made an object consisting of a jar and a label bearing the image of a horse and the inscription in printed letters *Confiture de cheval (Horse Preserves)*. Next I imagined a horse whose head was replaced by a hand with the little finger pointing forward, but I realized that this was merely the equivalent of a unicorn. I dwelt for some time on one intriguing combination: in a dark room I placed a horsewoman sitting by a table, her head resting on her hand while she gazed dreamily at a landscape shaped like a horse. The horse's lower body and legs were the colors of the sky and clouds. What put me at last on the right track was a rider in the position one takes when riding a galloping horse; from the sleeve of the arm thrust forward emerged the head of a race horse, and the other arm, thrown back, held a whip. Next to this horseman, I placed an American Indian in the same posture, and suddenly I sensed the meaning of the three shapeless masses I had set upon the horse at the beginning of my experiments. I knew they were riders, and I finished off *La Chaine sans fin (The Endless Chain)* as follows: in a deserted landscape, under a dark sky, a rearing horse carries a modern horseman, a knight of the Late Middle Ages, and a horseman from antiquity.

Nietzsche believed that without an overheated sexual makeup Raphael would never have painted his hordes of Madonnas. . . . This is at

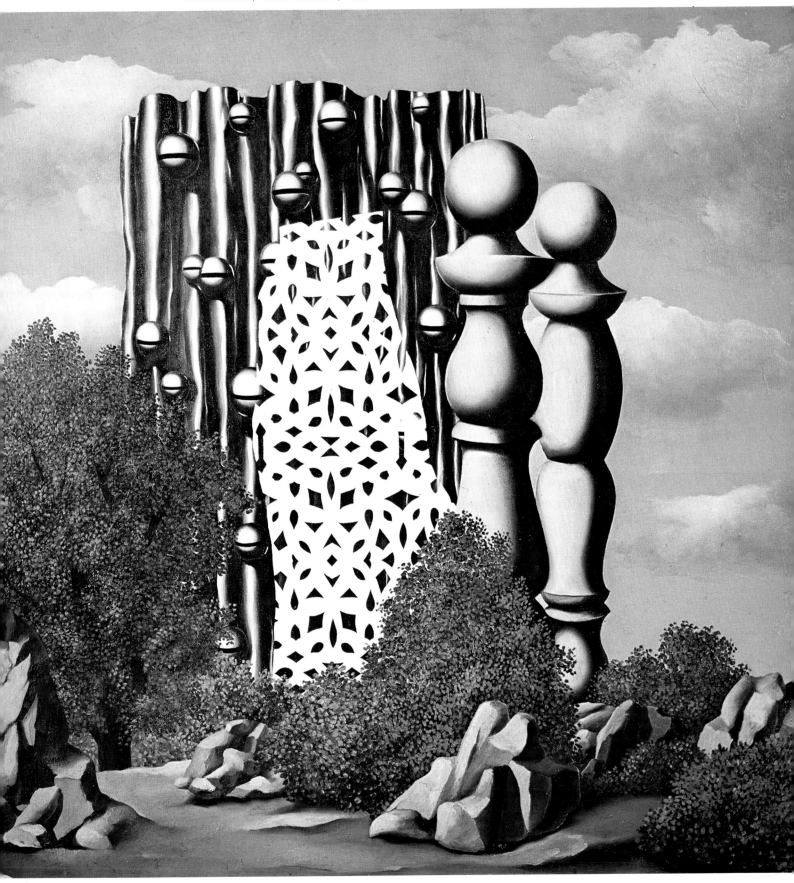

177. *L'annonciation (The Annunciation)*. 1930. Oil on canvas, 44⅞ x 57½" (114 x 146 cm). Private collection, Brussels, Belgium

178. *Le mois des vendanges (The Time of the Harvest)*. 1959.
Ink drawing, 7 x 10½″ (17.8 x 26.7 cm). Private collection,
New York, New York

179. *Le mois des vendanges (The Time of the Harvest)*. 1959.
Oil on canvas, 51⅛ x 63″ (130 x 160 cm). Private collection,
Paris, France

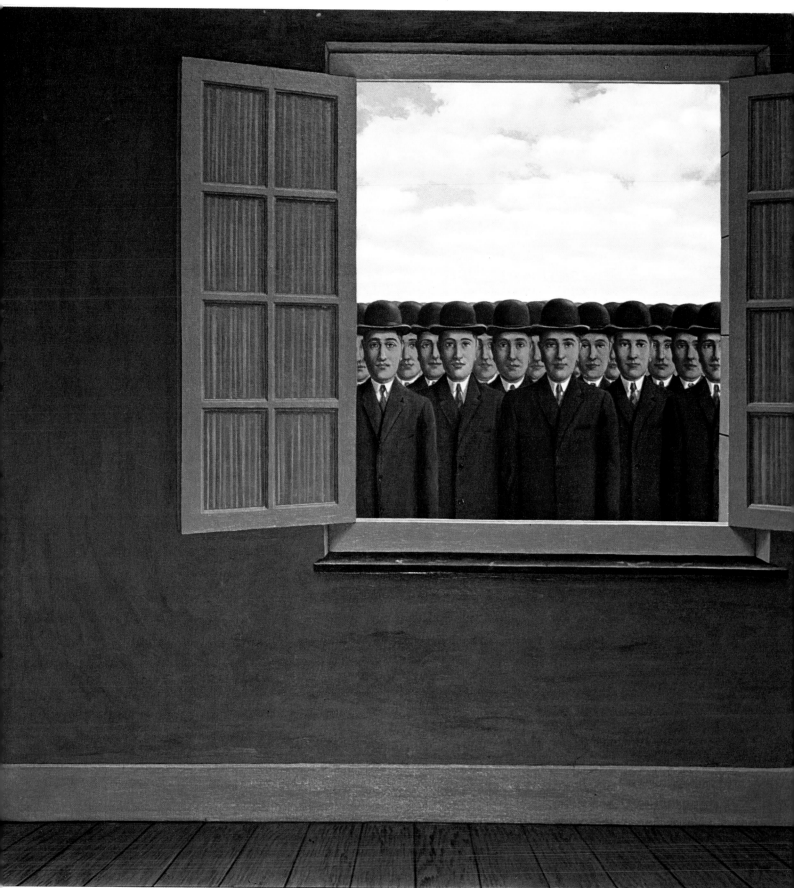

striking variance with the motives usually attributed to this Old Master; according to priests, it was the ardor of his Christian faith; aesthetes contend it was the desire for pure beauty, etc. . . . But [Nietzsche's] opinion brings us back to a healthier interpretation of pictorial phenomena. This disorderly world of ours, full of contradictions, keeps going more or less because of explanations, by turns complex and ingenious, that seem to justify it and render it acceptable to the majority of mankind. Such explanations account for one kind of experiment. It must be remarked, however, that what is involved is a "ready-made" experiment and that while it may give rise to brilliant analyses, this experiment is not itself based on an analysis of its own real circumstances.

Future society will develop an experiment that will be the fruit of a profound analysis, whose perspectives are being outlined under our very eyes.

It is thanks to a rigorous preliminary analysis that pictorial experiment as I understand it can now be set up. This pictorial experiment confirms my faith in life's unexpected possibilities.

All these overlooked things that are coming to light lead me to believe that our happiness, as well, depends on an enigma concerning man, and that our only duty is to attempt to understand it.

——René Magritte, lecture given November 20, 1938, at the Musée Royal des Beaux-Arts, Antwerp. A later abridged version, La Ligne de Vie II, dates from February 1940

The True Art of Painting

The effects of the art of painting are as numerous as the possible ways of understanding and practicing it.

The earliest drawings of prehistoric times required an immense mental effort from the caveman, not only to conceive them, but also to *dare* to conceive them despite the prejudices that held sway.

It is extremely likely that the first draftsman was killed for practicing black magic, and afterwards, when people had grown used to it, other draftsmen probably came to be regarded as gods, and finally, in the dawning age of heraldry, as mere disseminators of information.

In the twentieth century, these different prehistoric ways of understanding the art of painting persist. The painter who desires spiritual freedom still encounters widespread hostility, the official painter is an honored figure, the commercial painter is a salaried employee commissioned to decorate bordellos, churches, department store windows, advertising posters, and other means of modern propaganda.

Archaeology, both past and present, made note of all the methods of painting. But this reckoning is not very useful to someone who is looking for a manner of painting that would be useful to mankind.

The art of painting is an art of thinking, and its existence emphasizes the importance to life of the human body's eyes; the sense of sight is actually the only one concerned in painting.

The goal of the art of painting is to perfect sight through a pure visual perception of the exterior world by means of sight alone. A picture conceived with this goal in mind is a means of replacing nature's awesome spectacles, which generally require only a mechanical functioning of the eye because of the familiarity that obscures such repetitious or predictable natural phenomena. On the other hand, should nature suddenly take on a threatening aspect, it is not only sight but also the other senses—hearing, smell, touch, taste—that help throw us into a state of panic hardly conducive to our making fruitful contact with the exterior world.

Thus we see that a painter is mediocre if he doesn't give special consideration to the importance of his spectators' eyes. One example of a mediocre painting would be one executed to flatter a rich banker's patriotic sentiments and libidinous proclivities. It might show the banker before an unfurled flag, one arm brandishing an unsheathed sword and the other holding a lovely, swooning woman, her flesh revealed by a dress that has been torn by some routed barbarian. Clearly sight plays no especial role in such a painting: it presents the same painful spectacle as the sight of the door to a safe. The painting may be useful to the banker as an erotic or heroic stimulant, but these utterly banal excitements do not allow for a pure visual perception of the exterior world.

A less mediocre painter, one who recognized that the sole aim of painting is to involve the sense of sight, would still misunderstand this aim if he executed a painting like the following: a blindfolded man walking through a forest is being approached by a murderer armed with a knife. This would be a mistake, because although the man's sight would be necessary for his survival, it only becomes important at this moment of danger due to a temporary feeling of anxiety. This picture would mean that if it weren't for the murderer the man's sight would be less important.

Modified, the same subject could give way to the following: a blindfolded man walking through a forest (without a murderer). In this case the importance of the man's sense of sight would undoubtedly be called into question, but not as effectively as it would if the spectator's own eyes were given the opportunity to realize their full potential.

To achieve this result, the painter must invent his pictures and bring them to completion under very difficult circumstances. He must start off with a contempt for fame and thus forgo the material comforts that might enable him to work in peace. He must have contempt for fame, since in order to win that fame he would have to paint mediocre pictures like those described earlier. Fame will come on its own, or it won't. (The fame of Da Vinci, Galileo, [or] Mozart adds nothing to their achievements.)

In addition to a life subject to ridicule, insult, or worse (since he will be considered a humbug or degenerate), the painter is constantly faced with professional problems because his way of understanding and practicing the art of true painting obeys an implacable law: the perfect picture does not allow for meditation, which is a feeling as banal and uninteresting as patriotism, eroticism, etc. The perfect picture produces an intense effect only for a brief moment, and the feelings that recall the initial response are to a greater or lesser degree mitigated by habit. This inexorable law forces the painter to outdo himself with each new picture, not in the sense of some futile elaboration but rather as a productive renewal. In accordance with this law, the spectator must be disposed to experience a moment of unique awareness and to admit his powerlessness to prolong it. This unique contact for the spectator takes place in front of the picture (the first spectator is the painter himself), and it is vital at the moment this contact is made that the picture not be divorced from the wall on which it is hung, the floor, the ceiling, the spectator, or from anything else that exists.

The special problems the painter must resolve are psychological in nature. The painter must not allow himself to be led astray by the technique of the art of painting, which has been further complicated by the succession of different manners of painting that have emerged over the past century. The caveman's simple linear representation was replaced by the same representation increasingly perfected so as to fill in the body's outline with its apparent volume. The science of perspective and the study of anatomy placed at the painter's dis-

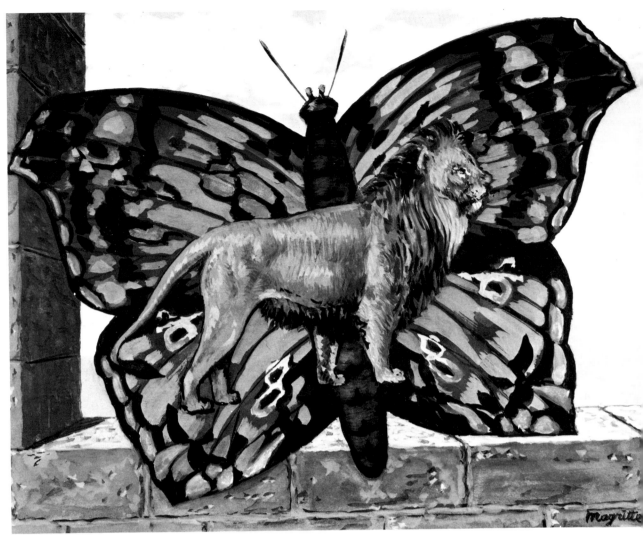

180. *La place au soleil (The Place in the Sun)*. 1956. Gouache, 6¼ x 8⅛" (16 x 20.5 cm). Galerie Isy Brachot, Brussels, Belgium

posal infallible means for achieving trompe l'oeil effects to the point where easy experiments can leave no room for doubt of this fact.

About 1900, at the moment when this technique had reached perfection, it became clear that it was operating in a vacuum: the countless landscapes and portraits were unable, despite their numbers, to inspire anything but boredom.

The century began with discoveries that replaced old techniques with new ones in every field of endeavor. Painters, tired of lifeless painting, joined in the general infatuation with technique and attempted to give painting renewed youth. The cinema showed them images in motion on a screen, and this astonishing novelty incited them to compete with it. Unfortunately, the problem was badly posed. The technique of the art of painting having been perfected, it was useless to seek painting's rejuvenation in still another technique. In fact, a perfect technique of the art of painting was available, but it was being used without intelligence or effectiveness while the clumsy technique of the newborn art of cinema still derived its effects from its novelty.

So painters, misunderstanding the problem of painting, cast about for new techniques, and through them managed to restore to painting a few fleeting moments of superficial vitality. The

Impressionists, Cubists, Futurists, all experienced moments of agitation and excitement due to original techniques, but they were futile, since these same moments of agitation and excitement could be achieved, and better, through other means than those related to painting.

Now that these technical experiments have come to an end (along with their successors such as abstract or nonfigurative art, Constructivism, Orphism, etc.), the technical problem can be posed to the painter correctly as a function of the desired result; and the great importance of technique, assuming one has mastered it, can be restored to its proper proportions as a *means.*

Since the true goal of the art of painting is to conceive and execute paintings that are able to give the viewer a pure visual perception of the exterior world, the painter must not contravene the natural workings of the eye, which sees objects according to a universal visual code: for example, the eye perceives the object "sky" as a blue surface. If the painter wishes to give a pure visual perception of the sky, he must employ a blue surface, adopting all the visual characteristics of that surface (nuances, perspective, luminosity, etc.). This presents no technical problem to the painter who has mastered the technique necessary to represent this blue sur-

face, which, for the sense of sight, is all that is needed to depict the sky. However, it does present a psychological problem: how can the sky be represented according to the desired result? What should be done with the sky? There are some fine possibilities open to us; we have only to know how to use them. Some solutions will be found in the painter's technique, while others are better suited to the cinematographic technique, which is also capable of creating pure visual perception. Thus, the idea of an immobile flash of lightning can be of little help to a painter, since this image in a painting would be associated with the idea of its flashing movement; whereas on a screen, by means of simple trick photography, the spectator could see a stroke of lightning immobilized in a tumultuous sky. In this regard, the cinema ideally should, like painting, obey the psychological law mentioned earlier and only show a stroke of lightning long enough for the eyes to register its immobility, because once this moment has passed the lightning's immobility will become devoid of any interest.

For the painter, the search for ways to convey the sky, a pipe, a woman, a tree, or any other object, is his principal labor. This work is carried out in total obscurity, even though [the painter] must protect his sense of freedom within his

obscurity if he wants to keep from being carried off course by the magnetic pull of chance.
——René Magritte, Le Véritable Art de Peindre, 1949

I am thinking of further researches, because of the idea I had about what could make certain pictures valid. Their realization depended on the exactness of the solutions found for the problems that had been posed, in the following manner: once an object or any subject had been chosen as a question, another object had to be found in answer, one secretly linked to the first by complex bonds so as to verify the answer. If the answer asserted itself, self-evident, the union of the two objects was striking. . . .

The researches that led up to these revelations were undertaken, I realize now, to find a unilateral, irreversible meaning in some objects. Although the answers clarify the questions, the questions do not clarify the answers. If the dagger is the answer to the rose, the rose is not the answer to the dagger; neither is water to the boat, nor the piano to the ring. This verification allows us to go on to investigate the answers that are also questions, resolved by the objects that originally played the role of questions. Is this possible? It seems to demand that the human will attain that quality Edgard [sic] Poe attributes to divine works, "where cause and effect are reversible." If we can conceive this quality, it is perhaps not impossible for us to attain it through a process of enlightenment.
——René Magritte, La Carte d'Après Nature, no. 1, October 1952

I had a little idea: instead of writing a strange word under an object, I thought of trying to paint a plum on a pear, or something else, such as a locomotive on a recumbent lion, etc.
——Letter from René Magritte to Mirabelle Dors and Maurice Rapin, February 14, 1956

I'm also sending you a sketch of a variant of La place au soleil (The Place in the Sun). It occurs to me that this image could be joined successfully with a volume of La Femme Assise (The Seated Woman)*. Be joined with, not illustrate.
——Letter from René Magritte to Mirabelle Dors and Maurice Rapin, February 24, 1956

*By Guillaume Apollinaire

I'm continuing La place au soleil. The latest thing I've done is the delineation of the Egyptian scribe on a lovely apple.
——Letter from René Magritte to Mirabelle Dors and Maurice Rapin, March 13, 1956

I would reproduce six different paintings* of La place au soleil, including:
 The scribe "on" the apple
 Botticelli's Primavera "on" a bowler-hatted individual seen from behind
 Gérard's Madame Recamier "on" her chair
 A bird "on" a leaf, and two other pictures whose objects remain to be found. . . .
 The origin that I know for La place au soleil was an often overlooked "chance." On sketches we often see indications that remind the painter of what he has seen: one painter, for example, writes "pale green, red," etc., on his sketches. On a map

" La Place au Soleil "

181. Pen sketch in a letter from René Magritte to Mirabelle Dors and Maurice Rapin, February 24, 1956

183. Drawing for *Le bouquet tout fait (Ready-Made Bouquet).* n.d. Collection Robert Rauschenberg, New York, New York

182. *La place au soleil (The Place in the Sun).* 1956. Oil on canvas, 19⅝ x 25⅝" (50 x 65 cm). Private collection, Brussels, Belgium

made to give directions, we write: "road to . . . square, theater, etc. . . ." On an architect's plan: "room, corridor, garden, etc. . . ."

The words written on drawings are not put there without some mental process. "Chance" intervenes when one realizes one can write words on a drawing not to "inform," but just to write them, to describe a drawing on which words are written. And these words are not meant to be decorative motifs, but rather to be joined with images—to the extent of words that mean what they designate; to the extent of images that represent objects. . . .

La place au soleil is an "objective stimulation," if you like, with the difference that the image placed "on" another takes on an even stranger character: instead of an apple "on" the same apple, we have a scribe.
——*Letter from René Magritte to Mirabelle Dors and Maurice Rapin, March 21, 1956*

*For a book whose title, La Place au Soleil, would relate to these new images.

I have continued my *Places au soleil* [sic], but see how the title is no longer good for a big tree in the evening on which one sees a crescent moon! In this case, we are given a better, or in any event another, description of *La place au soleil:* what we see on one object is another object hidden by the one that comes between us and the hidden object.
——*Letter from René Magritte to Mirabelle Dors and Maurice Rapin, April 20, 1956*

I have just painted the moon on a tree in the blue-gray colors of evening. Scutenaire has come up with a very beautiful title: *Le seize septembre (September Sixteenth).* I think it "fits," so from September 16th on, we'll call it done.
——*Letter from René Magritte to Mirabelle Dors and Maurice Rapin, August 6, 1956*

One can question the obligation to experience a feeling "determined" by what we look at. Something familiar is sometimes seen with a feeling of strangeness, and we can have a familiar feeling with regard to so-called mysterious things. In both possibilities, one finds the union either of a feeling of strangeness, the familiar object, and ourselves, or of a familiar feeling, the mysterious object, and ourselves. This does not imply that our feelings are "determined," nor that the painter can decide which feeling a painting ought to inspire. It should be noted in this regard that everything that is "determined" (or rather is considered to be) conspicuously lacks charm and interest: we don't really like a picture upon learning what it has

allegedly "determined." It is immediately "lost sight of" in favor of a tedious and irrelevant commentary.

The feeling we experience while looking at a picture cannot be separated from either the picture or ourselves. The feeling, the picture, we, are joined in our mystery.
——*Letter from René Magritte to Paul Colinet, 1957*

If painting were obliged to express emotions or set forth ideas, I would express neither optimism nor its opposite.

We cannot be too unsure of the effectiveness of our so-called power of expression. What we feel when looking at a painting, or when looking into a blue distance, for example, does not imply that we are "determined" by what appears to us. Yet painting—like the blue distance and everything else—reveals images of the world, and it can happen that in looking at them, painting them, thinking about them, we have this unfamiliar feeling of our mystery—one we also have sometimes with our eyes closed.
——*Letter from René Magritte to Paul Colinet, 1957*

Things are neither as simple nor as complicated; in my opinion, the *theme* consists of the following: *a picture inside out*—whatever the subject it represents in this way—within something (like a landscape) right side out. One version of the picture *Le réveille-matin (The Alarm Clock)* would be possible by representing a face (or a landscape) on the inside-out picture. But if I paint on an easel representing, for example, an afternoon sky (right side out) against a nocturnal sky (right side out), it's another "theme," although there's still a picture and an easel.

I'm called a "Surrealist," but I don't worry about it. I sometimes care about stating clearly certain ideas that are completely useless. I consider "wasting one's time" in this way is as good as another. Like everyone, I believed in the existence of the "unconscious" as though I really needed to believe in it. I've given that and other things up without feeling diminished or extended and without becoming simpler or more complicated.
——*Letter from René Magritte to Defosse, February 3, 1958*

"Large formats." Their dimensions alone produce an "effect." Any idiot's picture enlarged on a 50-yard-high surface set up in a field would create a sensational "effect." I am wary of such an effect, and that of miniatures. . . .

The question of "going beyond" art seems to exist on a level that means nothing to me. I "paint pictures," officially I am an *artiste-peintre*. I'm neither this side nor the other of artistic thought: I think I'm somewhere else.
——*Letter from René Magritte to Maurice Rapin, March 31, 1958*

Attached are the replies I made during an interview that's supposed to be broadcast. I hope they amuse you. Yours, René Magritte.

1. René Magritte, at this moment an exhibition of your paintings is being held at the Museum of Ixelles. I believe it's a retrospective, isn't it?

Yes, it is. The Museum of Ixelles has hung almost a hundred pictures chosen from among those I painted from 1926 to fairly recently.

2. How do you feel when you see your works again some time after having painted them?

My feeling is that I didn't do too badly in painting pictures that can surprise me as though I hadn't actually created them.

3. Don't you feel somewhat paternal when you see such a large exhibition of your work?

Of course, but with the perplexity of a father who doesn't really know why his children turned out so beautiful or ugly.

4. If you, the painter, are perplexed when you look at your paintings, it's understandable that people visiting your exhibition are confused, especially if they have some aesthetic preference for painters they feel they can more easily understand.

It's not only understandable, but I think it demonstrates that if certain things seem familiar or "nonperplexing" to us, it's because of notions that make them pass as such. I've taken care to paint precisely those pictures that don't have a familiar look and have nothing to do with naïve or sophisticated notions.

5. One could say, then, that you avoid like the plague expressing ideas in your painting?

I avoid it as much as possible. I feel that words express enough ideas, sometimes very beautiful ones but all too frequently tedious, without painting having to add its own. As I see it, painting is not meant to express ideas, even ideas of genius. If the painter has genius, he has a genius for images, not for ideas.

6. But don't the titles of your paintings evoke ideas?

Perhaps, since even a misunderstood word can evoke the idea that there is meaning. But the words we do understand do not always necessarily evoke ideas. The title of a picture is an image made up of words. It joins up with a painted image without trying to satisfy a need to understand ideas. The title and the picture enrich and refine thought, which enjoys images whose meaning is unknown.

7. I'm tempted to ask you why thought enjoys images with unknown meanings?

It seems obvious that enigmas and puzzles are appealing to thought. The game consists in finding what is hidden. But the game has nothing to do with images whose meanings remain unknown. I believe that thought enjoys the unknown, that is to say, what is unknowable, since the meaning of thought itself is unknown.
——*Letter from René Magritte to André Bosmans, April 16, 1959*

The pictorial language, like other languages, evokes mystery de facto if not de jure.

I try—insofar as possible—to paint pictures that evoke mystery with the precision and charm necessary to the realm of thought. It's obvious that

184. *Le réveil-matin (The Alarm Clock)*. 1953. Oil on canvas, 20½ x 24⅝" (52 x 62.5 cm). Private collection, Rome, Italy

this precise and charming evocation of mystery is composed of images of familiar objects, brought together or transformed in such a way that they no longer satisfy our naïve or sophisticated notions.

In coming to know these images, we discover the precision and charm that are lacking in the "real" world in which they appear.
——*René Magritte, Preface to exhibition catalogue,* René Magritte, *Musée d'Ixelles, April 19, 1959*

An image (after having been conceived with the sole intention of creating a beautiful image) can be successfully joined with a text. . . . The word "illustration" should be eliminated. It is the "joining" of an existing text with an image chosen from among preexisting images that establishes the felicitous encounter between images and words. . . .
——*Letter from René Magritte to André Bosmans, May 11, 1959*

This manner [of representing the image] is indispensable, otherwise there is no visible representation of the image. What is superfluous and best avoided are the originality, fantasy, and awkwardness that can become part of the manner.
——*Letter from René Magritte to André Bosmans, October 1960*

Have thought some more about the "art of mime." It must be avoided as far as possible. Mime "ex-presses" emotions (if one indeed recognizes a certain facial expression as expressing a specific emotion, as taught us by convention).

If you could tell Dallas that my painting is wholly alien to anything conventional, it would be wonderful, but would it be difficult to say? Especially since in Dallas they seem so taken with the notion of mimicry!

I'm giving you a lot of problems, but fortunately they are only those befitting a magnificent and outstanding ambassador.
——*Letter from René Magritte to Harry Torczyner, October 21, 1960*

I'm happy to learn that you put "squarely" to Dallas what I thought about comparing mime and my painting. I particularly maintain that my painting *expresses nothing* (nor do other paintings, for that matter). Just because painting corresponds to (or engenders) some of our feelings doesn't mean it expresses them. To believe it expresses feeling would be to admit, for example, that an onion expresses the tears we shed when peeling it. The tear-onion peeling relationship is an obvious and inevitable one (except for those with blocked tear ducts). The painting-emotion relationship is just as clear (except for the blind or the wooden). But the conclusion—onion expressing tears or painting-onion the emotions we feel upon looking at

it—is one of those mistaken notions whose elimination is a utopian dream. (A brave man asked me only yesterday, "What painting 'expresses' joy?"! With all the goodwill in the world, I was unable to make him understand that it was the painting he took joy in looking at.)
——*Letter from René Magritte to Harry Torczyner, October 24, 1960*

As for the onion story—written in a letter—if it is to be printed. I think it should be "cleaned up" as follows:

There is a mistaken idea about painting that is very widespread—namely, that painting has the power to express emotion, something of which it is certainly incapable. It is possible that one may be moved while looking at a painting, but to deduce by this that the picture expresses an emotion is like saying, for example, that a cake "expresses" the baker's feelings and expresses the pleasure we derive from tasting it. . . . (I've replaced onion with cake, thereby avoiding the objection that the onion is not [like the picture] a manmade object.)
——*Letter from René Magritte to Harry Torczyner, November 1960*

Mr. McAgy has unintentionally given me the opportunity to clear up this question of "expression": a mime doubtless "expresses" emotions, if one agrees that this or that grimace is the expression of this or that feeling. Without forgetting that the mime is not expressing his own feelings—in fact, he can express goodness and yet be wicked and thoroughly incapable of a good action—without forgetting this, can we still believe that what he is expressing deserves to be called an expression of goodness? And what interest does this kind of caricature of expression have?
——*Letter from René Magritte to Harry Torczyner, November 14, 1960*

Resemblance—as the word is used in everyday language—is attributed to things that have or do not have qualities in common. People say "they resemble each other like two drops of water," and they say just as easily that the imitation resembles the original. This so-called resemblance consists of relationships of similarity and is distinguished by the mind, which examines, evaluates, and compares. Such mental processes are carried out without being aware of anything other than possible similarities. To this awareness things reveal only their similar qualities.

Resemblance is part of the essential mental process: that of resembling. Thought "resembles" by becoming what the world presents to it, and by restoring what it has been offered to the mystery without which there would be no possibility of either world or thought. Inspiration is the result of the emergence of resemblance.

The art of painting—when not construed as a relatively harmless hoax—can neither expound ideas nor express emotions. The image of a weeping face does not express sorrow, nor does it articulate the idea of sorrow: ideas and emotions have no visible form.

I particularly like this idea that my paintings *say nothing.* (Neither, by the way, do other paintings.)

There is a mistaken idea about painting that is very widespread—namely, that painting has the

power to express emotion, something of which it is certainly incapable. Emotions do not have any concrete form that could be reproduced in paint.

It is possible that one may be moved while looking at a painting, but to deduce by this that the picture "expresses" that emotion is like saying that, for example, a cake "expresses" the ideas and emotions of those of us who see it or eat it, or again, that the cake "expresses" the thoughts of the chef while baking a good cake. (To the man who asked me, "Which is the picture that 'expresses' joy?" I could only answer "The one that gives you joy to see.")

The art of painting—which actually should be called the art of resemblance—enables us to describe in painting a thought that has the potential of becoming visible. This thought includes only those images the world offers: people, curtains, weapons, stars, solids, inscriptions, etc. Resemblance spontaneously unites these figures in an order that immediately evokes mystery.

The description of such a thought need not be original. Originality or fantasy would only add weakness and poverty. The precision and charm of an image of resemblance depend on the resemblance, and not on some imaginative manner of describing it.

"How to paint" the description of the resemblance must be strictly confined to spreading colors on a surface in such a way that their effective aspect recedes and allows the image of resemblance to emerge.

An image of resemblance shows all that there is, *namely, a group of figures that implies nothing.* To try to interpret—in order to exercise some supposed freedom—is to misunderstand an inspired image and to substitute for it a gratuitous interpretation, which, in turn, can become the subject of an endless series of superfluous interpretations.

An image is not to be confused with any aspect of the world or with anything tangible. The image of bread and jam is obviously not edible, and by the same token taking a piece of bread and jam and showing it in an exhibition of paintings in no way alters its effective aspect. It would be absurd to believe [this appearance] capable of giving rise to the description of any thought whatsoever. The same may be said in passing to be true of paint spread about or thrown on a canvas, whether for pleasure or for some private purpose.

An image of resemblance never results from the illustration of a "subject," whether banal or extraordinary, nor from the expression of an idea or an emotion. *Inspiration gives the painter what must be painted:* that resemblance that is a thought capable of becoming visible through painting—for example, an idea the component terms of which are a piece of bread and jam and the inscription, "This is not bread and jam"; or further, an idea composed of a nocturnal landscape beneath a sunlit sky. De jure such images suggest mystery, whereas de facto the mystery would be suggested only by the slice of bread and jam or the nocturnal scene under a starry sky.

However, all images that contradict "commonsense" do not necessarily evoke mystery de jure. Contradiction can only arise from a manner of thought whose vitality depends on the possibility

[Autobiographical statement in René Magritte's handwriting:]

Après avoir suivi les cours de l'académie des Beaux Arts, en 1916 et 1917, j'ai cherché avec les moyens dont je disposais comment peindre des tableaux qui ne me soient pas indifférents (la peinture dite " d'expression de sentiments " me laissant indifférent et, d'autre part, la peinture bornée aux effets picturaux purement formels ne me paraissant pas valoir la peine d'être regardée) j'ai essayé avec l'aide des théories futuristes, cubistes et dadaïstes — de peindre d'une manière satisfaisante. Ce fut une période de recherches qui a duré près de dix années, sans être convaincantes. C'est vers 1926 que ces diverses recherches ont été abandonnées grâce à ce que je considère comme étant la révélation de ce qu'il fallait peindre : ce qu'il fallait peindre était ce qu'il faut peindre à présent, en 1962. Ce qu'il faut peindre se borne à une pensée qui peut être décrite par la peinture. Etant donné que les sentiments et les idées n'ont aucune apparence visuelle, cette pensée (qui peut être décrite par la peinture et devenir visible) ne comprend aucune idée ni aucun sentiment. Elle s'identifie à ce que le monde apparent offre à notre conscience — Cependant, cette pensée n'a pas la passivité d'un miroir = elle est éminemment active, elle unit-dans l'ordre qui évoque le mystère du monde et de la pensée — les figures du monde apparent = ciels, personnes, rideaux, inscriptions, solides, etc — Il est à remarquer que cette pensée (qui vaut la peine d'être décrite par la peinture) n'"assemble" pas n'importe quoi, ne "compose" pas = elle unit les choses de telle sorte que ces choses visibles évoquent le mystère sans lequel il n'y aurait rien. Comme exemples, un paysage nocturne sous un ciel ensoleillé et une montagne en forme d'oiseau, (d'autre part) démontrent que la peinture-telle que je la conçois.— n'est pas orientée par des recherches formelles, mais concerne la pensée, exclusivement par son manque de solution de continuité avec le monde et son mystère.

René Magritte
le 20 mars - 1962

of contradiction. Inspiration has nothing to do with either bad or good will. Resemblance is an inspired thought that cares neither about naïveté nor sophistication. Reason and absurdity are necessarily its opposites.

It is with words that titles are given to images. But these words cease being familiar or strange once they have aptly named the images of resemblance. Inspiration is necessary to say them or hear them.
——*René Magritte, statement in exhibition catalogue* René Magritte in America, *the Dallas Museum for Contemporary Arts and The Museum of Fine Arts of Houston, 1960*

. . . the word *illustrator* (here in its true sense: one who renders illustrious) also means in other cases something we should be wary of. An image that accompanies a text—if it is valid—is never an "illustration," and it never results from an illustrator's procedure. Yes, there are sometimes pleasant illustrations, but they add nothing to the text illustrated. However, an image conceived with no thought other than its conception can felicitously *join* a text and enrich it by accompanying it. Then it's not a question of illustration, nor of pleasant art.
——*Letter from René Magritte to Pierre Demarne, July 22, 1961*

185. Autobiographical statement by René Magritte, March 20, 1962. *See* Appendix *for translation*

186. *L'idole (The Idol).*
1965. Oil on canvas,
21¼ x 25⅝" (54 x 65 cm).
Private collection,
Washington, D.C.

AFTERWORD

Today, René Magritte has become a more powerful presence than ever before.

"Two works appeared one after the other in 1977 and 1979: *Ideas and Images* by Harry Torczyner, and *The Complete Writings of Magritte* assembled by André Blavier (Paris: Flammarion). This, in my opinion, was a major event leading to the knowledge of the man, the artist, and the oeuvre," writes José Pierre in his *Magritte* (Paris: Somogy, 1984, p. 12).

Since my book was first published eight years ago, the painting *Decalcomania,* reproduced on the jacket, was stolen from Baron Chaim Perelman, a professor of philosophy and logic, and his wife, Fella, friends of the painter, on a quiet weekend in a quiet neighborhood in Uccle, Belgium. The circumstances were so mysterious that they could have been concocted by one of the detective-story writers Magritte loved so much.

As the tale is told, the thieves belonged to a gang of spoiled, rich youngsters, who, after the robbery, panicked and, rather than return the masterpiece, destroyed it. The story was perhaps planted by the real thieves. The painting may still be around and may surface again, as has happened before with other works of the artist.

Battalions of philosophers of all nationalities, famous, less famous, or unknown, have illustrated their publications with the images of the painter in order to elaborate on his work or in order to fit his work to their doctrine, theory, or preference. They have an alibi: the intellectual company kept by Magritte as reflected by his life, his correspondence, and the volumes of his library.

Museum directors, art historians, critics, and essayists find a cosy shelter for their musings in the catalogues of the numerous Magritte exhibitions which tour the world, including finally Paris.

Psychiatrists and psychoanalysts have a field day with the oeuvre of Magritte. The fact that the artist disbelieved and disliked them perversely stokes the fires of their unrelenting enthusiasm. His widow, Georgette, still strong and well, and the surviving friends of the artist, wherever they reside, can count on a call at least once a month by followers of Freud or Jung or Adler or Reich or Lacan, and this nomenclature is far from complete.

They must all feel frustrated now that David Sylvester has definitively disposed of the romanticized account given by Louis Scutenaire of the circumstances surrounding the suicide of Magritte's mother.

As told by Scutenaire, her face was covered by her nightgown when her body was found in the river Sambre within hours of her disappearance. Every detail of this tale is wrong. David Sylvester documents the way she was dressed on the night of her disappearance, and the fact that while Magritte's mother drowned on February 24, 1912, her body was only recovered on March 12. It had spent nearly three weeks in a polluted river, and was first taken to the faraway house of a stranger before being finally returned to the family home.

During his lifetime Magritte was totally indifferent to what was written about his person, even by a close friend. He was always deeply concerned about whatever was said or written about his work. Magritte never discussed with anybody the tragedy of his mother's death. The implicit *démenti* of the myth was issued by Magritte himself. In Nice on June 2, 1964, in my room at the now gutted but then palatial Hotel Ruhl, he related his encounter with a short, bearded priest whom he had met at the post office and invited to the house. There he sees *La magie noire (Black Magic,* painted in 1935):

> I never knew women were made differently from men, but recently while administering Extreme Unction and annointing the feet of a dying woman, the sheet slipped off.

Perhaps this priestly reportage is the source of the legend (see p. 24), which has become the credo of a succession of repetitive authors who, misled, misinterpret the work of the painter.

Too little importance has been attached to Magritte, the craftsman. Magritte was proud of the perfect control of his movements in handling brush and paint. He was as meticulous in painting as in writing. His calligraphy corresponds to his brush strokes. Many problems were technical, and their technical solution was sometimes interpreted arbitrarily by critics and art historians as having a profound meaning.

In a composition, the inclusion of an object could be dictated not by inspiration but by technical necessity.

In 1962, when Magritte painted *La peine perdue (Wasted Effort),* two large standing blue curtains made out of clouds, with a small light blue curtain on each side, he posited one of his "bells" at the left of the canvas, telling me: "I put this object there as a pictorial device because it pulls the painting together."

Painting *L'arc de triomphe (The Arch of Triumph),* a tree and its leaves, he said that it was in response to a challenge to paint an object together with its component parts and to use only shades of blues and greens.

When my friends Evi and Denise asked why he seemed to place himself in front of the stone "balustrade" which appears in so many of his paintings, he wrote to me on May 2, 1958:

> I could answer something which does perhaps not sound very bright: I have to be somewhere, yes, always on the same side of the "balustrade" to see and to look. One has to be on one side, because the other sides are taken by others than myself, and each side is particularly convenient to the person who occupies it.

Some weeks later, in conversation, Magritte added that stone balustrades or low stone walls were used by him both to frame the image and to serve as a personal sign, a trademark signaling that this was a painting by Magritte. He told me the same thing about the use of curtains in some of his paintings. I

remember Magritte being furious when, in the mid-sixties, Paul Delvaux used a curtain in one of his works.

Magritte did not have any consideration for what he called, ironically, the "unique original." In 1966, we exchanged correspondence about a method called Kamagraphie, which he wanted to test for one of his paintings. "The original oil painting can be perfectly reproduced two hundred times, but the original is destroyed in the process." These two hundred multiples, indistinguishable from one another, would represent two hundred originals according to Magritte.

At the same time, he was resentful of imitation or plagiarism, so often disguised as "Homage to Magritte." He wanted his own images legitimately to populate the earth.

Forged paintings attributed to Magritte are increasingly numerous. They are manufactured by specialists, mostly in Belgium and Italy, and often marketed in the United States. I had a number confiscated in New York. Some were clumsy, but some were so clever that reputable dealers had been taken in.

Today, the work of Magritte inspires the theater, the ballet, film, and television. Above all, the world of advertising uses, abuses, and misuses the images and the ideas of Magritte. Obviously there is an interaction between the work of Magritte and the advertising world's inexhaustible need for visual means of persuasion. A body of work meant to be subversive in order to liberate man is exploited in order to condition man.

At one time I discussed Truth with Magritte. The occasion was a request to illustrate a quote from John Milton's "Aeropagitica" on the victory of truth: "Though all the winds of doctrine were let loose to play upon the earth, so Truth be in the field, we do ingloriously...to misdoubt her strength. Let her and Falsehood grapple: who ever knew Truth put to the worse in a free and open encounter?"

He sent me the gouache of a bowler-hatted man with his back to the viewer, a loaf of bread and a glass of water painted on his black coat, facing a stormy sea, with a sailing ship tossed by the waves under a dark sky filled with bolts of lightning. Afterward Magritte, on March 24, 1958, wrote a text to go with the gouache:

> This is Truth, the essence of which is mystery and not a relative truth about which Pascal, for example, said "a truth which is truth here and not truth there." The Truth (which no philosopher has ever exactly defined) is unknown. We do not see the face. Neither do we see the face of the personage painted by Magritte. He is like Truth. He is true—there are in him two elements, simple and pure (simple and pure as one assumes truth to be), to wit, a loaf of bread and a glass of water...The personage who is vested with Truth is impassive. He gives the feeling that the spectacle of the unleashed forces of evil has no power to infringe upon his integrity. The contrast between the firmness of this personage and the disorder, the fury of the elements, is the same as the contrast between the doctrinary tempests unleashed against the Truth of which he was thinking.

Was this a self-portrait?

Some twenty years ago, René and Georgette Magritte visited New York. On a rainy winter day, I accompanied them to the house of Edgar Allan Poe in the Bronx. There was a big armoire, and on the top of it a stuffed raven. It looked like a stage set, a somewhat dusty decor, but Magritte wanted it to be real, willed it to be true, and it became all true, as tears came to his eyes. Silent, for a moment he stood still amidst memories that had inspired him, then suddenly he left, we followed, he never to come back, and always to remain present.

HARRY TORCZYNER

New York, New York
January 8, 1985

APPENDIX/TRANSLATIONS

This appendix contains English translations of the fifty-one letters and documents printed in facsimile in the text either in whole or in part. The figure number of each facsimile illustration, together with the number of the page on which it appears, has been provided for each item in this appendix.

1 Fig. 13 (page 20)
Letter from René Magritte to Paul Colinet, 1957

Latest idea; *Hope is well-being*
Dear Friend,
30 rue Paul Spaak. $30—3+0 = 3—3 \times 3 = 9$
The die is cast, we are leaving *Jette* on the 18th.
You will have already noticed that 18 consists of 1 and 8, thus $1+8 = 9$.
You will also, I'm sure, have noticed that the *home* we are living in is 1 *home,* the one we left makes another 1, and the one we are moving to another 1. Together, they make 3 *homes,* and the number 3 multiplied by itself gives 9.
(The number in brackets is the same as the 9-month formation of a baby.)
Fine. The *home* we left in Paris before we moved to Jette was number 201, or $2+0+1 = 3$, $3 \times 3 = 9$
Our *home* in Jette was $135—1+3+5 = 9$
The *home* we will soon be in bears the number $207—2+0+7 = 9$
The number 9, multiplied by itself, gives 81, and $8+1 = 9$
What do you think?
It's on the Boulevard Lambermont, Brussels, 3, thus $3 \times 3 = 9$
Would you work out a formula for changing addresses that I could have printed up for distribution? For and until Friday evening, or 11 o'clock with the [?]? I hope,

Mag.

2 Fig. 16 (page 21)
Letter (excerpt) from René Magritte to Maurice Rapin, December 20, 1957, showing floor plan of the Magritte house at 97 rue des Mimosas, Brussels, Belgium

The house I've just rented is also a question mark. Since my wedding, I've always lived in apartments. Will I be too "calm" there?
Here's the plan for the ground floor:

tree tree

No. 97, rue des Mimosas (Brussels III)

tree tree tree

There will be a guest room and I hope you'll use it when vacation time comes.
A house is fine in some ways, but I recall an *unread-*

able book by Souvestre (the brother of the author of FANTÔMAS), called *A Garret Philosopher,* and I'd like just to live in a room or a garret like the one Souvestre describes. I think it must be a really perfect pleasure to read FANTÔMAS in such a dwelling.

Until soon dear friend,
yours,
René Magritte

[*The words in the floor plan are*]
pine tree, gate to the garden, easel, piano, dining room, hall, kitchen, toilet, and fence.

3 Fig. 45 (page 39)
Letter from René Magritte to Harry Torczyner, April 22, 1965

22 ~~August~~ April 1965

Dear Friend,
I got your letter of April 17 with great pleasure: it's the first sign we've had of the existence of a land other than this Italian isle. Until now, it's been awfully cold here in the "land of sun." I don't know whether the benefits of the treatment aren't being compromised by the unsatisfactory temperature that prevails here. (The hotel doesn't have heat.) From a gastronomical point of view, there are astonishing "surprises" *ex contrario:* stringy chicken comes covered with a mound of raw spinach. "Cream of vegetable" soup is hard to tell from wallpaper paste. We are said to be in the best hotel in Casamicciola. I think we got here too early: the good season (if it's not a myth) will appear after our return to Brussels.
As for the cure, it lasts for a good hour: 1st, a mudbath; 2nd, a bath in mountain water; 3rd, rest; 4th, massage. This takes place at around 8 AM on an empty stomach. There hasn't been any improvement as yet in the health *status quo* that prevailed in Brussels. It's an effort for me to write, to sit, to lie down, etc.
I don't know what to tell you about filling requests for exhibitions. Kansas City, for example, ought perhaps to be canceled if the N.Y. museum has set a date that doesn't allow for organizing several exhibitions?
Georgette and I were very happy to hear your news. Our best wishes to you and Marcel [sic].

R.M.
(On the 16th I sent you an airmail card, and one to Suzi.)

4 Fig. 51 (page 44)
Letter from René Magritte to Harry Torczyner, September 18, 1965

18 September 1965

Dear Friend,
Your letter of the 15th contains a good question. Both good, and unfortunate: it makes me understand better Soby's ideas, which aren't very "catholic." In-

deed, if there is any influence, it can be said that Chirico is responsible for it (since about 1925, the date when I first knew his work). For that matter, in a book on Max Ernst, Waldberg does not hide the fact that Ernst also underwent Chirico's influence. Max Ernst and I admit to it readily, but with a little bit of critical sense it is soon obvious that our "personalities" rapidly came to the fore and that our relationship to Chirico was no more than the one the other Surrealists shared to a greater or lesser degree, and in very different ways.

If it's a question of Max Ernst's influence, one has to talk about Frits van den Berghe, who was far from the Surrealist spirit; he only used the exterior aspect of Ernst's painting and in some people's eyes he passes for a "precursor of Surrealism in Belgium."

As for the books of Éluard and Ernst, I didn't know them until I met them in 1927. Then—as now—I was very little "in the know" about artistic goings on.

If one takes into consideration what I've painted since 1926 (*Le jockey perdu*—1926—for example, and what followed), I don't think one can talk about "Chirico's influence"—I was "struck" about 1925 when I saw a picture by Chirico: *Le chant d'amour*. If there is any influence—it's quite possible—there's no resemblance to Chirico's pictures in *Le jockey perdu*. In sum, the influence in question is limited to a great emotion, to a marvelous revelation when for the first time in my life I saw truly poetic painting. With time, I began to renounce researches into pictures in which the *manner of painting* was uppermost. Now, I know that since 1926 I've only worried about *what should be painted*. This became clear only some time after having "instinctively" sought what should be painted.

So there will be two drawings for Seitz and Lady X.

Until soon, dear Harry, and friendly greetings to you and Marcelle.

R.M.

5 Fig. 53 (page 46)
Letter (excerpt) from René Magritte (written in London) to Louis Scutenaire and Irène Hamoir, February 18, 1937

I'm writing to you since I suppose that since you're crippled up—as Scut tells me among his usual jokes—you won't be coming to London this weekend.

London is a revelation. Of course, I'm only just beginning to discover it. But until now, everything is perfect (of course I don't speak English, but "there's something"). Yesterday evening we went to visit Henry Moore, a charming sculptor, sort of Arp-Picasso, the son of a miner, with a young Russian wife ADMIRABLY stacked (a sort of robust wasp). I'm expecting Georgette this coming Friday. Maybe Colinet will come with her? The joker hasn't written me yet. What does this mean?

Until soon, my friends, with my best wishes—
Magritte

6 Fig. 56 (page 51)
Letter (excerpt) from René Magritte to Maurice Rapin, May 22, 1958

My latest picture began with the question: how to paint a picture with a glass of water as the subject? I drew a number of glasses of water:

[illustrations]

a line [illustration] always appeared in these drawings.

Then this line [illustration] became deformed [illustration] and took the form of an umbrella [illustration]. Then this umbrella was put into the glass [illustration], and finally the umbrella opened up and was placed under the glass of water [illustration]. Which I feel answers the initial question.

The picture so conceived is called:
Les vacances de Hegel

I think Hegel would have liked this object that has two contrary functions: to repel and contain water. Wouldn't that have amused him as we are amused when on vacation?

Your friend,
René Magritte

7 Fig. 57 (page 53)
Letter (excerpt) from René Magritte to Paul Colinet, 1957

... springs immediately to mind:
[illustration] blackboard
however, it's like the preceding title: however amusing, it's insufficient. Along the same lines:
[illustrations]
PTO

8 Fig. 76 (page 67)
Notes (complete) for an illustrated lecture given by René Magritte at the Marlborough Fine Art Gallery, London, February 1937

THE NAMING OF THINGS

Ladies and Gentlemen,

The demonstration we are about to embark upon will attempt to show some of the characteristics proper to words, to images, and to real objects.

(1) A word can replace an image:
Chapeau *HAT*.

(2) An image can replace a word. I will demonstrate this by using a text of André Breton, in which I will replace a word with an image:
[illustration]

Si seulement IF ONLY THE *SUN* WOULD SHINE TONIGHT.

(Jean Scutenaire) *On ne peut pas* ONE CANNOT GIVE BIRTH TO A *FOAL* WITHOUT BEING ONE ONESELF [illustration]

Paul Éluard: *Dans les plus sombres* yeux *se ferment les plus clairs.* THE DARKEST *EYES* ENCLOSE THE LIGHTEST.
[illustration]

[illustration]

(Paul Colinet) *Il y a* THERE IS A *SPHERE* PLACED ON YOUR SHOULDERS.

David Gascoigne (Mesens) *Masque de veuve* WIDOW'S *MASK* FOR THE WALTZ.

Humfrey [sic] Jennings THE FLYING BREATH OF EDUCATION [illustration]

(3) A real object can replace a word:
Le pain du crime. THE *BREAD* OF CRIME.

(4) An undifferentiated form can replace a word:
Les naissent THE [illustration] ARE BORN IN WINTER.

(5) A word can act as an object:

Ce bouquet THIS BOUQUET IS TRANSPARENT

(6) An image or an object can be designated by another name:

L'oiseau	[illustration]	THE BIRD
La montagne	[illustration]	THE MOUNTAIN
Voici le ciel	[illustration]	BEHOLD THE SKY (skaie) (dis is de skaye)

(7) Certain images have a secret affinity. This also holds true for the objects these images represent. Let us search for what should be said. We know the bird in a cage. Our interest is increased if we replace the bird with a fish, or with a slipper.

These images are strange. Unfortunately, they are arbitrary and fortuitous.

[illustrations]

However, it is possible to arrive at a new image that will stand up better beneath the spectator's gaze. A large egg in the cage seems to offer the required solution.

[illustration]

Now let us turn to the door. The door can open onto a landscape seen backwards.

The landscape can be represented on the door.

Let us try something less arbitrary: next to the door, let us make a hole in the wall that will be another door. This juxtaposition will be improved if we reduce these two objects to one. Thus, the hole comes naturally to be in the door, and through this hole we see darkness.

This image can be further enhanced if we illuminate the invisible object hidden by darkness. Our gaze always tries to go further, to see the object, the reason for our existence.

Notes for an illustrated lecture given by René Magritte at the London Gallery, London, February 1937.

9 Fig. 77 (page 68)
Les mots et les images (Words and Images).
**Illustration in *La Révolution Surréaliste*
(Paris), vol. 5, no. 12 (December 15, 1929),
pp. 32–33**

WORDS AND IMAGES

[*first column*]
An object is not so linked to its name that we cannot find a more suitable one for it
[illustration]
Some objects can do without a name:
[illustration]
Often a word is only self-descriptive:
[illustration]
An object encounters its image, an object encounters its name. It can happen that the object's name and its image encounter each other:
[illustration]
Sometimes an object's name can replace an image:
[illustration]
A word can replace an object in reality:
[illustration]

[*second column*]
An image can replace a word in a statement:
[illustration]
An object makes one suppose there are other objects behind it:
[illustration]

Everything leads us to think that there is little relation between an object and what it represents:
[illustration]
Words that serve to designate two different objects do not reveal what can separate these objects from each other:
[illustration]
In a picture, words have the same substance as images:
[illustration]
In a picture, we see images and words differently:
[illustration]

[*third column*]
An undifferentiated form can replace the image of an object:
[illustration]
An object never performs the same function as its name or its image:
[illustration]
Now, in reality the visible outlines of objects touch each other, as if they formed a mosaic:
[illustration]
Vague figures have a necessary meaning that is as perfect as precise figures:
[illustration]
Written words in a picture often designate precise objects, and images vague objects:
[illustration]
Or the opposite:
[illustration]

René Magritte

**10 Fig. 92 (page 75)
Letter from René Magritte to Harry
Torczyner, August 19, 1960**

August 19, 1960

Dear Friend,

I have received your letter of August 16th and the "special" documents. Thank you. I'll get in touch with the manager of the Mayfair, whose name has something Dutch about it.

I am happy to hear about the welcome you've given *Le tombeau des lutteurs.* The date 1944 shows that during that period the painting I envisaged—attempting to bring it into harmony with the Impressionist spirit—wasn't *always* (in 1954) in accord with that spirit. "My usual manner" was sometimes, rather always, there to testify that I would recover once and for all. The 1944 pictures, such as *Le tombeau des lutteurs,** were, in fact, painted in "my usual manner," which has since come to be the only one that I feel is truly necessary for painting, without fantasy or eccentricity, ideas already "sublime" enough that they do not need to be anything but a precise description. I firmly believe that a beautiful idea is ill served by being "interestingly" expressed: the interest being in the idea. Those ideas that need eloquence to "get across," for example, are incapable of making an effect on their own.

This is one of my convictions—which are often solely tested by all kinds of interpreters, who try to add something "of themselves" when they recite poems, paint pictures, etc.

At the moment, I'm waiting for you to be freed from the chains fastening you to your desk so that you can think about making a little trip to Belgium.

Best wishes to you and your family, who have my heartfelt feelings,

René Magritte

Le tombeau des lutteurs was, of course, painted in 1960

11 Fig. 100 (page 80)
Letter (excerpt) from René Magritte to
Harry Torczyner, July 1958

I await your news. As for mine, the best I can do is tell you the solution to the problem of painting a picture with a chair as subject. I looked for a long time before realizing that the chair had to have a tail (which is more "striking" than the timid animal feet that chairs sometimes have). I'm very satisfied with this solution. What do you think?

<div align="right">Yours,
René Magritte</div>

12 Fig. 122 (page 89)
Letter (excerpt) from René Magritte to
Mirabelle Dors and Maurice Rapin, August 6,
1956

I have just painted the moon on a tree in the blue-gray colors of evening. Scutenaire has come up with a very beautiful title: *Le Seize Septembre*. I think it "fits," so from September 16th on, we'll call it done.

13 Fig. 152 (page 103)
Gouache study for an ashtray, *La*
métamorphose de l'objet (Metamorphosis of
***the Object)*, 1933**

[illustration]

Dear Lady Admirer,
　Here's the bottom. If the person with ashtrays wants to put a border on it, he should simply put equal concentric circles on a white border: [illustration] the same white as in the drawing. I hope it will please you as much as Cleopatra pleased Bonaparte. Until one of these days soon. Yours, M

14 Fig. 173 (page 115)
Letter (excerpt) from René Magritte to Harry
Torczyner, with pen sketch of *Le puits de vérité*
***(The Well of Truth)*, January 13, 1962**

A while ago I sent Suzi the design of a new picture (a pant leg and a shoe), asking her what she would call it.

[illustration]　The title has finally been found: *L'étalon* [*The Standard*] (in the sense of the immutable—almost—unity of measurement.

15 Fig. 185 (page 133)
Autobiographical statement by René
Magritte, March 20,1962

After having taken courses at the Académie des Beaux-Arts in 1916 and 1917, I tried with the means I possessed to find a way to paint pictures that would interest me (I was indifferent to the paintings said to "express feelings," and, on the other hand, painting restricted to purely formal pictorial effects didn't seem to me worth looking at), and I tried—with the help of Futurist, Cubist, and Dadaist theories—to paint in a way that would satisfy. That was a research period that lasted for nearly ten years, without reaching any conclusion. About 1926, these various investigations were abandoned because of what I deem to have been the revelation of *what was to be painted: what was to be painted was what must be painted now, in 1962*. What must be painted is limited to a thought that can be described in painting. Given the fact that feelings and ideas have no visible appearance, this thought (which can be described by painting and therefore becomes visible) includes no idea and no feeling. It is like what the apparent world offers to our awareness—Yet this thought is not passive, like a mirror: it is highly ordered, it unites—in the order evocative of the world's mystery and of thought—figures from the apparent world: skies, characters, curtains, inscriptions, solids, etc.—It should be noted that this thought (which is worth describing in painting) does not "assemble" just anything, it doesn't "compose": it unites objects in such a way that visible objects evoke the mystery without which there would be nothing. As examples, a nocturnal landscape beneath a sunny sky and, on the other hand, a mountain shaped like a bird, both demonstrate that painting—as I conceive it—is not guided by formal researches, but involves thought, exclusively because of its lack of solution of the world's continuity and mystery.

<div align="right">René Magritte
March 20, 1962</div>

MAGRITTE/CHRONOLOGY

1898 René-François-Ghislain Magritte born November 21 in Lessines, in the Belgian province of Hainaut, the son of Léopold and Régina Magritte (née Bertinchamp)

1910 the Magrittes move to Châtelet (Hainaut), where René studies drawing

1912 Magritte's mother commits suicide by drowning in the River Sambre. René studies at the Lycée Athénée

1913 Magritte, his father, and his brothers Raymond and Paul settle in Charleroi. Magritte meets the thirteen-year-old Georgette Berger at a fair

1916-18 Magritte studies, intermittently, at the Académie Royale des Beaux-Arts in Brussels

1918 The Magritte family moves to Brussels. René works in Pierre Flouquet's studio and discovers Futurism

1920 First exhibition in Brussels at the Galerie Le Centre d'Art

1921 Military service

1922 Magritte marries Georgette Berger. Works as a designer in a wallpaper factory with the painter Victor Servranckx. Together they write *L'art pur: Défense de l'esthétique* (unpublished). Magritte discovers De Chirico's painting *Le chant d'amour (The Song of Love,* 1914). Magritte's paintings are influenced by Cubism, Futurism, and abstract art. He makes poster designs and advertising sketches

1926 Paints *Le jockey perdu (The Lost Jockey)* and receives a contract from the Galerie le Centaure in Brussels. In one year, he paints sixty canvases

1927 First one-man exhibition at the Galerie Le Centaure is unfavorably received. Moves to Le Perreux-sur-Marne, near Paris. Plays an active role in the Parisian Surrealist circle and shows his work at Camille Goemans' gallery the following year

1929 Publishes "Les mots et les images" ("Words and Images") in *La Révolution Surréaliste.* Visits Dali in Cadaqués, Spain

1930 Magritte returns to Belgium and resides at 135 rue Esseghem in Jette-Brussels

1936 First one-man exhibition in the United States at the Julien Levy Gallery, New York

1937 Stays for three weeks in London at the home of Edward James

1938 First one-man show in London at the London Gallery. On December 10 Magritte delivers a lecture entitled "La Ligne de Vie" ("The Lifeline") in Antwerp

1940 Joins the exodus of Belgians following the German invasion of May 19. Spends three months in Carcassonne, France, before returning to Georgette in Brussels

1943-45 Attempts Surrealist paintings "in full sunlight," employing the technique of the Impressionists

1945 Joins and abandons the Communist Party

1948 Fauvist period Magritte calls "l'époque vache"

1952-53 Paints *Le domaine enchanté (The Enchanted Domain),* a series of eight panels later enlarged under his supervision for murals at the Casino Communal, Knokke-Le Zoute, Belgium

1954 Retrospective at the Palais des Beaux-Arts, Brussels. Writes "La pensée et les images" ("Thought and Images") for the catalogue

1956 Awarded the Guggenheim Prize for Belgium

1957 Moves to 97 rue des Mimosas, Brussels-Schaerbeek. Paints *La fée ignorante (The Ignorant Fairy),* the design for a mural in the Palais des Beaux-Arts at Charleroi, later executed under his supervision

1960 Retrospective exhibitions at the Dallas Museum for Contemporary Arts and The Museum of Fine Arts, Houston. Luc de Heusch makes a film with and about Magritte entitled *La leçon des choses, ou Magritte,* premiered April 7, 1960

1961 Designs and supervises a mural for the Palais des Congrès, Brussels, entitled *Les barricades mystérieuses (The Mysterious Barricades).* Writes "Le rappel à l'ordre ("The Call to Order"), *Rhétorique,* no. 1, May 1961

1962 Writes "La leçon des choses" ("The Object Lesson"), *Rhétorique,* no. 4, January 1962. Exhibition at the Walker Art Center, Minneapolis

1964 Writes "Ma conception de l'art de peindre" ("My Conception of the Art of Painting"), *Rhétorique,* no. 11, May 1964. Exhibition at the Arkansas Art Center, Little Rock

1965 Retrospective at The Museum of Modern Art, New York. Georgette and René Magritte visit the United States for the first time

1966 René and Georgette Magritte visit Israel

1967 Exhibition at the Museum Boymans-van Beuningen in Rotterdam. Magritte dies on August 15. Exhibition at the Moderna Museet, Stockholm

1969 Retrospective exhibitions at The Tate Gallery, London; Kestner-Gesellschaft, Hanover; and Kunsthaus, Zurich

1971 Exhibition at the National Museum of Modern Art, Tokyo, which travels to the National Museum of Modern Art, Kyoto

1973 Retrospective loan exhibition at Marlborough Fine Art, London

1976 Exhibition at the Institute for the Arts, Rice University, Houston

1977 Exhibition, "René Magritte: Ideas and Images," Sidney Janis Gallery, New York. The eight panels constituting *Le domaine enchanté* (from the Casino Communal, Knokke-Le Zoute, Belgium) exhibited at Metropolitan Museum of Art, New York

1978 Retrospective exhibitions at the Palais des Beaux-Arts, Brussels, and at the Centre National d'Art et Culture Georges Pompidou, Paris

SELECTED BIBLIOGRAPHY

WRITINGS BY MAGRITTE

René Magritte was a prolific writer of manifestos, statements, articles, and personal letters, which dealt with his own artistic activities and also constituted a running account of his views on the general artistic, political, and social issues of his time. The following material has been consulted in the formulation of this volume.

Dors, Mirabelle, and Rapin, Maurice. *Quatre-vingts Lettres de René Magritte à Mirabelle Dors et Maurice Rapin*. Paris: CBE Presses, 1976

Magritte, René. Unpublished letters and statements from the personal archives of Georgette Magritte, Pierre Alechinsky, André Blavier, André Bosmans, Dominique de Menil and the Menil Foundation, Pierre Demarne, Mirabelle Dors and Maurice Rapin, Marcel Mariën, Irène Hamoir and Louis Scutenaire, André Souris, and Harry Torczyner

Mariën, Marcel (ed). *René Magritte: Manifestes et autres écrits*. Brussels: Les Lèvres Nues, 1972

Rapin, Maurice. "René Magritte," in *Aporismes*. Viry-Chatillon, France: S.E.D.I.E.P., 1970, pp. 20–36

BOOKS ABOUT MAGRITTE

Blavier, André. General bibliography up to 1965 in Waldberg, Patrick, *René Magritte*. Brussels: André de Rache, 1965, pp. 285–336
————. *Ceci n'est pas une pipe. Contribution furtive à l'étude d'un tableau de René Magritte*. Verviers, Belgium: Temps Mêlés (publication of the Fondation René Magritte), 1973

Bussy, Christian. *Anthologie du Surréalisme en Belgique*. France: Éditions Gallimard, 1972

Demarne, Pierre. "René Magritte," *Rhétorique*, no. 3, September 1961

Foucault, Michel. *Ceci n'est pas une pipe*. Montpellier, France: Fata Morgana, 1973

Gablik, Suzi. *Magritte*. Greenwich, Connecticut: New York Graphic Society, 1973

Hammacher, A. M. *Magritte*. New York: Harry N. Abrams, 1974

Larkin, David. *Magritte*. New York: Ballantine Books, 1972

Lebel, Robert. *Magritte, peintures*. Paris: Fernand Hazan, 1969

Mariën, Marcel. *René Magritte*. Brussels: Les Auteurs Associés, 1943

Michaux, Henri. *En rêvant à partir des peintures énigmatiques*. Montpellier, France: Fata Morgana, 1972

Noël, Bernard. *Magritte*. Paris: Flammarion, 1976

Nougé, Paul. *Renè Magritte, ou les images défendues*. Brussels: Les Auteurs Associés, 1943

Passeron, René. *René Magritte*. Paris: Filipacchi-Odégé, 1970

Robbe-Grillet, Alain. *René Magritte: La belle captive*. Brussels: Cosmos Textes, 1975

Robert-Jones, Philippe. *Magritte: Poète visible*. Brussels: Laconti, 1972

Schneede, Uwe M. *René Magritte: Leben und Werk*. Cologne: M. DuMont Schauberg, 1973

Scutenaire, Louis. *René Magritte*. Brussels: Éditions Librairie Sélection, 1947
————. *René Magritte* (Monographies de l'Art Belge). Brussels: Ministère de l'Éducation nationale et de la Culture, 1964. First edition published by De Sikkel, Antwerp, 1948

————. *La Fidélité des images —René Magritte: Le cinèmatographe et la photographie*. Brussels: Service de la Propagande Artistique du Ministère de la Culture Française, 1976
————. *Avec Magritte*. Brussels: Lebeer-Hossman, 1977

Vovelle, José. *Le Surréalisme en Belgique*. Brussels: André de Rache, 1972, pp. 63–164

Waldberg, Patrick. *René Magritte*. Brussels: André de Rache, 1965

MAJOR EXHIBITION CATALOGUES (arranged chronologically)

Sidney Janis Gallery, New York. *Magritte: Words vs. Image*. March 1–20, 1954. 21 works

Palais des Beaux-Arts, Brussels. *René Magritte*. Brussels: Éditions de la Connaissance, 1954. May 7–June 1, 1954. 93 works

Dallas Museum for Contemporary Arts. *René Magritte in America*. December 8, 1960–January 8, 1961. In collaboration with The Museum of Fine Arts, Houston. 82 works

Obelisk Gallery, London. *Magritte: Paintings, Drawings, Gouaches*. September 28–October 27, 1961. 28 works

Alexandre Iolas Gallery, New York. *René Magritte: Paintings, Gouaches, Collages, 1960–1961–1962*. May 3–26, 1962. 23 works

Casino Communal, Knokke-Le Zoute, Belgium. *L'Oeuvre de René Magritte*. Brussels: Éditions de la Connaissance, 1962. July–August, 1962. 104 works

Walker Art Center, Minneapolis. *The Vision of René Magritte*. September 16–October 14, 1962. 92 works

Arkansas Art Center, Little Rock. *Magritte*. May 15–June 30, 1964. 97 works

The Museum of Modern Art, New York. *Magritte*. Introduction by James Thrall Soby. 1965. In collaboration with the Rose Art Museum (Brandeis University, Waltham, Massachusetts), The Art Institute of Chicago, the University Art Museum (University of California, Berkeley), and the Pasadena Art Museum. 82 works

Museum Boymans-van Beuningen, Rotterdam. *René Magritte*. August 4–September 24, 1967

Moderna Museet, Stockholm. *René Magritte: Le mystère de la vérité*. October 7–November 12, 1967

Byron Gallery, New York. *René Magritte*. November 19–December 21, 1968. 55 works

The Tate Gallery, London. *Magritte*. London: Arts Council of Great Britain. Introduction by David Sylvester. February 14–March 30, 1969. 101 works

Kestner-Gesellschaft, Hanover. *René Magritte*. 1969. 107 works

National Museum of Modern Art, Tokyo. *Rétrospective René Magritte*. Traveled to National Museum of Modern Art, Kyoto. 1971

Grand Palais, Paris. *Peintres de l'imaginaire: Symbolistes et surréalistes belges*. 1972. Included 46 works by Magritte

Marlborough Fine Art, London. *Magritte*. October–November, 1973. 87 works

Institute for the Arts, Rice University, Houston. *Secret Affinities: Words and Images by René Magritte*. October 1, 1976–January 2, 1977. 48 works

LIST OF ILLUSTRATIONS

All figure numbers are in *italics*. Asterisks refer to color plates.

PHOTOGRAPH CREDITS